BERNINI

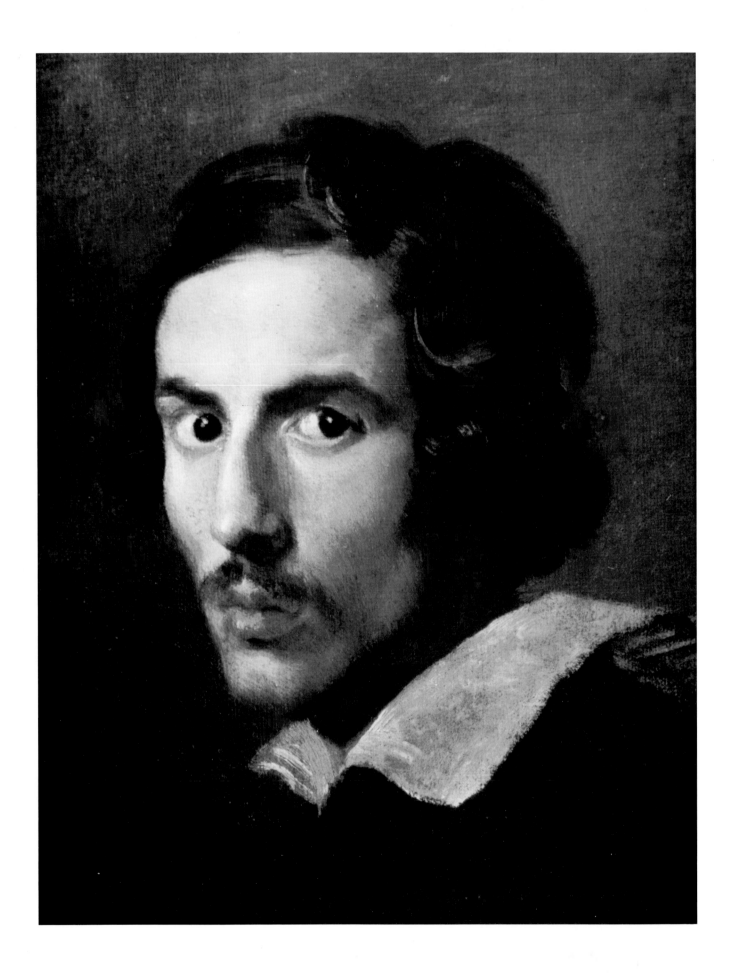

GIANLORENZO
BERNINI

BY
CHARLES SCRIBNER III

HARRY N. ABRAMS, INC., PUBLISHERS

For my baroque boys, Charles and Christopher

ACKNOWLEDGMENTS

It is a pleasure to acknowledge my mounting debt to John Rupert Martin and Julius S. Held, who encouraged my parallel study of Rubens and Bernini over the years, generously shared their own insights and scholarship, and contributed so much to this book. To Jacques Barzun I am deeply grateful for his critical eye and editorial chisel, which left no page unimproved. Among the many friends and scholars from whom I have benefited through conversation and correspondence, I wish especially to thank Irving Lavin, Joan Nissman, Mark Weil, David Coffin, Marc Worsdale, Olga Raggio, Judith Bernstock, Andrew Ciechanowiecki, Michael Hall, and the late Howard Hibbard. At the Frick Art Reference Library, Joan Pope provided invaluable assistance. In Rome, Brian Aitken proved the ideal companion as he made me see familiar marbles afresh, through the lens of classical antiquity. Special thanks go also to Patricia Bonicatti and Walter Persegati at the Musei Vaticani, to Princess Orietta Doria at the Palazzo Doria-Pamphilj, and to Roberta Schneiderman, Anne Lincoln, DeeDee and Halsted van der Poel, Ariel Herrmann, and the late Cardinal Pignedoli, each of whom helped to make Rome seem my second home. At Abrams, I was blessed by a creative triumvirate—editor Beverly Fazio, photo editor Neil Hoos, and designer Ellen Nygaard Ford—and by Cathy Cain, the angel of communications. Several new photographs were commissioned from David Finn, whose eye for details and sensual contours was a source of refreshment and revelation. Above all, I thank my parents, who financed the early years of study and provided unflagging support of every kind. Finally, I recall a most harmonious trio, the Three Graces of Holland Road—Andrée and Ritchie Markoe and Holly Pyne (or so were their names then)—who concluded in Rome our whirlwind tour of Europe in the summer of '73. Today my wife, Ritchie remains the constant image drawn from that August when I first fell under Bernini's spell in the Piazza Navona.

PHOTOGRAPH CREDITS

© A.C.L. Bruxelles: 49; Alinari: 12 (both), 13, 17 (both), 19 (above left), 23 (below), 27 (above), 32 (above right); Bibliotheca Hertziana, Rome: 30 (above), 33 (below), 37 (above); Canali, Rome: 77 (below); David Finn: 49, 63, 95 (left/below right), 97 (all), 99 (below left/below right), 119 (below left/ below right), 125 (below left); © 1990 Her Majesty Queen Elizabeth II: 20 (left), 30 (below left); Istituto Centrale per il Catalogo e la Documentazione: frontispiece, 2, 7, 8 (above), 10 (above), 11, 16 (above), 23 (above), 25 (above), 35 (above), 42 (left), 44 (below left); Photographie Giraudon: 44 (above); © R.M.N.: 40, 109; Scala/Art Resource, New York: 51 (above), 57, 61, 65, 67, 71, 73, 79, 81, 83, 85, 87, 89, 91 (all), 93, 99 (above), 101, 103 (both), 105, 107, 113, 115, 117, 119 (above), 121, 123, 125 (above); Charles Scribner III: 41, 42 (right), 75, 95 (above right); Vanni/Art Resource, New York: 111; Giorgio Vasari: 69; The Victoria and Albert Museum, London/Art Resource, New York: 59.

Editor: Beverly Fazio
Designer: Ellen Nygaard Ford
Photo Research: Neil Ryder Hoos

Frontispiece: Gianlorenzo Bernini: *Self-Portrait.* 1623. Oil on canvas, 15⅜ × 12³⁄₁₆″ (39 × 31 cm). Galleria Borghese, Rome

Library of Congress Cataloging-in-Publication Data

Scribner, Charles.
Bernini / by Charles Scribner III.
 p. cm.—(Masters of art)
Includes bibliographical references.
ISBN 0-8109-3111-7
1. Bernini, Gian Lorenzo, 1598–1680. 2. Artists—Italy—Biography. I. Title. II. Series: Masters of art (Harry N. Abrams, Inc.)
N6923.B5S37 1991
709′.2—dc20 90–46202
 CIP

CONTENTS

———————

GIANLORENZO BERNINI: IMPRESARIO OF THE BAROQUE

Gianlorenzo Bernini personified the style and era we call the Baroque. He dominated almost an entire century. His audience comprised Europe's leading patrons, prelates, and princes, but, except for a six-month entr'acte in Paris, Rome was his lifelong stage. His monumental presence throughout the Eternal City is as resonant as the ancient ruins. In marble, travertine, bronze, stucco, and gilt; in paint, through glass and shimmering water, sculptured space and channeled light, Bernini left his imprint on the Catholic capital, the indelible stamp of genius. Within its walls he created another realm, one of imagination incarnate, which three centures later still shapes our experience of Rome and transfigures it.

Yet Gianlorenzo himself was not a native Roman. He was born in Naples on December 7, 1598, "by divine plan," according to his biographer Filippo Baldinucci, "so that this child might for Italy's good fortune bring illumination to two centuries."[1] His father, Pietro, was a successful Florentine sculptor who had also practiced painting in Rome before moving south to the court of Naples. There he married a Neapolitan girl, Angelica Galante. Most of Pietro's early sculptures (and all of his paintings) have slipped into anonymity; were it not for his son, Pietro — like Leopold Mozart — would today command a minor footnote. His works (figs. 1, 7, 9) exemplify the refined, passionless style of late Mannerism that was soon to be displaced by its full-blooded Baroque offspring. It is as father and teacher of his famous son that Pietro shines by reflected glory.[2]

In 1605 Pietro Bernini was called back to Rome by Pope Paul V (Borghese) to work on his burial chapel in Santa Maria Maggiore. The Bernini family settled, this time permanently, in spacious quarters near that ancient basilica, which, like Rome itself, was being restored in Counter-Reformation splendor by a reinvigorated papacy. The dawn of the Baroque had already broken over the Eternal City. The new style had been heralded by artists arriving from the north, the Carracci brothers and Caravaggio. Their blending of a new naturalism or verisimilitude in painting with a revival of the heroic, classical contours of Michelangelo and Raphael would soon be embraced by sculptors — above all, by Gianlorenzo Bernini.[3]

The year 1600 saw the unveiling of the Carracci's monumental frescoed ceiling in the Palazzo Farnese (fig. 2), revealing in its combined sensuality and erudition, its sympathetic reinterpretation of ancient mythology, and its spatial illusionism the hallmarks of the Baroque. These visionary yet rationalized assaults on the senses, the integration of real and fictive space, and the impassioned, often ecstatic emotional content were to leave a

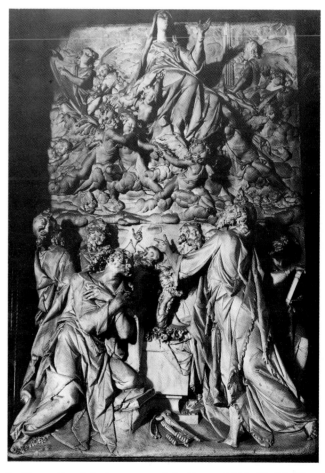

1. Pietro Bernini. *Assumption of the Virgin.* 1606–10. Marble relief. Santa Maria Maggiore, Rome

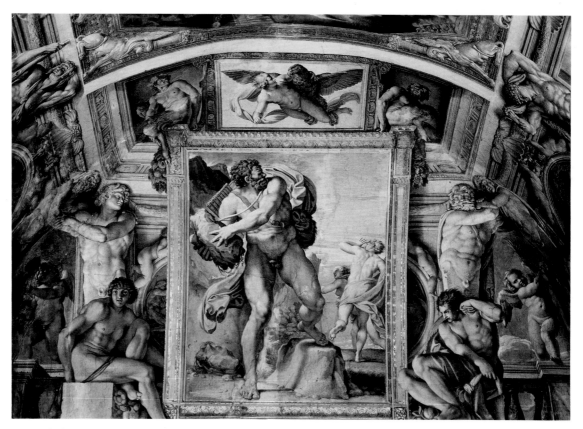

2. Annibale Carracci. *Polyphemus and Acis.* 1599–1600. Fresco. Galleria Farnese, Rome

lasting impression on Bernini. In later years he was to reserve the highest praise for Annibale Carracci for "combining the grace and draftsmanship of Raphael, the knowledge and anatomical science of Michelangelo, the nobility of Correggio, the coloring of Titian, the fertile imagination of Giulio Romano and Andrea Mantegna . . . as if by walking through a kitchen with a spoon he had dipped into each pot, adding from each a little to his own mixture."[4] At the same time, Caravaggio was introducing his dramatic use of chiaroscuro (see fig. 3)—the emotionally charged and spiritualized contrast of light and shadow—in major Roman altarpieces both celebrated and censured for their radical naturalism. Caravaggio was to flee the city a year after the Bernini family's arrival; yet his legacy was not confined to painters, as Gianlorenzo would later demonstrate by translating both his intense realism and metaphysical illumination into three dimensions. A third, less conspicuous, presence in Rome was the Flemish painter Peter Paul Rubens, who was commissioned in 1606 to paint the high altarpiece of the Chiesa Nuova (figs. 4, 30), the mother church of the city's Catholic renewal by the Oratorians. Rubens's ensemble of three monumental panels that spiritually define the sanctuary space was to find its High Baroque fulfillment, a generation later, in the art of the mature Bernini.[5]

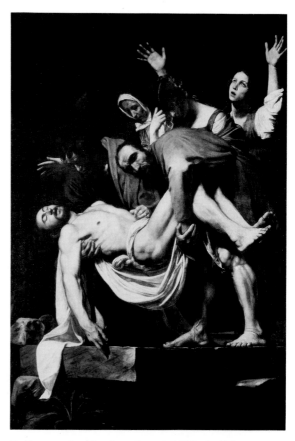

3. Caravaggio. *The Entombment.* 1602–4. Oil on canvas, 118⅛ × 79¹⁵⁄₁₆″ (3 × 2.03 m). Vatican Museums, Rome

4. Peter Paul Rubens. *The Madonna di Vallicella and Angels.* 1608. Oil on slate, 15′11″ × 8′9½″ (4.85 × 2.68 m). Santa Maria in Vallicella, Rome

from his Neapolitan mother that he derived his volcanic personality and dramatic flair — "fiery in temperament, constant in work, and passionate in his wrath," in son Domenico's summation. According to Baldinucci, Gianlorenzo was only eight years old when he carved his first marble head. Pietro is said to have been warned by Maffeo Barberini, the future Pope Urban VIII, "Watch out, the boy will surpass his master." To which the enlightened father replied, "It doesn't bother me, Your Eminence, for in this game the loser wins." Pietro proved an ideal teacher; by mixing praise and criticism he instilled in his son the habit of being in constant competition with himself. Even in his old age Gianlorenzo was to confess he had never done anything that completely pleased himself. Or as Domenico explained, "Praise served only as the stimulus to work because applause, which is wont to make others vainly satisfied with themselves, aroused in him the most burning desire to make himself more worthy of it by his deeds."

While his father and assistants were at work in Santa Maria Maggiore, young Gianlorenzo spent "three continuous years from dawn until the sounding of the Ave Maria in the Vatican" drawing copies of the master-pieces of ancient sculpture (fig. 5). Even if this academic

All modern accounts of Bernini's life rely up-on two early and interrelated biographies — one by the Florentine academician Filippo Baldinucci, commissioned by Queen Christina of Sweden and published in 1682; the other by the sculptor's son Domenico, published in 1713. Both appear to derive, synoptically as it were, from a lost manuscript by Domenico based on his father's reminiscences, several of which were independently recorded in the Sieur de Chantelou's diary of Bernini's sojourn in France, still the primary source of the sculptor's penetrating — and equally colorful — views on himself, his art, and his contemporaries.[6] Yet while these accounts vividly reflect the public man, they reveal little of his private life. No doubt Bernini intended it so. His biography was ultimately to be pre-served not in prose but in his art: it is carved in stone.

We know little of Gianlorenzo's earliest years except the one essential fact: he was a prodigy. From his Florentine father he inherited his innate facility in wielding a chisel, in shaping stone as though it were as "malleable as wax" or "pliable as pasta"; perhaps it was

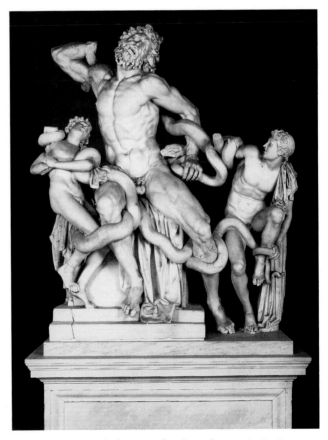

5. Agesandros, Polydoros, and Athenodoros of Rhodes. *Laocoön.* Late 2nd century B.C. Marble, height 95″ (2.41 m). Vatican Museums, Rome

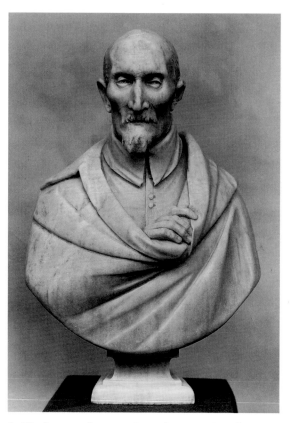

6. Gianlorenzo Bernini. *Bust of Antonio Coppola.* 1612. Marble, height 26⅜″ (67 cm). San Giovanni dei Fiorentini, Rome

Like Michelangelo, the young Bernini not only studied and sketched but thoroughly absorbed into his fingers the masterpieces of classical sculpture. His earliest mythological piece, *The Goat Amalthea and Infant Zeus with Satyr* (c. 1611–12; plate 2), was for centuries miscatalogued as a Hellenistic original. A deliberate forgery? Probably not—but it was most certainly a precocious performance by the adolescent student of antiquity. According to Baldinucci, the "first work to emerge from his chisel" was the portrait bust of Bishop Giovanni Battista Santoni, the late majordomo of Pope Sixtus V (c. 1611; plate 1). Gianlorenzo's special talent was first identified—and exploited—in the field of portraiture: his uncanny ability to capture a likeness in stone "quickly gained such fame that men spoke of him in the Roman academies as an incredible marvel, something never before seen." Soon afterward, Pietro, serving as agent for his thirteen-year-old apprentice, contracted with the hospital of San Giovanni dei Fiorentini to furnish a posthumous bust of its benefactor Antonio Coppola (fig. 6). The grave realism of this bust evokes its early Roman republican ancestors. Its convincing attribution to Gianlorenzo provides a documented anchor for the legendary claims of precocity: it

schedule was magnified in nostalgic retrospect, it is clear that the youth's classical education was, above all, a visual one. (His schooling in the humanities was reportedly overseen by Cardinal Barberini, a dedicated scholar and poet and a friend of Galileo, among other luminaries of the day.) By the age of ten, Gianlorenzo had been introduced to the foremost collector in Rome, the cardinal-nephew Scipione Borghese; soon he was presented to the pope himself, who gravely commanded the boy to draw a head. Gianlorenzo started to draw, then stopped abruptly and asked, "What head does Your Holiness wish—a man or a woman, old or young, with what expression—sad or cheerful, scornful or agreeable?" "In that case," Paul V replied, "you know how to do everything." The resultant sketch of St. Paul, his namesake, so impressed the pontiff that he announced to the surrounding cardinals, "This child will be the Michelangelo of his age." Truer words could not have been spoken, whether in papal prophecy or biographical hindsight. Paul embraced the lad, brought forth a casket of gold medals, and told him to help himself. Gianlorenzo took twelve—"as many as he could hold in his little hands."[7]

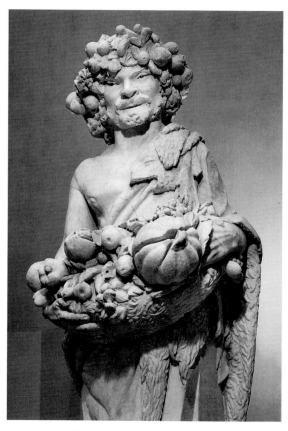

7. Pietro (and Gianlorenzo?) Bernini. *Herm of Priapus.* 1616. Marble, height 8′6⅜″ (2.6 m). The Metropolitan Museum of Art, New York

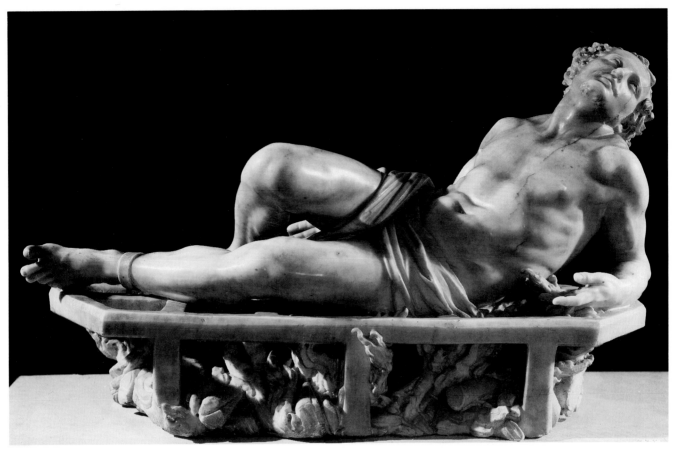

8. Gianlorenzo Bernini. *St. Lawrence.* c. 1615–16. Marble, 26 × 42½″ (66 × 108 cm). Collection Contini Bonacossi, Florence

was carved in four months.[8] Perhaps other such portraits will yet emerge to fill in the lacunae of Gianlorenzo's early efforts in his father's studio. The years of apprenticeship surely yielded several collaborations between father and son; at the same time, Pietro's protégé undertook his own works of increasing scale and complexity. His advancing technique of shaping stone into painterly flesh is already evident in the tabletop *Putto with Dragon* (c. 1613–14; plate 3). Pietro's influence is evident in the flaccid physiognomy of this beguiling, buck-toothed *putto;* but its childlike animation and tactile conviction place it beyond the reach of the senior Bernini's guiding hand.

In the *Four Seasons* at the Villa Aldobrandini (c. 1613), a distinction may be drawn between the Michelangelesque *Autumn,* recently attributed to Gianlorenzo, and its decorative companions by Pietro.[9] In the collaborative *Faun Teased by Cupids* (plate 5), which dates from a few years later, the more ambitious and spirited configuration suggests a youthful variation by Gianlorenzo on one of his father's garden themes—a Mannerist spiral of shapes that beckons the viewer around the piece in search of the optimum view. While separating the hands of father and son is inevitably conjectural, we

tend, with good reason, to credit to the younger Bernini those passages of arresting naturalism, where smooth flesh is firmly supported by bone and sinew.

Annibale Carracci, who died in 1609, is said to have admired some of Gianlorenzo's *"picciole statue"* and to have urged the boy to study Michelangelo's *Last Judgment* for a full two years in order to learn a true representation of musculature. Gianlorenzo's initial religious works offer early Baroque reflections of the High Renaissance master. According to Domenico, his first nude figure, the *St. Lawrence* (c. 1615–16; fig. 8), was created "out of devotion to the saint whose name he bore." (Years later Bernini explained that his paired Christian forenames, John and Lawrence, in honor of his paternal grandfather, were the result of his having been preceded by six sisters!) The Early Christian saint meets his fiery martyrdom on a gridiron, a reincarnation of Michelangelo's Vatican *Pietà.* Gianlorenzo's personal identification with his patron saint, the motive behind the marble, is revealed by the extreme pains he took to reproduce Lawrence's suffering: "In order to represent the effect that the fire should have on the flesh and the agony of martyrdom on the face of the saint, he placed himself with his bare leg and thigh against a

11

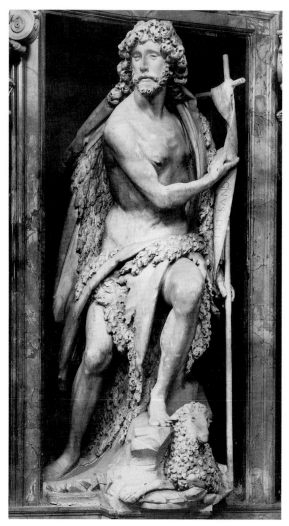

9. Pietro Bernini. *St. John the Baptist.* 1614–15. Marble. Barberini Chapel, Sant' Andrea della Valle, Rome

memorial chapel in Sant' Andrea della Valle displayed a bronze replica of Michelangelo's *Pietà*.

A year or so later (c. 1616–17) Gianlorenzo demonstrated his firmer grasp of the Michelangelesque form in his *St. Sebastian* (plate 4), another under-life-size figure, which he carved for his early mentor Maffeo Barberini, perhaps to be displayed in the cardinal's family chapel near Strozzi's. Life still courses though the veins of the wounded and unconscious saint. Compared with Pietro's *John the Baptist* (fig. 9), already ensconced in the Barberini chapel, Gianlorenzo's achievement explains why Maffeo ultimately decided to keep it for his private collection; and why, in the contract of 1618 for four *putti* to crown the chapel pediments, Pietro stipulated that they would be executed collaboratively "by my hand and the hand of my son Gianlorenzo."[11] While still legally underage and not yet eligible for acceptance into the sculptors' guild, Gianlorenzo was commissioned—perhaps on Barberini's recommendation—to carve his first papal portrait: the bust of Paul V (c. 1617–18; fig. 10), whose timeless effigy he rendered *all' antica,* with classically blank eyes. At the other end of the spectrum he pursued a more painterly approach to physiognomy in his *Blessed and Damned Souls* (fig. 11), the sculptural evocation of psychological extremes. If the *Anima Beata* reflects the Raphaelesque purity of a Guido Reni saint, the *Anima Dannata* conjures up Caravaggio's *Medusa* (Uffizi, Florence) with Gianlorenzo's own mirrored features trans-

lighted brazier"—then sketched his painful reflection in a mirror. A startled Pietro wept that his son, "still young and tender," would pursue his craft to such a degree that "he portrayed in himself the torment of a true St. Lawrence in order to carve a fictive one."[10] The revolutionary Caravaggio once claimed that an artist who did not strive to imitate nature indulged in mere child's play; the adolescent sculptor clearly concurred. Yet Lawrence's upturned face reveals, above all, not brutal anguish but an ecstatic consummation of the soul with God, a transcendent vision that prefigures Bernini's mature religious works. In his virtuoso translation into sculpture of a subject heretofore reserved to painters, Bernini entered the age-old competition, or *paragone,* between painting and sculpture. With no palette at hand, he conveyed color through chiaroscuro; even the insubstantial, flickering flames that lick the martyr's body have been captured in cold marble. It is hardly surprising that this piece was acquired by a leading Florentine collector, Leone Strozzi, whose

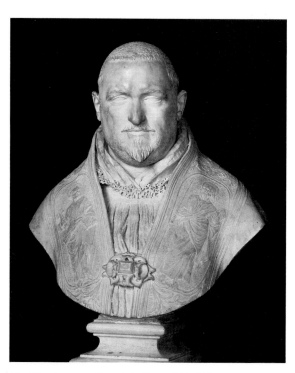

10. Gianlorenzo Bernini. *Bust of Paul V.* c. 1617–18. Marble, height 13¾" (35 cm). Galleria Borghese, Rome

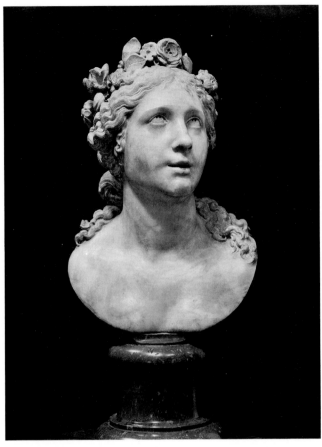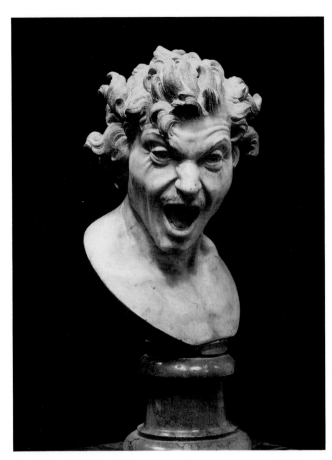

11. Gianlorenzo Bernini. *Blessed and Damned Souls.* c. 1619–20. Marble, life-size. Palazzo di Spagna, Rome

figured into an expression of damnation, formerly the domain of painters—or of Dante.

Bernini's years of study of antiquity (and of Michelangelo) and his collaboration with Pietro bore monumental firstfruits in a series of mythological life-size sculptures commissioned by the new Maecenas, Cardinal Scipione Borghese, for his villa on the Pincio. Begun in 1618 and finished a year later, the *Aeneas, Anchises, and Ascanius* (plate 6) illustrates a passage from Virgil translated into a marble ascent of the three ages of man. Its Mannerist torsion, a precarious twisting and piling of forms, suggests the residual influence—if not intervention—of Pietro, but the brilliant contrasts of textures confirm Gianlorenzo's authorship on the eve of his admission into the Guild of St. Luke as a *maestro*. His proficiency in re-creating the spirit of classical antiquity underscored his subsequent restoration of the Borghese *Hermaphrodite* (Louvre, Paris), for which Gianlorenzo provided a well-upholstered mattress of soft curves and deep folds as a sensual base for the recumbent figure of ambiguous sexuality.[12]

Bernini's ability to paint in marble, to create with a chisel the sensation of color, took a giant's step forward in his *Neptune and Triton* (c. 1620–21; plate 7).

Designed to dominate Domenico Fontana's fountain at the Villa Montalto, the terrifying lord of the seas wields his trident while his son sounds a heraldic note on the conch. Bernini raised this sculptural conception to a High Baroque pitch in his next Borghese group, *Pluto and Proserpina* (plate 8). Pluto stands on the threshold of Hades and on the brink of consummating his abduction of the fair maiden Proserpina. Transposing Giambologna's Mannerist *Rape of the Sabines* (fig. 12) into a strongly frontal composition, Bernini revived the Renaissance ideal of sculpture composed for a single, primary viewpoint. There are, to be sure, alluring peripheral views of this lustful configuration, but these sensual sideshows are clearly subordinated to the main dramatic axis.[13] From Proserpina's tear-stained cheek to Pluto's fingers grasping her thigh, it is as though Bernini had translated a Rubens into marble.

If Borghese was impressed, he was not unduly proprietary: in enlightened self-interest he gave the Pluto to his successor, the new papal nephew, Cardinal Ludovico Ludovisi. Pope Paul V had died in January 1621; for his funeral in Santa Maria Maggiore, Bernini designed a catafalque, his first monumental (though ephemeral) combination of sculpture and architecture.

13

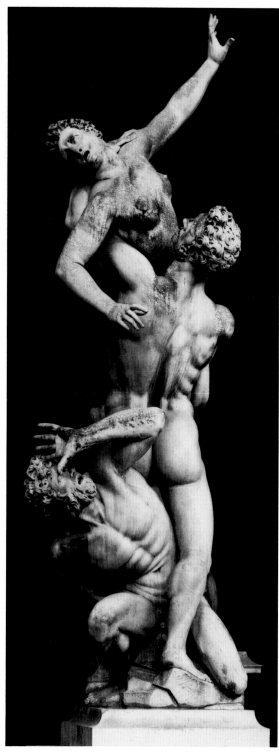

12. Giambologna. *Rape of the Sabines.* 1583. Marble, height 13′5½″ (4.1 m). Loggia dei Lanzi, Florence

years"—was admittedly a flourish of Baroque hyperbole, his ecclesiastical accomplishments proved enduring. He reformed the papal selection process through the introduction of secret balloting and established the Sacred Congregation for the Propagation of the Faith to coordinate the missionary activity of the Church. Finally he canonized the leaders of the Catholic (or Counter-) Reformation: Philip Neri, Ignatius of Loyola, Francis Xavier, and Teresa of Avila.

Gregory observed that "there is no situation more difficult or dangerous than that of a pope's nephew after the death of his uncle"[14]—as the eclipsed Scipione abruptly discovered. Cardinal Ludovisi now held the keys to papal patronage and promoted the careers of his Bolognese compatriots, the painters Guercino and Domenichino. In the realm of sculpture Ludovisi was preoccupied in amassing his vast collection of classical antiquities; but, like Borghese, he was an enthusiastic admirer of Gianlorenzo, whom he regularly invited to dinner "for his stimulating conversation." Already it seems the artist's wit was as sharp as his chisel. Almost immediately Bernini was employed to produce three papal busts, two bronzes and a marble. (Nine years earlier, the twelve-year-old Gianlorenzo had first carved the elder Ludovisi's portrait—now lost—before the archbishop's departure for Bologna.) The definitive marble version (fig. 13) represents Bernini's first creation of a formal "speaking likeness."[15] The bareheaded Gregory is portrayed—and liturgically arrayed—not as a crowned pontiff or temporal ruler of the papal dominions, but as the spiritual successor of the apostle Peter. Not only does the elaborately decorated cope, abbreviated and outlined in a sweeping curve, solve the inherent problem of truncation (or arbitrary amputation), but it provides a symbolic context for its most telling feature: the parted lips. Unlike the earlier bust of Paul V (fig. 10), Gregory's sharply drilled irises peer into eternity, his lips framing a prayer or papal benediction. The pope was clearly pleased. At the age of twenty-two, Gianlorenzo was knighted as *Cavaliere di Cristo.* Along with its gold chain and cross, the title brought a handsome pension. That same year, he was elected *principe,* or president, of the artists' Academy of St. Luke.

Bernini's busts from the early 1620s were not limited to popes. Among his subjects were several cardinals (De Sourdis, Dolfin, Montalto), clerics (Monsignor dal Pozzo), and patricians (Antonio Cepparelli and, a few years earlier, Giovanni Vigevano), including several relatives—both living and deceased—of Maffeo Barberini, such as the posthumous bust of his uncle and benefactor Francesco (National Gallery, Washington). His effigy of the Spanish jurist Pedro de Foix Montoya

The Borghese pope was succeeded by the old and frail Gregory XV (Ludovisi). Jesuit-trained and imbued with the fervent spirit of the Counter-Reformation, Gregory was as learned as he was pious; he had been a brilliant jurist and a model bishop. But beset by illness, this enlightened pope was to reign less than two and a half years (1621–23). While his tomb inscription—"Every month of his pontificate was as important as five

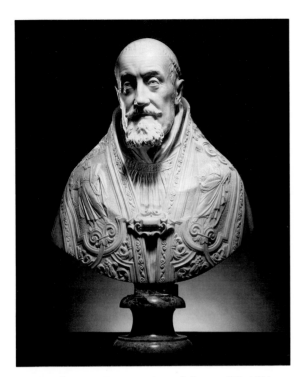

13. Gianlorenzo Bernini. *Bust of Gregory XV.* 1621. Marble, height 32¾" (83.2 cm) with base. Private collection, Canada

(1622; plate 9) was considered at its unveiling more alive than the sitter: Cardinal Barberini dubbed the marble the original and the monsignor "the portrait." The next year Bernini applied the same lively technique to the posthumous bust of the Jesuit theologian Robert Bellarmine, whose body had been exhumed in 1622 for reburial in a marble tomb erected in the Gesù. Bracketed by statues of Wisdom and Religion (yet another collaboration with Pietro), this intensely praying effigy represents Gianlorenzo's early transformation of a traditional funerary motif into a tangible denial of death.

For the new cardinal-nephew, Bernini restored the ancient *Ares Ludovisi* (Museo delle Terme, Rome); at the god of war's new foot, he gave Eros a fresh pair of arms and a classicized head. Paradoxically, Bernini's own ancient favorites were fragmentary: the *Pasquino* ("so mutilated and ruined that the remaining beauty is recognized only by true connoisseurs")[16] and the *Torso Belvedere* (which he considered unfinished), both of which he ranked above that undisputed masterpiece, the *Laocoön* (fig. 5). By the time Cardinal Borghese had reinsured his favor with the new administration by giving Bernini's *Pluto* to his successor, Borghese's acquisitive eye had doubtless shifted to the *Apollo and Daphne* (1622–25; plate 10), a still more miraculous metamorphosis, from a divinely overtaken nymph into a laurel tree. (To dampen ecclesiastical criticism of its

unabashed eroticism, the cardinal-poet Barberini supplied a moralizing inscription.) Work on the Apollo was interrupted for a year (1623–24) while Bernini undertook his fourth and final Borghese sculpture, the *David* (plate 11), a dramatic infusion of biblical heroism into the pagan assemblage. Its dynamic *contrapposto* derives both from ancient sculpture and from that early Baroque masterpiece of muscular mythology, Carracci's Farnese Ceiling (fig. 2). The psychological intensity is heightened by the anticipation of violence; latent power is momentarily suspended. At the same time the viewer is thoroughly engaged within the surrounding space, which feels as if electrically charged—an effect that Bernini was to develop and exploit throughout his career. Collectively, the Borghese sculptures validate their creator's old-age claim that in his youth he "never struck a false blow"; he had been so enamored in his labors "that he did not work the marble but devoured it." Four decades later, passing through the villa and catching sight of the sculptures, Bernini exclaimed: "Oh, what little progress I have made in art, when as a youth I handled marble in this way."[17]

By the time the *David* was completed, Gregory XV was dead. Cardinal Barberini reassured Gianlorenzo that "whoever becomes pope will find he must necessarily love you if he does not want to do an injustice to you, to himself, and to whoever professes love of the arts"[18]—then donned the papal tiara as Pope Urban VIII. The Bolognese interlude gave way to two decades of Florentine favoritism.

Unlike his predecessor, Barberini was unusually young (fifty-five) and robust. He combined the intellectual and aesthetic worldliness of the Renaissance popes with an ascetic, Counter-Reformation piety. Originally trained in the law, this scion of a wealthy merchant family from Florence had distinguished himself in ecclesiastical diplomacy; his early years as papal ambassador to France left him a thorough Francophile. There he cultivated a taste for belles lettres, poetry, languages, and recondite scholarship. His escutcheon, a triad of Barberini bees, he adapted from the French royal coat of arms. As a young prelate Maffeo had hired a team of Florentine sculptors and painters—including the Bernini, father and son—to decorate his family chapel in Sant' Andrea (fig. 9). As pope he was to raise patronage to an unparalleled plane, and he had at hand the perfect impresario. It is said that on the day he took office he summoned Gianlorenzo (then age twenty-four) and announced: "Your luck is great, *Cavaliere,* to see Cardinal Maffeo Barberini pope; but ours is much greater to have Cavaliere Bernini alive in our pontificate."[19] In addition to new official posts—superintendent of

15

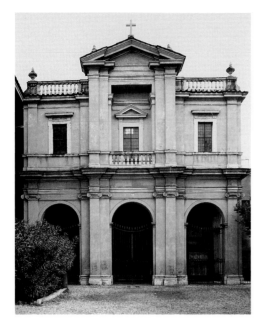

14. Gianlorenzo Bernini. *Facade of Santa Bibiana.* 1624–26. Rome

the Acqua Felice aqueducts and master of the Papal Foundry—Urban was to bestow on Gianlorenzo artistic commissions that would epitomize both his papacy and his High Baroque, triumphal restoration of Rome. This pope was true to his chosen name. Throughout his lengthy tenure he demonstrated the importance of being Urban: the city itself was to symbolize the universal (catholic) primacy, both spiritual and temporal, of this worldly yet providential pontiff.

Eager as he was to make Bernini "his Michelangelo," Urban instructed him to study architecture and painting. "For a full two years," according to Domenico, he now devoted himself to "nothing but coloring." Though Raphael was the only master Bernini acknowledged, it is clear that Carracci, Reni, and Andrea Sacchi—his tutor—were formative influences. Gianlorenzo's self-portrait of 1623 (frontispiece) demonstrates his early facility for capturing, with striking economy of brushstrokes, the salient features that enliven his handsome face. This penetrating yet, with lips slightly parted, seemingly spontaneous glimpse into the looking glass seeks comparison with his more dramatic reflections in stone (see figs. 8, 11; plate 11). His painterly approach to sculpture was reciprocated by a sculptural application of color and highlights to "model" the two-dimensional image and bestow upon it an impressionistic immediacy. According to Baldinucci, Bernini painted more than 150 pictures (200, by Domenico's count). Only a dozen or so have been identified but enough to demonstrate that in this medium alone he could have earned his place in the annals of art. Nevertheless, painting remained for him a cre-

ative *divertimento*: the major papal tasks that now engaged him were in every sense three-dimensional.

Bernini's first architectural commission, in 1624, was to renovate and design a new facade for the small church of Santa Bibiana, dedicated to the Early Christian martyr Vivian, whose remains had recently been discovered in the sanctuary. The portico frontispiece (fig. 14), an inventive adaptation of Maderno's "palace facade" of Saint Peter's, is composed of a two-storied loggia of three bays punctuated by superimposed pilasters.[20] Bernini's rhythmic juxtaposition of small and large orders is dominated by a vertical thrust in the crowning central pediment that accentuates the liturgical axis from entrance to altar. Inside, Bernini commemorated the patron saint in his first major religious statue (plate 12). Framed by a classical niche and lit by a recessed window in the vault, Bibiana (Vivian) looks heavenward to the source of divine illumination, the rippling folds of her drapery evoking the turbulence of a soul enraptured by the love of God—a theme that Bernini was to develop throughout his career as the Catholic artist par excellence.

But, for the moment, a bigger challenge loomed at the spiritual center of Catholic Christendom. In the same year, Urban commissioned Bernini to erect above the papal altar and the tomb of St. Peter a baldachin,

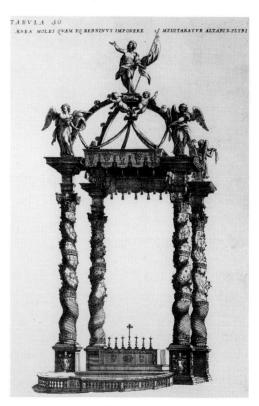

15. Gianlorenzo Bernini. *Baldacchino* (first project). 1628. Engraving by Girolamo Frezza in F. Bonnani, *Numismata summorum Pontificum Templum Vaticani* (Rome, 1696). Vatican Library, Rome

16

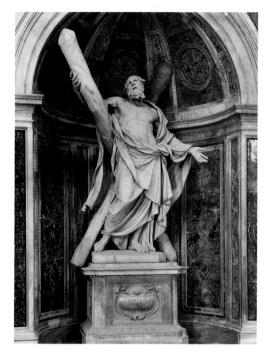

16. François Duquesnoy. *St. Andrew.* 1629–39. Marble, over-life-size. Saint Peter's, Rome

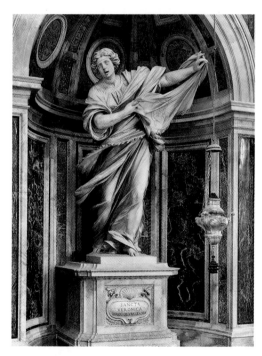

17. Francesco Mochi. *St. Veronica.* 1629–39. Marble, over-life-size. Saint Peter's, Rome

or ceremonial canopy, projected into architecture of towering proportions (fig. 15; plate 13). As a boy, Gianlorenzo had visited the basilica accompanied by Annibale Carracci, who supposedly announced, "Believe me, the day will come when a genius will make two great monuments in the middle and at the end of this temple on a scale in keeping with the vastness of the building." Not able to restrain himself, the youth exclaimed, "Oh, if only I could be the one."[21] Urban now

gave him the chance to fulfill both his wish and his prodigious talent.

Under Gregory XV, Bernini had been engaged to make four huge stucco angels for a temporary baldachin. Urban's decision to combine the papal altar and apostle's tomb in a single monument now set the stage for Bernini's unique fusion of architecture and sculpture, a ceremonial landmark that fills the void under Michelangelo's dome and establishes a focal point at the crossing of Maderno's nave. The bronze Solomonic columns, symbolizing the ancient Holy of Holies from the Temple of Jerusalem, are conjoined by an exotic flourish of volutes. Crowned by a gold cross, the entire edifice stands over ninety feet high. Its source of bronze included revetments from the portico of the ancient Pantheon, which Urban had melted down for the principal temple of Christendom (as well as for cannons in the papal arsenal). Roman tongues wagged: *Quod non fecerunt barbari, fecerunt Barberini* — "What the barbarians did not do, the Barberini did." Domenico provided a more poetic gloss on the appropriation: "Heaven had preserved" the pagan bronze "for a better use in honor of the Prince of the Apostles."

Not all Bernini's contemporaries applauded his invention: a cloth canopy cast in bronze and effortlessly suspended by lithe angels poised on four freestanding columns. The painter Agostino Ciampelli disapproved of its "grave breach of architectural etiquette." Two centuries later, in 1853, an American tourist, George Stillman Hillard, dubbed it a "huge uncouth structure," saying it resembled "nothing so much as a colossal four-post bedstead without the curtains."[22] But the critical consensus at its completion was overwhelmingly favorable, and a committee was convened to determine the maestro's reward. One man suggested a gold chain worth five hundred ducats, a princely sum. Urban's response? "Well, the gold will be Bernini's, but the *chain* [of prison] is due the one who gave such fine advice!" The prodigal pope had already spent 10 percent of the entire income from the papal states — 200,000 scudi — on the nine-year project; Bernini himself was paid 10,000 scudi, plus generous pensions, with plum posts awarded to his brothers. Bernini later maintained it was only "by chance" that the proportions turned out so well.

Before the *Baldacchino* was completed, Urban expanded the commission by deciding to enshrine four precious relics in the surrounding piers, where Bernini hollowed out niches for their respective saints.[23] The supremely extroverted *Longinus* (plate 14) he carved himself. The other figures — saints Veronica, Helena, and Andrew (figs. 16, 17) — were executed by his asso-

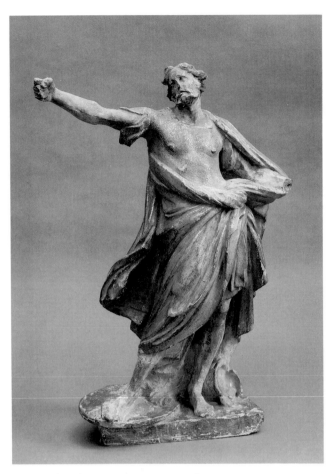

18. Gianlorenzo Bernini. *Bozzetto of St. Longinus.* c. 1630. Terra-cotta, height 20¾" (52.7 cm). Courtesy of The Fogg Art Museum, Harvard University, Cambridge, Mass.; Alpheus Hyatt and Friends of the Fogg Fund

ciates Francesco Mochi, Andrea Bolgi, and François Duquesnoy, whose success was applauded from afar by his Flemish compatriot Peter Paul Rubens. Bernini composed his *Longinus* through some two dozen clay *bozzetti* (see fig. 18) as his conception of the Christian hero evolved from its classical origins into its full-blown, High Baroque realization. Above each statue Bernini illustrated its relic in heavenly suspension: these concave reliefs were, in turn, framed by the original marble Solomonic columns from Old Saint Peter's (fig. 19). Work on the pier decorations continued until 1640.

During these years Bernini had little time for commissions outside Saint Peter's and began to employ collaborators to realize his ideas. Already he was beginning to establish himself as the chief employer of virtually every able stonecarver in Rome. One contemporary artisan later wrote that "to work in Rome is to work for Bernini." For the high altar of Sant' Agostino he designed in 1626 an exquisite pair of praying angels (fig. 21), derived from Guido Reni's recently completed

Trinity (fig. 20) for Santissima Trinità dei Pellegrini. Bernini's contrapuntal gestures—like the expressive duet of a Renaissance Annunciation—established a motif that he was to revive many years later at Saint Peter's (see plate 40). Their sculptural juxtaposition on a pediment may have been suggested by a recent title page of Rubens, whose Baroque inventions were widely disseminated by engravers.[24] Here Bernini entrusted the final execution to Giuliano Finelli, a technically gifted carver who, according to a contemporary source, had assisted on the *Apollo and Daphne* (plate 10) and *St. Bibiana* (plate 12). Yet like so many studio collaborators and engravers, Finelli was a master of detail, not of invention or composition. His subsequent career as soloist proved unremarkable.

In 1629 Carlo Maderno died. Bernini succeeded him as Architect of Saint Peter's and soon took up—to his eventual misfortune—Maderno's plan for bell towers flanking the facade; meanwhile, with Borromini's assistance, he completed Maderno's Palazzo Barberini. His career in fountain design had been prefaced by his official appointment in 1623 as superintendent of the Acqua Felice, a week after Urban had named Pietro Bernini its "architect." Two years later Gianlorenzo was appointed to oversee the renovation of the aqueducts feeding the fountains in the Piazza Navona, which he would eventually channel into his famous *Four Rivers Fountain* (plate 26). Following Pietro's death in 1629, Gianlorenzo succeeded him as architect of the Acqua Vergine, the source of his first monumental contribution to the city of fountains, where Bernini's signature is writ in water. This refreshing landmark in the Piazza di Spagna made a virtue of necessity. The low pressure did not permit spouts higher than ground level. So he designed the *Barcaccia* (or "old boat," 1627–29; plate 15) as though it were rising and falling with the sea, its cannons spouting water. The pope himself supplied explanatory verses for this brilliant *concetto*: a militant papal fountain cast in that ancient symbol of the unsinkable Church.

Urban's immortality, the subject of Bernini's first papal tomb (plate 18), commissioned in late 1627, was to engage the artist for two decades. Once again Bernini took traditional forms and breathed new life into them. Beneath Urban's massive bronze effigy—a pontifical blessing frozen in eternity—skeletal Death inscribes his gilded name for posterity, bracketed by the living virtues Charity and Justice. Bernini was to create more than a half-dozen portraits of his benefactor. This moving chronicle of Urban's passage through his pontificate—the toll of time and triumphs, the weight of office and worldly cares—reveals the unusual inti-

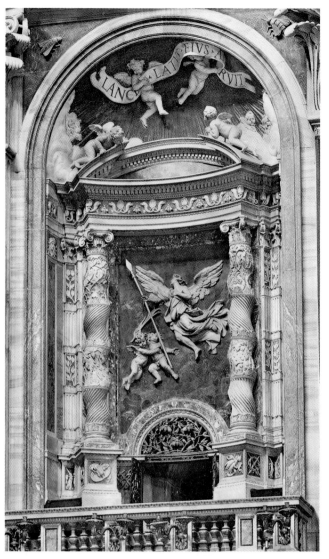

19. Gianlorenzo Bernini. *Relief of Holy Lance, Framed by Solomonic Columns.* 1633–40. Marble. Saint Peter's, Rome

20. Guido Reni. *The Trinity.* 1625. Oil on canvas. Santissima Trinità dei Pellegrini, Rome

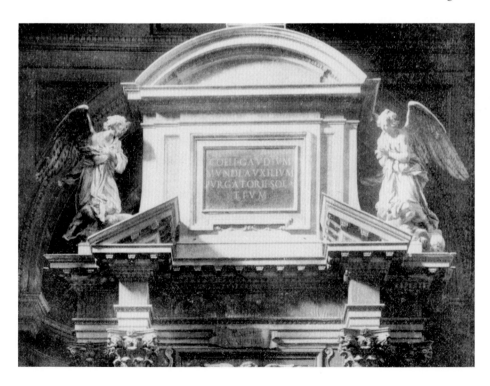

21. Gianlorenzo Bernini and Giuliano Finelli. *Angels over High Altar.* 1626–28. Marble. Sant' Agostino, Rome

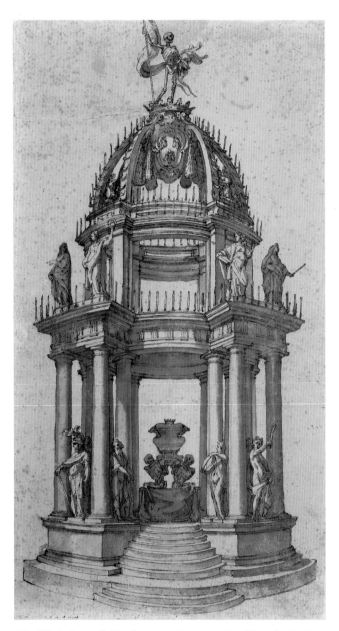

22. Workshop of Gianlorenzo Bernini. *Catafalque for Carlo Barberini.* 1630. Pen and ink on paper, 19 × 10¼″ (48.5 × 26.1 cm). Windsor Castle, Royal Library

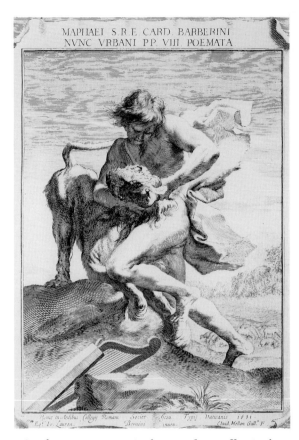

23. Gianlorenzo Bernini. Title page for Maffeo Barberini, *Poemata* (Rome, 1631), 8½ × 5¹³⁄₁₆″ (21.5 × 14.7 cm). Engraving by Claude Mellan

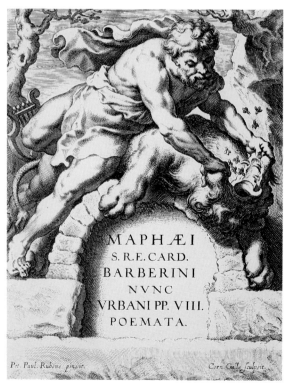

24. Peter Paul Rubens. Title page for Maffeo Barberini, *Poemata* (Antwerp, 1634), 6⅞ × 5⁵⁄₁₆″ (17.5 × 13.5 cm). Engraving by Cornelis Galle I. University of Rochester Library

macy between artist and pope. Bernini had free access to Urban's private apartments; the two men often dined together and conversed well into the night. "When sleep brought an end to discussion, it was Bernini's task to pull the blinds, close the windows, and take his leave," Baldinucci records. On one memorable occasion, Urban reciprocated by visiting Bernini's house "accompanied by sixteen cardinals . . . to the marvel and applause of all Rome."[25]

For Urban's brother Carlo, who died in 1630, Bernini designed a magnificent catafalque in Santa Maria in Aracoeli on the Capitoline (fig. 22). Its crowning skeleton, poised in triumph, recalls the Risen Christ originally planned for the *Baldacchino* (fig. 15). For the

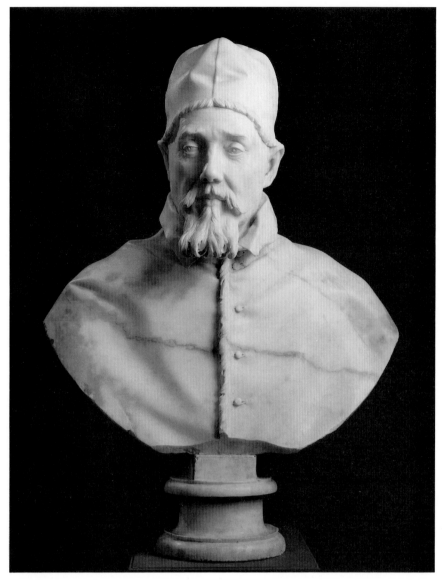

25. Gianlorenzo Bernini. *Bust of Urban VIII.* 1632. Marble, height 37¼" (94.7 cm)
with base. National Gallery of Canada, Ottawa

same church he designed Carlo's memorial plaque, and for the Senate House on the piazza he carved Carlo's posthumous portrait, a marble head attached to an antique torso of Julius Caesar, with limbs restored by Bernini's classicizing rival Alessandro Algardi. A few years later, by permission of the now purely decorative senators, Bernini's commanding statue of an enthroned Urban was installed in the building that had long stood for Rome's republican origins. The senators were not alone in their superannuation: "The only use of cardinals these days," wrote the ambassador from the republic of Venice, "is to act as a grandiose crown for the pope."[26]

At the other end of the scale, Urban's literary achievements were embellished by a deluxe Roman edition of his *Poemata,* for which Bernini supplied the author's portrait and an allegorical title page of the youth David struggling with a lion (1631; fig. 23). Three years later, for the Antwerp edition, Rubens composed his Baroque variation on the Old Testament theme (fig. 24), replacing Bernini's David with a full-grown Samson, who opens the jaws of a lion to release a swarm of Barberini bees. Bernini's contemplative bust of Urban (1632; fig. 25), appearing between the two editions, provides an equally poetic image of the author-pope.[27]

During the Barberini pontificate, portraits outside the papal family were exceptional—such as the bust (destroyed) of the ill-fated Charles I, which, based on a triple portrait by Van Dyck, Urban had commissioned as a gift to the Catholic queen Henrietta Maria in the vain hope of restoring England to the Roman faith. Scipione Borghese's long-standing friendship with both the sculptor and the pope was rewarded in 1632 by a definitive "speaking likeness" (plate 19). Bernini's pre-

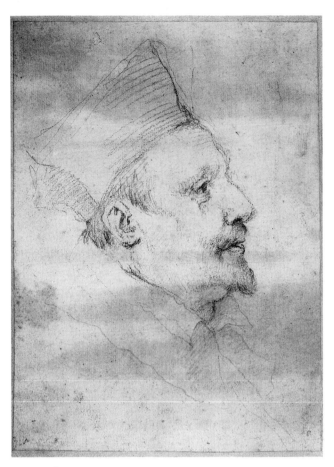

26. Gianlorenzo Bernini. *Cardinal Scipione Borghese.* 1632.
Graphite and red chalk on paper, 10⅞ × 9⁵⁄₁₆″ (27.6 × 23.7 cm).
The Pierpont Morgan Library, New York, IV, 1976.1988.18

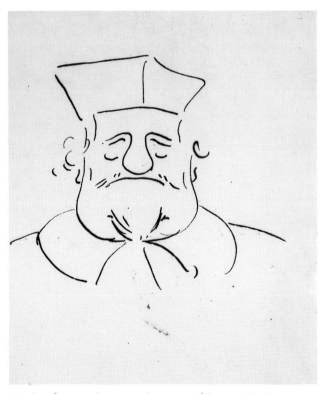

27. Gianlorenzo Bernini. *Caricature of Scipione Borghese.*
c. 1632. Pen and ink on paper, 10⅞ × 7⅞″ (27.5 × 20 cm).
Vatican Library, Rome

paratory drawing (fig. 26) provides a vivid glimpse of
the man behind the marble, with no hint of imminent
mortality: a year later, Borghese would be dead. Ber-
nini's teasing caricature of the cardinal (fig. 27) is
equally revealing of his uncanny ability to capture with
a few sharp strokes of the pen the essence of identity.
According to Domenico, "He delighted in caricaturing
princes and other great persons for the pleasure they
then received in seeing themselves and others, at once
admiring the great ingenuity of the artist and amusing
themselves with such entertainment."[28] Because of a
flaw in the original marble he secretly carved a second
version (fig. 28), with which he surprised the cardinal at
the unveiling, transforming initial disappointment into
irrepressible delight: sculptural technique was matched
by flawless timing.

It was at this time that Bernini began his second-
ary career as a stage designer and playwright. In 1632
Urban's nephews Antonio and Francesco produced the
opera *Sant' Alessio* at the Palazzo Barberini, where Pietro
da Cortona eventually designed a theater to house three
thousand spectators. Stefano Landi composed the mu-
sic; the libretto was by Giulio Rospigliosi, the future
Pope Clement IX, with whom Bernini would soon
collaborate on several Barberini productions. His sets
were famous not for their elaborateness or special
effects but for the total persuasiveness of the dramatic
illusion. Disdaining complicated contraptions that usu-
ally broke down, Bernini sought "to avoid putting on
anything that lacks perfection." He noted that the
machines in his plays "hardly cost him a cent and always
worked." In his comedy *The Fair,* he introduced a walk-
on who "accidentally" brushed his torch repeatedly
against the backdrop, ignoring the audience's apprehen-
sive cries, until finally the set caught fire. The terrified
spectators arose in what threatened to turn into a
deadly stampede, when—presto—"at the height of the
confusion and fire, the scene was changed with extraor-
dinary orderliness, and the apparent conflagration
became a most delightful garden. The audience's
astonishment at this sudden novelty was greater than
the terror caused by the fire, so that everyone, being
stupefied, excused his fear by praising the deception."[29]

Bernini exploited a similar false alarm in *The
Flooding of the Tiber,* staged at a makeshift theater at his
own house in 1638. During the performance—just a
year after the real flood—some deliberately weakened
dikes broke, and a "great quantity of real water poured
onto the stage and rushed down toward the audience,"
which panicked and prepared to bolt "when suddenly,
with the opening of a sluice gate, all that great abun-
dance of water was swallowed up with no more damage

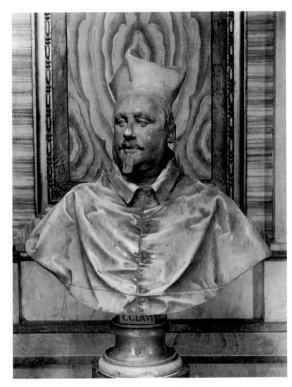

28. Gianlorenzo Bernini. *Bust of Scipione Borghese* (second version). 1632. Marble, height 30¹¹⁄₁₆″ (78 cm). Galleria Borghese, Rome

reshaped the plastic arts, that is, the ability "to make appear true what was in substance false."

Domenico reports that Bernini's comedies of the mid-1630s offered a welcome distraction from "a long illness — an acute fever and mortal sickness" that forced him to bed and disrupted Urban's plan to have him fresco the benediction loggia of Saint Peter's, the chief commission for which Gianlorenzo had taken up the study of painting ten years earlier. His few identified canvases from this decade (plates 16, 17) reveal the continued influence of Sacchi as well as the early Poussin, whose 1629 altarpiece of *The Martyrdom of St. Erasmus* at Saint Peter's left a lasting impression on both Bernini and his painter-collaborator Carlo Pellegrini. At the same time, the 1630s witnessed the most restrained and classicizing of Bernini's sculptures, such as the pope's monument in the Aracoeli celebrating the restoration of Urbino (under Urban) to the papal states, and the *Tomb of Countess Matilda* (fig. 29) in Saint Peter's commemorating — more wishfully than historically — the deference paid by secular rulers to the pope. De-

to the audience than that of fear." Bernini's comedies were noted for their (often ad-lib) witticisms and satirical *bons mots* aimed at the rich and famous. These theatrical counterparts to his graphic caricatures were "so forthright, full of spirit, and founded on the truth, that many virtuosi attributed some to Plautus, others to Terence" — ancient Roman dramatists whom, Domenico said, "the *Cavaliere* had never read." The only surviving (and incomplete) manuscript, aptly titled *The Impresario* at its American premiere in 1981, is a comedy about the production — literally behind-the-scenes — of a play within a play, with Bernini self-cast in the leading role of actor-director-producer. In a similar interplay of illusion and reality, at the end of his *Two Theaters* the rear curtain rose to reveal a second audience facing the first across the stage. The final barrier between player and spectator, already blurred in the early Borghese sculptures, had been dissolved. In 1644 the English writer John Evelyn recorded in his diary that Bernini gave "a public opera wherein he painted the scenes, cut the statues, invented the engines, composed the music, writ the comedy and built the theatre all himself." He omitted only Bernini the actor-director, whose alter ego in *The Impresario* proclaims that "ingenuity, design, is the magic art by means of which one so deceives the eye as to create amazement." In the theater Bernini improvised with the same genius that

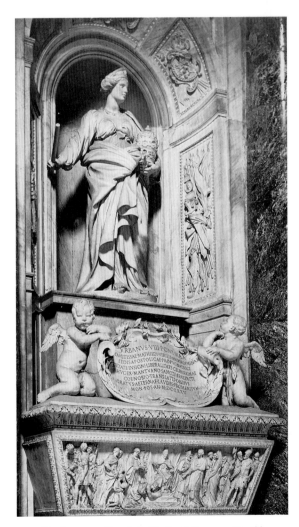

29. Gianlorenzo Bernini. *Tomb of Countess Matilda.* 1633–37. Marble. Saint Peter's, Rome

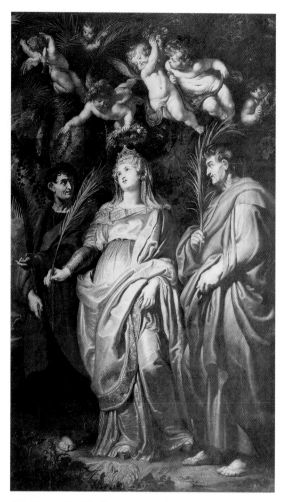

30. Peter Paul Rubens. *St. Domitilla*. 1608. Oil on slate, 13′6⅝″ × 8′5³⁄₁₆″ (413 × 257 cm). Santa Maria in Vallicella, Rome

spite her Rubensian origins (fig. 30), *Matilda* has been described as "chilly."[30] Yet this graceful revision of a medieval Tuscan countess into a classical Roman clearly appealed to Urban, who had several small bronzes cast from Bernini's *modello*. The triumphal niche, moreover, represents Bernini's seminal integration of figures and framing architecture. The Aracoeli memorial inscription—similarly discounted by modern critics—introduces a stained-glass window as the colorful centerpiece of a sculptural ensemble, a glowing device that Bernini would eventually set ablaze in the apse of Saint Peter's (plate 29).

Bernini's "classical recession," which may reflect the passing influence of Algardi and Duquesnoy,[31] was punctuated by an emphatically robust portrait of his mistress, Costanza Bonarelli (c. 1636–37; plate 20). She was the wife of Bernini's assistant Matteo, who was laboring on the *Matilda*. By all accounts the affair was a stormy one, ending in recriminations so explosive that the pope himself had to intervene: "Rare man, sublime genius, and born by divine inspiration and for the glory of Rome, to bring light to the century," Urban wrote in defense of his protégé, whose admitted "fiery temperament and youthful inclination to pleasure" was evidently undampened. On one occasion, later, sword drawn, an enraged Gianlorenzo broke into his mother's house in search of his brother Luigi, whom he threatened to kill. Having chased Luigi into Santa Maria Maggiore, he then tried to kick down the door of the sanctuary. Bernini's mother wrote in desperation to Cardinal Francesco Barberini, asking him "to use the authority given you by God . . . and restrain the impetuosity of my son, who today indubitably stops at nothing, almost as if for him there were neither great lords nor justice."[32] The mother's plea was not in vain: Urban urged his sculptor to settle down and marry. At first Bernini demurred, claiming that his statues would be his children and keep his memory alive for centuries. But in the end he complied, and with typical success. In 1639 he married Caterina Tezio, the twenty-two-year-old daughter of a poor lawyer—so poor, legend has it, that Bernini himself secretly supplied her dowry. (Years later he told of how he had once asked Pope Urban for a dowry for a "young orphan girl," who, he pleaded, was very beautiful. The pope replied, "If she is beautiful, she already has her dowry."[33]) Caterina and Gianlorenzo were to produce eleven children during their thirty-four years of marriage. Surprisingly, we have no visual records of Bernini's spouse or any of his children—unless they remain to be identified in the works that occupied the second forty years of his life.

Urban's old diplomatic ties to the French court prompted in 1640 a gift to the king's omnipotent minister, Cardinal Richelieu, of the latter's bust by Bernini, this time based on a triple portrait by Philippe de Champaigne. But the pope's generosity did not extend to sharing the sculptor with the French crown. At the beginning of his pontificate Urban had advised Bernini against making a trip to Paris; now, toward the end of his reign, he counseled him to decline the new lucrative offers because "he was made for Rome and Rome was made for him."[34] As if proof were needed, Bernini had already begun work on his glistening landmark outside the Palazzo Barberini. Finished a year later, the *Triton Fountain* (1642–43; plate 21) arises from the sea to sound through his conch an aquatic fanfare for the Barberini pope. Bernini's new conception of the Roman fountain was organic sculpture—of marble, travertine, and water. It was joined a year later, across the piazza, by the *Fountain of the Bees* (1644), the inscription on which explains its more pedestrian purpose as "a convenience to provide for the needs of the people" —and, we might add, horses.

Bernini's metamorphosis of the Roman fountain was paralleled by his transformation of ecclesiastical epitaphs, from the startling (if ultimately benign) skeletons proclaiming the immortal fame of Alessandro Valtrini and Ippolito Merenda (1639) to Maria Raggi's ecstatic apotheosis in Santa Maria sopra Minerva (1647; plate 23). For the Raimondi family, he adapted his increasingly painterly treatment of memorial sculpture to fill an entire chapel (fig. 31). On each side, above their tombs, kneeling effigies of Francesco and Girolamo turn in prayer toward a concave relief above the altar of *St. Francis in Ecstasy.* The vision is bathed in supernatural light from a concealed window—a sculptural application of Caravaggio's chiaroscuro.

Urban's flair for artistic patronage was not matched by political perspicacity as a temporal ruler. His laudable, if naive, search for a negotiated settlement to the Thirty Years' War was thwarted at every turn by the single-minded Richelieu, who viewed such "religious" wars only in the light of national self-interest. Urban's military posture proved equally futile. He spent vast sums on armaments to ensure Rome's defense—one of his first architectural commissions to Bernini had been to plan new fortifications in the Borgo—but his punitive War of Castro against the duke of Parma precipitated an invasion of the Papal States, followed by panic, taxes, and a humiliating peace treaty that

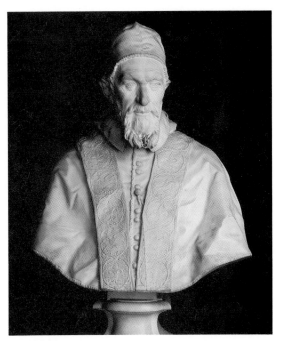

32. Alessandro Algardi. *Bust of Innocent X.* 1646. Marble, life-size. Galleria Doria-Pamphilj, Rome

hastened the pope's death a few months later. He left his successor, Innocent X (Pamphilj), with a papacy on the brink of bankruptcy: such was the price of Rome's—and his family's—glorification over two decades. The emperor Augustus was said to have found Rome brick and left it marble. Urban had found it stone and left it Baroque.

As impresario of Barberini extravagance, Bernini fell from favor with the new administration. Innocent X was seventy years old at his election. A grave and practical Roman by both birth and temperament, he had neither the desire nor the means to rival his Florentine predecessor. One of his first acts was to set up a commission to investigate the looting of the papal treasury; the ex-papal family fled to France. In a hostile parody of an encomium to Bernini, the critic Passeri reveals the lethal jealousy to which Urban's artistic dictator was now exposed: "That dragon who ceaselessly guarded the orchards of the Hesperides made sure that no one else should snatch the golden apples of papal favor. He spat poison everywhere, and was always planting ferocious spikes along the path that led to rich rewards."[35] That the first of Bernini's two bell towers at Saint Peter's was causing cracks in the edifice, and alarm in the Vatican, did not help his case. His rivals, among them the disgruntled Borromini (whom Baldinucci describes as a "certain person semi-skilled in art whom the pope greatly trusted"), seized their chance and persuaded Innocent that the tower had to be pulled down at Bernini's own expense. Down with it went his

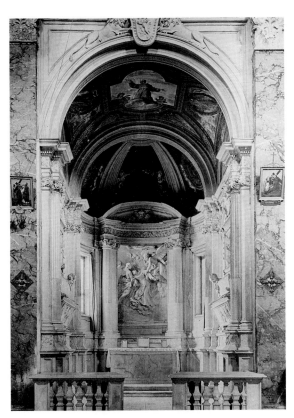

31. Gianlorenzo Bernini. *Raimondi Chapel.* c. 1640–48. San Pietro in Montorio, Rome

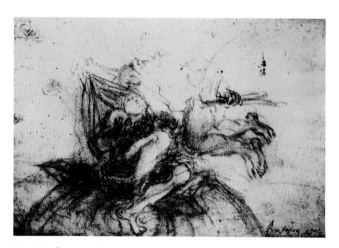

33. Gianlorenzo Bernini. *Truth Unveiled by Time.* 1646. Black chalk on paper, 12⅝ × 14⅝ (32.1 × 37.2 cm). Museum der bildenden Künste, Leipzig

immediate reputation. He sought private vindication in stone, an allegorical statue of Truth (plate 22), which he left as a perpetual legacy to his heirs. The airborne Father Time (fig. 33), who was to reveal Truth's naked splendor, he never completed. But in another sudden revolution of Roman fortune, Truth would soon reveal herself—not through time but through the master's art—confirming in Bernini's hindsight that "Rome sometimes sees poorly but never goes blind."[36]

Even at the nadir of his reputation Bernini was permitted to keep the title Architect of Saint Peter's and to finish Urban's tomb. But Innocent's few commissions were bestowed on Borromini in architecture and Algardi in sculpture (see fig. 32). Undeterred and wasting no time, Bernini turned to private patrons. In 1647 he began work on his most celebrated masterpiece, the *Ecstasy of St. Teresa* (plate 25), for the Cornaro family's memorial chapel in Santa Maria della Vittoria. There Bernini described a mystical experience in overtly physical metaphors, a consummation of the spiritual and the sensual that, according to Domenico, "conquered art." The sculptor's eldest son, Monsignor Pier Filippo Bernini (who may have been the boy model for the angel), years later composed a madrigal of clerical approbation: "A swoon so sweet should have eternal guise; but since suffering does not rise to the heavenly portal, Bernini in this stone made it immortal."[37] Gianlorenzo himself judged it "the least bad work I have done."

Meanwhile, Innocent was finally brought around by the clever intervention of his nephew-in-law Prince Nicolò Ludovisi, for whom Bernini soon afterward designed the gracefully convex facade of the (present-day) Palazzo di Montecitorio. As de facto papal architect, Borromini had been employed to renovate the

Piazza Navona as a grand courtyard for the Pamphilj family palace. Bernini was pointedly excluded from the competition to design as its centerpiece a triumphal fountain featuring a recently excavated obelisk. Yet Ludovisi prevailed upon him to create a model, which the prince set up on a table at the end of a hallway where the pope would be sure to see it on his way from dinner. Innocent admired it for half an hour until he realized he too had been set up. "This design cannot be by any other than Bernini," he announced. "This is a trick of Prince Ludovisi, so that despite those who do not wish it we will be forced to make use of Bernini; since whoever would not have his designs executed must be sure not to see them."[38] Gianlorenzo had won over yet another pope. A less flattering (and less credible) account, promulgated by Roman gossips, was that Bernini had bribed Innocent's sister-in-law, the indomitable Donna Olimpia, by presenting her with a model cast in silver—of which there is no trace in any inventory. Probably his clay *modello* (fig. 34) had been gilded to resemble a *trionfo da tavola,* or tabletop sugar sculpture, and was later upgraded by rumor.[39]

In defiance of gravity, the massive obelisk—the ancient symbol of Light, capped by the Pamphilj dove—is raised on a hollowed mountain from which spring the Rivers of Paradise, a multilevel allegory grounded in an engineering marvel (plate 26). There was, evidently, some concern expressed about this delicate balance of nature and art, in response to which the

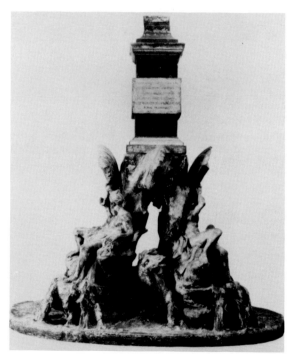

34. Gianlorenzo Bernini. *Modello of Four Rivers Fountain.* 1648. Terra-cotta. Private collection, Rome

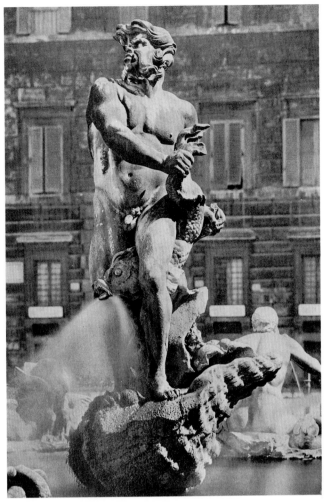

35. Gianlorenzo Bernini. *Moro Fountain.* 1653–54. Marble. Piazza Navona, Rome

water might be turned on briefly. Not on such short notice, Bernini replied. The resigned pontiff gave his blessing and turned to depart "when he heard a loud sound of water; turning back he saw it gush forth on all sides in great abundance." At Bernini's prearranged signal the ducts had been opened, providing a rush of pleasure comparable to that from his sudden unveiling of the second Borghese bust a decade earlier. "In giving us this unexpected joy," Innocent proclaimed, "you have added ten years to our life."[40] Yet there were limits to Bernini's powers; the pope was to live but three years. Bernini completed the piazza by adding a Triton and spouting fish, the so-called *Moro* (or Moor; fig. 35), as a dynamic focal point to Giacomo della Porta's sixteenth-century fountain at the southern end. The Triton's corkscrew *contrapposto* provides a sequence of satisfying views, an old Mannerist feature that Bernini revived in response to its unusual context. His original twisting centerpiece, a giant conch shell, had turned out too small for the basin and was later transplanted in the gardens of the Villa Pamphilj on the Gianicolo.

Bernini continued to accept private commissions. His tomb of Cardinal Pimentel (fig. 36) in Santa Maria sopra Minerva "extended" its narrow church setting through the illusionistic relief of a wall monument that

annoyed Bernini pretended to study its apparent instability, then ordered his assistants to string ropes attaching the obelisk to the buildings at either side. That done, he heaved a sigh of relief, then departed smiling. Years later he used to pull down the blinds of his carriage when passing by the fountain, lamenting that he was "ashamed to have done so poorly." This demonstrative tour de force, an ephemeral, splashy showpiece rendered permanent, admittedly appears, in hindsight, light-years from the spiritualized aesthetic of the artist's late style. Yet we continue to succumb to the magic of that glistening centerpiece that for the past three centuries has celebrated the Piazza Navona—and Rome—in an immovable feast. Its Rococo descendant bubbles up a few streets away: the *Trevi Fountain,* which like virtually every subsequent fountain fantasy finds its Baroque source in Bernini.

Innocent was pleased. One day he arrived at the piazza "with about fifty of his closest confidants" to inspect the nearly completed fountain, which he savored for an hour and a half, then asked Bernini whether the

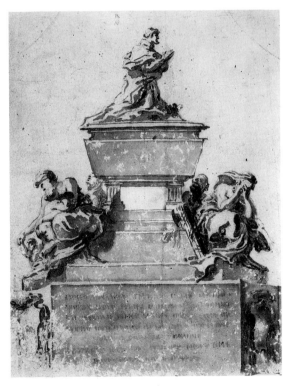

36. Gianlorenzo Bernini. *Tomb of Domenico Pimentel.* 1653. Graphite and wash on paper, 14¹³⁄₁₆ × 11¼" (37.6 × 28.6 cm). The Pierpont Morgan Library, New York, 1988.1

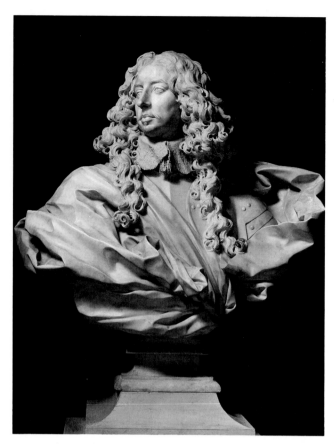

37. Gianlorenzo Bernini. *Bust of Francesco I d'Este.* 1650–51. Marble, height 42⅛" (107 cm). Galleria Estense, Modena

anticipates by two decades his final, freestanding papal tomb (plate 39). For Francesco d'Este, he carved his most vibrant portrait bust based on a painting (1650; fig. 37)—his last. It took Bernini fourteen months to complete and he vowed never again to portray an absent sitter. For King Philip IV, he designed a bronze crucifix for the burial chapel of the Spanish kings in the Escorial, a conclusive symbol of the Pamphilj pope's pro-Spanish policies.

Like his predecessor, Innocent discovered in politics and diplomacy the humiliating eclipse of papal power and prestige. He had sent Cardinal Fabio Chigi (who would soon succeed him as pope) as his representative to Münster, where the end of the Thirty Years' War was being negotiated by the Protestant allies, France, and the Catholic Hapsburg emperor. But by now the papacy was a helpless bystander in the brokerage of the rising nation-states. Furious at its final terms, Innocent officially denounced the treaty as "null and void, accursed and without any validity or effect for the past, present, or future"[41]—a protest that was universally ignored. The Holy Roman Emperor even forbade its publication in Hapsburg territories at the very time that Bernini's monument to enlightened Roman peace under the Pamphilj pope was being erected

in the Piazza Navona. (Not, to be sure, without popular complaints: Innocent funded the enormous expense of his fountain by a local tax on bread.)

In addition to a flattering portrait bust of this stern and cynical pontiff, Bernini undertook only two other major Pamphilj commissions. The first, in 1645, was to complete the nave decoration of Saint Peter's with medallions and *putti* carved in relief (1647–48) by an army of thirty-nine sculptors under the maestro's direction: a procession of papal apotheoses, variations on a theme he fully developed in his *Maria Raggi* (plate 23). The second, begun in the last year of Innocent's reign, was an equestrian statue of Constantine to be erected along the right aisle as a symbolic counterpart—and historical antecedent—of Urban's *Countess Matilda,* yet another monument to the papacy's waning claim of preeminence over temporal powers. It was to take twenty-three years, and three more popes, before Bernini would bring it to completion.

The austerity of the Pamphilj reign ended with Innocent's death in January 1655. While Donna Olimpia and her son Camillo squabbled over paying for the pope's coffin, Cardinal Chigi ascended the throne as Alexander VII. Born into a family of rich Sienese bankers, Fabio Chigi was an old friend of Bernini's and, like Urban, was determined to exploit papal patronage

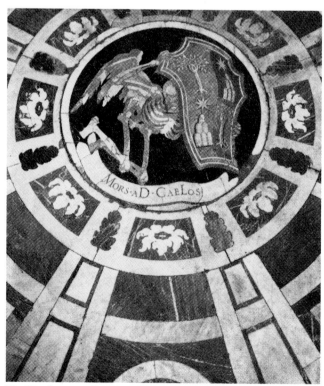

38. Gianlorenzo Bernini. *Skeleton with Chigi Escutcheon.* 1653. Marble floor inlay. Chigi Chapel, Santa Maria del Popolo, Rome

to the fullest. One of his early acts as a cardinal had been to commission Bernini to renovate the family burial chapel in Santa Maria del Popolo (fig. 38). Now on his first day as pope, he summoned Gianlorenzo "with expressions of the utmost affection" and encouraged him "to carry out the vast plans he had conceived for the greater embellishment of God's temple, the glorification of the papacy, and the decoration of Rome."[42] He named Bernini his private architect as well as Architect of Saint Peter's, a post Gianlorenzo had held since 1629. As much a dedicated scholar and bibliophile as ambitious builder, Alexander deserved his punning epithet *Papa di grande edificazione*; he gave Bernini full rein to fulfill his "edification" of Rome as the Baroque capital of Europe.[43]

In the first year of the new pontificate, Bernini renovated—and emblazoned with the star-crowned mountains of the pope's escutcheon—the ancient Porta del Popolo, through which Queen Christina of Sweden was to make her triumphal entry in December 1655. As she had already abdicated her throne, the price of her Catholic conversion, this triumph was confined to the arena of papal propaganda (her "moral victory" had left Sweden as Protestant as ever). Bernini also designed the ceremonial carriage. Upon being presented to Her Majesty he claimed credit only for its faults. "Then none of it is yours," she countered. When Christina founded her own academy, she found in Bernini a kindred spirit.

Baldinucci tells of Christina's first visit to the sculptor's studio. Far from adopting courtly airs, Bernini met her "dressed in the heavy, rough garment he was accustomed to wear when working in marble. Since it was what he wore for his art, he considered it to be the most worthy garment in which to receive that great lady." She, in turn, appreciated this "beautiful subtlety"; "as a sign of her esteem for his art"—and in pointed emulation of Alexander the Great and Charles V—she reached out to touch the garment. Bernini later commented that the queen "knew as much about the mysteries of art as those whose profession it was."[44]

In the same year, Bernini (and company) refurbished the interior of Santa Maria del Popolo. There he literally transfigured the Chigi Chapel with his *Daniel and Habbakuk* (plate 27); their dramatic relation bisects the circular Renaissance *tempietto* across the path of the entering viewer. In the pavement, under Raphael's dome, he had inserted a brilliantly colorful marble inlay of a skeleton bearing the Chigi crest and rising from the burial vault (fig. 38). The inscribed banderole spells out its meaning (while highlighting the Holy Year 1650, or MDCL): *Mors aD CaeLos*—"Death opens the way to Heaven."

39. Gianlorenzo Bernini. *Daniel.* 1655. Red chalk on paper, 14¾ × 9¼″ (37.5 × 23.4 cm). Museum der bildenden Künste, Leipzig

The works of the mature Bernini reveal a series of brilliant adaptations of his classical, Greco-Roman heritage.[45] *Daniel* is a transposition of the *Laocoön*, modulated through a series of drawings (see fig. 39) into a new Baroque expressiveness. The physical incorporation of the viewer in the "stage space" recalls his early *David* taking aim at an imaginary Goliath looming somewhere behind us, a principle that Bernini now applied on a far grander scale at Saint Peter's as he fused sculpture and architecture in a single composition. Nowhere is his creed of architectural humanism more clearly articulated than in his *Colonnade* for Saint Peter's (1656–67; fig. 40; plate 28). "The beauty of everything in the world, as well as in architecture," Bernini explained during the construction, "consists in proportion. One might say that it is the divine element since it originates in the body of Adam which has been created by God's hands and in his own image." (That was why, in his view,

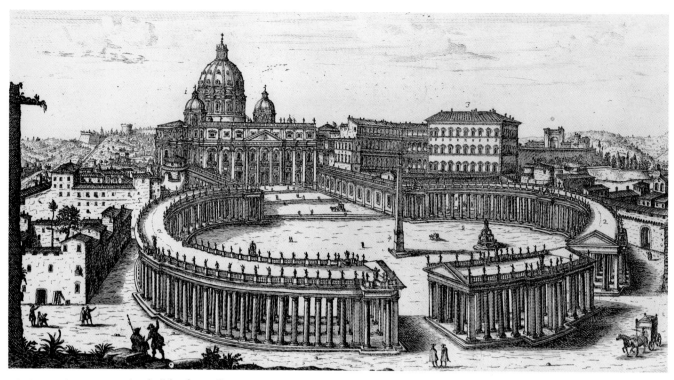

40. *Piazza di San Pietro* (with "third arm"). 1667. Engraving by Giovanni Battista Falda. Biblioteca Hertziana, Rome

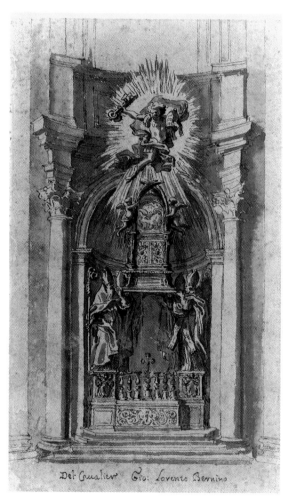

41. Workshop of Gianlorenzo Bernini. *Cathedra Petri* (first project). 1657. Chalk and wash on paper, 9½ × 5¹¹⁄₁₆″ (24.1 × 14.5 cm). Windsor Castle, Royal Library

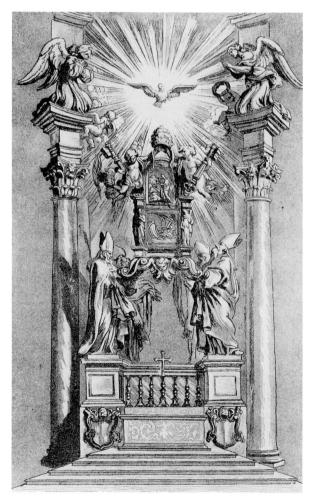

42. Gianlorenzo Bernini. *Cathedra Petri* (second project). 1657. Engraving by Conrad Metz, from *Imitations of Ancient and Modern Drawings* (London, 1798)

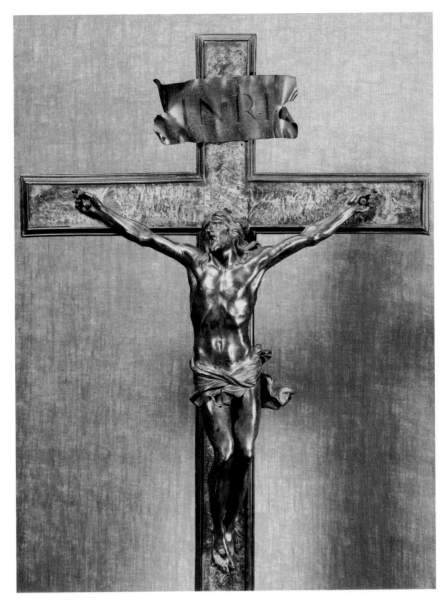

43. Gianlorenzo Bernini and Ercole Ferrata. *"Cristo Vivo" Crucifix.* 1659. Bronze, height 17¹¹⁄₁₆″ (45 cm). The Art Museum, Princeton University, New Jersey

sculptors made the best architects.) Conceived as the "embracing arms of Mother Church,"[46] Bernini's *Colonnade* was as functional as it was symbolic: the oval piazza permitted the assembled crowds to receive papal blessings dispensed alternatively from two distant windows.

Inside the basilica, Bernini fulfilled Carracci's prophecy by designing a sculptural finale in the apse (figs. 41, 42; plate 29), where the four great fathers of the Early Church effortlessly raise a huge bronze reliquary encasing the *Cathedra Petri,* the ancient throne of Peter. Although, strictly speaking, Saint Peter's is not a cathedral—the pope's seat as bishop of Rome is across the river at the Lateran—Bernini's elevated episcopal relic, framed by the *Baldacchino,* reinforced its status as the symbolic cathedral of all Christendom. Tomb, altar,

and throne are mystically combined in a glowing *Gesamtkunstwerk*—a total artwork of painting, sculpture, and architecture that converts theological dogma into tactile persuasiveness. For the twenty-five side altars Bernini designed bronze crucifixes and candlesticks. His *Cristo Morto,* the first of the two figures to be cast, recalled his crucifix for Philip IV in its taut, iconic display of the dead Christ, while the *Cristo Vivo* (fig. 43) revived the impassioned visage and animated S-curve of Daniel's torso and, ultimately, the *Laocoön*'s.[47]

In 1657 Bernini was commissioned to isolate the Pantheon and redecorate its stark interior. (He successfully declined—thrice—Alexander's invitation to gild the coffered dome with Chigi stars.)[48] While the project failed to progress beyond Bernini's initial sketches, he applied his study of that centrally planned

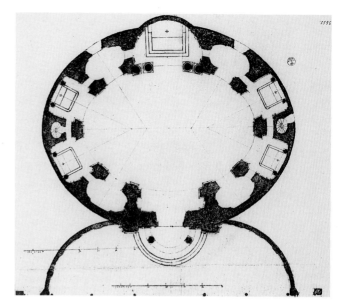

45. Workshop of Gianlorenzo Bernini. *Floor Plan of Sant' Andrea al Quirinale, Rome.* 1658–70. Uffizi Gallery, Florence (Gabinetto Disegni e Stampe)

44. Gianlorenzo Bernini and Antonio Raggi. *Interior of San Tomaso di Villanova,* Castelgandolfo. 1658–61

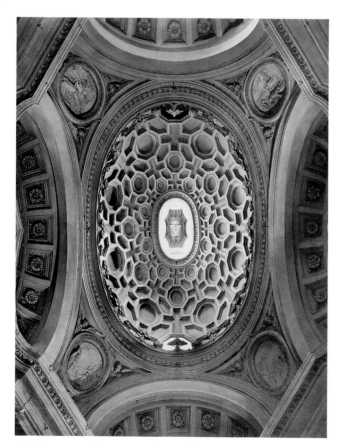

46. Francesco Borromini. *Dome of San Carlo alle Quattro Fontane,* Rome, 1638–41

temple to three small churches he designed for the Chigi pope. The first, and most conservative, was San Tomaso di Villanova (1658–61), built for the papal summer retreat at Castelgandolfo (fig. 44). Its domed Greek-cross plan was derived from Saint Peter's (before the seventeenth-century addition of Maderno's nave). Within its classical interior the sculptor-architect staged a permanent celebration of the patron saint: eight large roundels, held by *putti* and linked by festive garlands, illustrated events from St. Thomas's life. Bernini applied to the Michelangelesque dome a narrative program with sculptural embellishments that hark back to his Baroque transformation of the prototype, Michelangelo's crossing of Saint Peter's.

At the small Jesuit novitiate church of Sant' Andrea al Quirinale (1658–70; plates 30, 31), Bernini exercised his full powers as architectural impresario, coordinating the structure, its painted and sculptural adornment, and its iconography in a soaring synthesis. Like the contemporaneous piazza of Saint Peter's, the floor plan (fig. 45) was based on a transverse oval. Sant' Andrea represents nothing less than frozen theater, with a clearly sacred function: to fill and define an entire edifice by the intrusion of the transcendental into the worshipers' space as the martyr's soul rises overhead (plate 31). Bernini's classically restrained, sacred environment offers a stark contrast to Borromini's small masterpiece, San Carlino (fig. 46), a stone's throw down the street. "Better to be a poor Catholic than a

brilliant heretic," Bernini said of his former assistant, who had become a "corner cutter." Borromini's expressive violation of architectural grammar "ran counter to anything imaginable."[49] Borromini molded space: architecture was sculpture. To Bernini, architecture was primarily a setting for his sculpture and needed to conform to a classical canon based on human proportions.

The third and last of his variations on a circular church was built for the Chigi family at Ariccia, near Castelgandolfo. Bernini believed that "the most perfect forms were rounds, squares, hexagons, octagons, and so forth"; consequently "in grandeur of style, Saint Peter's is smaller than the Pantheon." Though he admired Michelangelo's dome—"there was nothing like it in antiquity"—he maintained that there were "a hundred errors in Saint Peter's but none in the Pantheon,"[50] to which he paid architectural homage in his rotunda of the Assumption (figs. 47, 48). A cylinder with temple portico, flanked by detached palace wings and facing the piazza, its configuration incorporated his earlier proposed revisions for the Pantheon. But inside the church, as at Sant' Andrea, the classical space was redefined by a narrative *concetto*: adorned by angels and garlands, the dome represents the heavenly destination

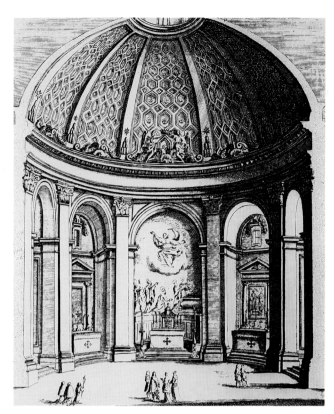

48. Gianlorenzo Bernini. *Santa Maria dell' Assunzione* (interior section), Ariccia. 1662–64. Engraving from D. de' Rossi, *Studio d'architettura civile* (Rome, 1702–21)

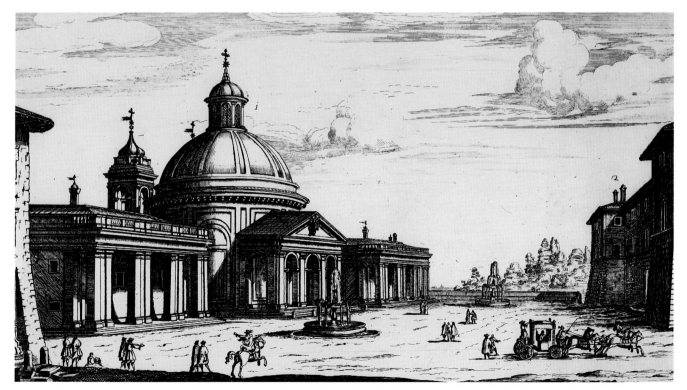

47. Gianlorenzo Bernini. *Santa Maria dell' Assunzione* (exterior), Ariccia, 1662–64. Engraving by G. B. Falda

33

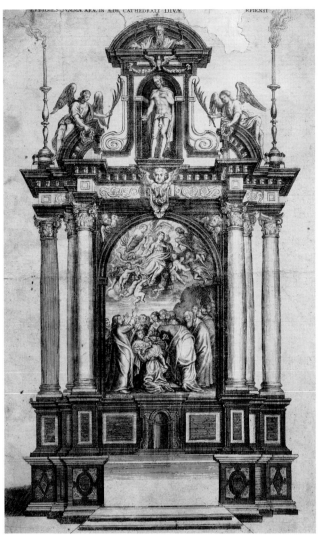

49. Peter Paul Rubens. *High Altar of Antwerp Cathedral.* 1626. Engraving by A. Lommelin, 18½ × 11⅝″ (47 × 29.5 cm)

del Popolo, which Bernini designed and supervised from afar—he carved two penitents for the entrance niches (the other two, flanking the altar, were by Ferrata and Raggi, who were then assisting him on the *Cathedra*). The sainted sinners Jerome (fig. 50) and Mary Magdalene (fig. 51)—a *contrapposto* of male and female, old and young—convey their contrition through turbulent garments, the symbolic "movements of the soul" that Bernini had introduced three decades earlier in his *Longinus,* here transposed to a higher key.

At Saint Peter's, Bernini returned to the equestrian monument of Constantine (plate 32) begun under Innocent X. Adapting his original conception (and the hewn block of marble) to its new site below the Scala Regia, the ceremonial staircase to the papal apartments at the right of the narthex, Bernini composed a sculptural solution to an awkward transition—the sharp left

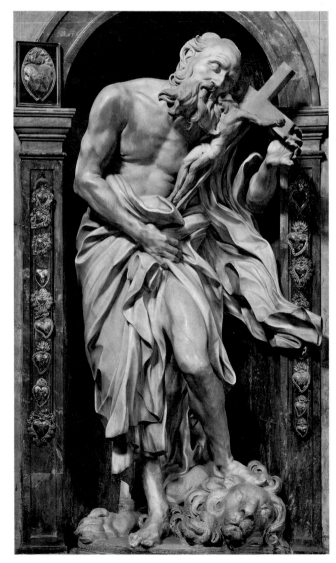

of the Virgin's assumption-in-progress, the subject of the painted altarpiece. Her implicit flight path—over the liturgical axis from entrance to altar—is framed by the two full-grown angels. These Christianized Roman Victories extend over the dark sanctuary (symbolizing her tomb) the crown she will receive as she ascends toward the oculus, the sole source of illumination. (In the Pantheon, Bernini explained, the overhead lighting made "everything in that temple, whether a statue of a man or a woman, appear more beautiful than it would elsewhere.") The sequential combination of Mary's assumption and coronation from painting to sculpture recalls Rubens's high altar of 1626 for the Antwerp cathedral, which Bernini may have known through its published engraving (fig. 49).[51]

In the early 1660s Bernini's sculpture evolved into the spiritualized expressiveness that characterizes his late style. For the Chigi Chapel in the cathedral of Siena—a Baroque variation on Raphael's at Santa Maria

50. Gianlorenzo Bernini. *St. Jerome.* 1662–63. Marble, height 70⅞″ (180 cm). Cathedral, Siena

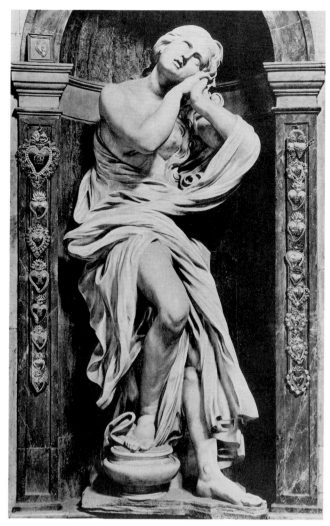

51. Gianlorenzo Bernini. *St. Mary Magdalene.* 1662–63. Marble, height 70⅞″ (180 cm). Cathedral, Siena

from Louis XIV to redesign the Louvre. The year before, the French minister Colbert had invited Bernini, along with Pietro da Cortona and Carlo Rainaldi, to submit competing plans. To no one's surprise Bernini was declared the winner. Bernini had already employed his pyrotechnical skills to honor the birth of Louis's son, the dauphin, with a display of fireworks on the hill of Santissima Trinità dei Monti (fig. 53). On this eventual site of the so-called Spanish Steps, Bernini had still earlier proposed a grand staircase featuring an equestrian statue of Louis XIV (1660; fig. 54). Despite a diplomatic fiction (to avoid antagonizing the pope) that Bernini's design was conceived by the French minister Mazarin's agent in Rome, the Abbé Benedetti, the plan came to naught: Alexander VII was not about to allow his French rival to erect a permanent monument to his own glory within the papal city. If Louis was to employ Bernini, it would have to be in Paris.[53]

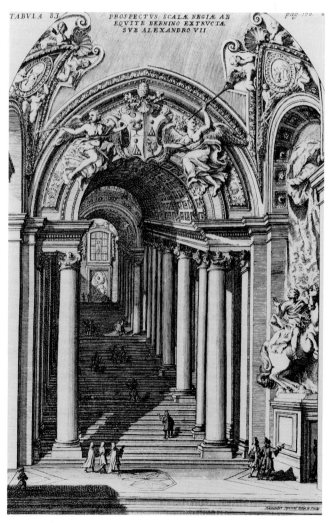

52. Gianlorenzo Bernini. *Scala Regia.* 1663–66. Saint Peter's, Rome. Engraving by Alessandro Specchi, 12 × 7¾″ (30.5 × 19.7 cm), from F. Bonanni, *Numismata summorum Pontificum Templi Vaticani* (Rome, 1696). Vatican Library, Rome

turn along the processional route from the basilica (fig. 52). The Roman emperor's conversion to Christianity by a luminous apparition was here staged in a visionary blending of marble, stucco, and light. "If you want to see what a man can do, you must give him a problem," Bernini believed, adding that "the highest merit goes to the architect who makes use of a defect in such a way that if it had not existed one would have to invent it." In 1663, as he proceeded afresh with the *Constantine*, he faced an apparently insurmountable problem in refurbishing the Scala Regia. In yet another triumph of illusion he camouflaged the narrowing of that steep, dark flight of steps by introducing colonnades of *seemingly* constant proportions; halfway up, he broke the tunnel effect by an illuminated landing. "If I had read that someone had done it, I wouldn't have believed it," was his fair appraisal of the work he considered "the least defective."[52]

Bernini's supervision of his various projects at Saint Peter's was interrupted in 1665 by a call to France

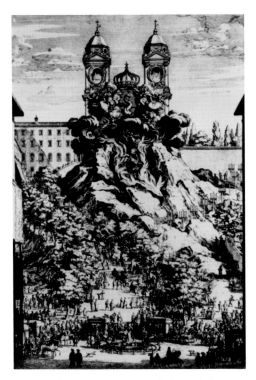

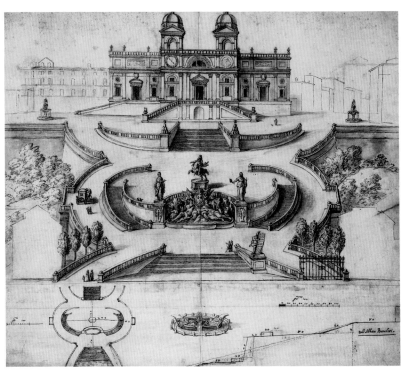

53. Gianlorenzo Bernini and G. P. Schor.
Fireworks for the Birth of the Dauphin. 1662.
Engraving by D. Barrière. Museo di Roma
(Gabinetto Communale delle Stampe)

54. Workshop of Gianlorenzo Bernini. *Steps for Santissima
Trinità dei Monti.* 1660. Pen and ink on paper. Vatican
Library, Rome

Compared with his contemporaneous design for the Chigi family palace (1664; fig. 55), Bernini's first plan for the new east wing of the Louvre (fig. 56) was extravagantly Baroque: an undulating, convex-concave facade, with giant pilasters punctuating two stories of arches. The flat roof, articulated by a balustrade and statues, was dominated at the center by a third story crowning the large oval hall around which the palace was symbolically organized. In the Palazzo Chigi, Bernini had broken with the prevailing Roman tradition (from the Palazzo Farnese to his own Palazzo di Montecitorio) by the vertical emphases of the giant pilasters, the sculpturesque progression of window enframements, and the Palladian balustrade with statues. His variation on this theme was too Baroque for the French, although it struck a responsive chord in the Italian architect Guarino Guarini, then in Paris, who eventually adapted it for his Palazzo Carignano in Turin.

Bernini's second project a year later modified the central section with a sweeping concave facade. Continued critiques and correspondence preceded the royal invitation, in which Louis assured the *cavaliere* that he had "a great desire to see and to know more closely a personage so illustrious." To the pope, Louis tactfully emphasized that the Louvre had been "the principal residence of the kings who are most zealous in all Christendom in the support of the Holy See" and signed himself "Your Most Devoted Son"—a flourish of filial piety belying the diplomatic realities that forced the pope's assent.[54] Alexander had already been humiliated by Louis when the papal ambassadors were excluded from the negotiations between France and Spain that concluded the Peace of the Pyrenees in 1659. Following a brawl between the papal guard and soldiers of the French ambassador, the Duc de Créquy, Alexander had averted an invasion of Rome only by an abject apology that included erecting a pyramid to commemorate his capitulation. So despite his desire to keep Bernini at work on the *Colonnade* and the *Cathedra,* the pope granted him a three-month leave. For his part, the sixty-six-year-old artist was persuaded to make the arduous journey north by his personal confessor, the Jesuit General Oliva, who said it was his Christian duty and that "even if an angel appeared from heaven telling him that he would die during his journey, he would still advise him to go."[55] Accompanied by his assistants Giulio Cartari and Mattia de' Rossi and his son Paolo, Bernini headed north on April 25, 1665, "to the sorrow and anxiety of the whole city."

In Florence, Bernini was entertained by the grand duke of Tuscany; his route included stops at Siena, Bologna, Milan, and Turin, where he was fêted by the

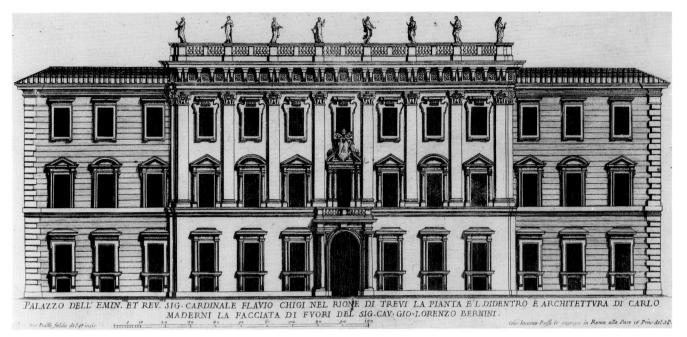

55. Gianlorenzo Bernini. *Palazzo Chigi.* 1664–67. Engraving by G. B. Falda

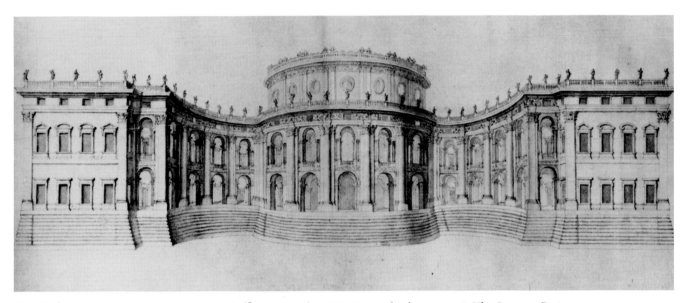

56. Gianlorenzo Bernini. *Louvre: East Facade* (first project). 1664. Pen and ink on paper. The Louvre, Paris

duke of Savoy. The journey was one long parade as "cities were depopulated by the townspeoples' desire to come out and see him." Bernini likened himself to "a traveling elephant." Crossing the border into France he was received by the royal officials in a manner usually reserved for foreign princes or ambassadors. "So many honors," Bernini wrote home from Lyon, "have been given me in this kingdom that they make me doubt my ability to live up to the magnitude of that idea which I know the king holds of me."[56] On June 2 he was met outside Paris by Paul Fréart, sieur de Chantelou, whom Louis had assigned to accompany Bernini throughout his stay and whose detailed diary provides a rich chron-

icle of the visit, as well as fresh glimpses into the mae-stro's work habits, attitudes, and wit. It begins with Chantelou's "little sketch," which may be compared with its subject's graphic reflection (fig. 57): "The *Cavaliere* Bernini is a man of medium height but well proportioned and rather thin. His temperament is all fire. His face resembles an eagle's, particularly the eyes. He has thick eyebrows and a lofty forehead, slightly sunk in the middle and raised over the eyes. He is rather bald, but what hair he has is white and frizzy. He himself says he is sixty-five [*sic*]. He is very vigorous for his age and walks as firmly as if he were only thirty or forty. I consider his character to be one of the finest formed by

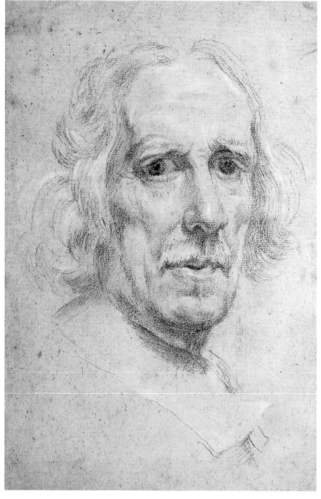

57. Gianlorenzo Bernini. *Self-Portrait.* 1665. Chalk on paper, 16¼ × 10¹¹⁄₁₆″ (41.3 × 27.1 cm). Windsor Castle, Royal Library

nature, for without having studied he has nearly all the advantages with which learning can endow a man. Further, he has a good memory, a quick and lively imagination, and his judgment seems perspicacious and sound. He is an excellent talker with a quite individual talent for expressing things with word, look, and gesture, so as to make them as pleasing as the brushes of the greatest painters can do. This is no doubt why his comedies have been so successful. . . ."[57]

Bernini stayed six months, twice as long as planned. At his first meeting with the king he explained his objective: "Sir, I have seen the palaces of emperors and popes and those of sovereign princes which lie on the road from Rome to Paris, but a palace for a king of France, a modern king, must outdo them all in magnificence." To the ministers and courtiers he pointedly added that he would hear of nothing trivial or small. He believed that "buildings are the mirror of princes" and proceeded accordingly. In his third and fourth plans for the Louvre, Bernini abandoned the concave facade (fig.

58); yet the palace remained thoroughly Italianate and pervaded by monarchical symbolism and grandeur. He had no interest in accommodating it to the surrounding architecture nor in making practical compromises for the king's comfort or convenience, the two chief concerns of Colbert. Bernini's comments on French architecture—indeed on everything French—were candid, to say the least. Paris, he remarked, "seemed nothing but a mass of chimneys, standing up like the teeth of a carding comb"; the dome of the Val-de-Grâce, "a little cap placed on a great big head"; the Porte Saint-Antoine, "like the door of a cupboard"; the Tuileries palace, "a colossal trifle . . . like an enormous troop of tiny children." The roofs were all too high: Mansart, he maintained, would have been a great architect if only he had studied in Rome. When Chantelou protested that Bernini had not yet seen France's great houses, the latter retorted that "he had come to France to work and not to sightsee." He had heard that France had spent enormous sums on her *châteaux,* yet "it was not money that built a beautiful house, but *this*"—and Bernini tapped his forehead. France had previously been famous only for her armies, he concluded, but henceforth "travelers would come to see the glories of her architecture."

Bernini's impromptu architectural pronouncements—he never wrote a treatise—followed traditional Renaissance theory of classical proportions based on the human figure, "the image of God," and hence divinely ordained. In his view, "practice and theory must be joined together." One of the most important requirements was "to have a good eye in assessing the *contrapposti,*" the illusionistic changes effected by juxtapositions, as in his *Colonnade,* which "made the facade of Saint Peter's appear higher than it actually is." On several visits to the Academy, Bernini proffered advice on painting and sculpture, some of it refreshingly practical: students should not draw by lamplight in the summer—because of the heat. (Less welcome, surely, was the suggestion that they import Greek models for their anatomy classes.) Before drawing from nature, they should imitate the ancient statues through plaster casts. The originals had to remain in Rome, Bernini explained, since "it was this prerogative of possessing what still remains of the beauty of antiquity that enabled Rome to produce great painters and sculptors." Extolling the virtues of Annibale Carracci and Guido Reni, he had no use for "the petty, miserable, niggling style" of French painters. The sole exception was Poussin, who had spent most of his career in Rome and whose reverence for classical antiquity matched his own. Upon seeing Poussin's second *Sacraments* series at Chantelou's

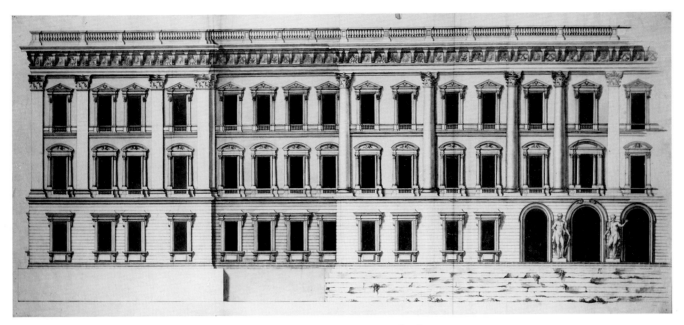

58. Gianlorenzo Bernini. *Louvre: East Facade* (fourth project). 1665. Pen and ink on paper (after Mattia de' Rossi's large model). Nationalmuseum, Stockholm

house, Bernini announced to his host, "You have done me a great disservice today by showing me the genius of a man who makes me realize that I know nothing." When told of that verdict, Colbert remarked, "Finally he has seen something in Paris he has liked."

Bernini's Louvre was doomed from the start. While he stressed its symbolism, Colbert was concerned about lowering the ceilings and the placement of staircases and privies. The king and Colbert wanted to preserve the character of the older sections erected by Louis's ancestors; Bernini wanted to transform the whole: "Tell the king that in trying to save the Louvre he has destroyed it." The Italian's witty aphorism referred only to external appearances, but unfortunately it echoed more literally the views of jealous French architects who constantly sought to undermine him. Even at the ceremonial laying of the cornerstone, Bernini must have doubted that his Louvre would ever be built. He recalled what Urban had prophetically told him of the French court when discouraging a move to Paris forty years earlier: "The enthusiasm with which an enterprise is started very soon peters out; after being fussed over and thought much of for a year or two, one is dropped completely." When asked whether he would come back in a few years to see its completion, Bernini confessed that while "his interest in the Louvre was greater than in anything else he had done, it was usual for him to be interested in his work at the beginning, but once finished, his feeling for it evaporated, for he

realized that it was far from the perfection he had envisaged." In the end, France was not to be ruled from a Roman palazzo; yet Bernini's designs would nonetheless leave his imprint on future royal palaces north of the Alps—from Hampton Court to Stockholm and Saint Petersburg. Even in France his Italianate treatment of the facade and parapeted roof would find reflection in the Sun King's ultimate residence—Versailles.

On a more human scale Bernini left behind a masterpiece that alone would justify the six-month intermezzo: his portrait bust of the king (plate 33). Unlike Francesco d'Este's (fig. 37), this one was prepared by a spate of life drawings and over twenty clay *bozzetti*. He sketched the king at council meetings, even on the tennis court, in order to attain a "speaking likeness," as he had done with Cardinal Borghese. Once when the king glanced in his direction, Bernini jested, "I'm stealing something of yours." "Yes," the king replied, "but only to give it back." "I give back less than I take," Bernini countered. When one day a courtier commented on his apparent effortlessness, Bernini replied, quoting Michelangelo, that he paid for it in blood. The sixty-six-year-old maestro contrasted his efforts ("hesitating at each stroke") with the innocent facility of his youth, when he "never struck a false blow"; he had since discovered "that he knew less than nothing, a truth which he was not aware of at that time." He entertained the courtiers—and himself—by sketching

59. Paolo and Gianlorenzo Bernini. *Christ Child Playing with Nail*. 1665. Marble relief. The Louvre, Paris

caricatures, including a cutting profile of Colbert: his pen was as sharp as his wit. When asked why he did no caricatures of women, he replied (in a play on the word's literal meaning, a "charged" or "loaded" image) that "ladies should not be loaded—except at night!" Having completed his sketches and models, he tackled the brittle marble block in the king's presence. "Miracle of miracles," he exclaimed at the end of one sitting, "that a king so meritorious, youthful, and French should remain immobile for an hour!"[58] The result was the Baroque apotheosis of the portrait bust, indeed of royal iconography. Amidst the predictable complaints that he had taken too many liberties with the royal features, he prognosticated to Louis's physician: "My king will last longer than yours."

Bernini longed to return to Rome. News that his wife had taken ill brought him to tears; when that crisis passed, his concern shifted to his "children that could not travel"—the neglected *Colonnade* and *Cathedra*. Between sessions on the king's bust he discreetly assisted his son Paolo, who was carving a marble relief, the *Christ Child Playing with Nail* (fig. 59), for the queen. Colbert was unduly impressed by the eighteen-year-old's seeming precocity—more the result of paternal assistance than inherited talent—and asked whether Bernini "was not afraid lest he should prove to be even more talented than his father." Doubtless irritated at yet another gratuitous taunt by the haughty minister, Bernini recalled (with a slight slip of chronology) that at that age he had carved the *Apollo and Daphne* (plate 10). Paolo was urged to stay on in Paris, an invitation his father, not surprisingly, vetoed.

In September, Bernini was inducted into the French Academy of Fine Arts and promised to oversee the training of its students in Rome. A month later, frustrated and angry, Bernini complained that while he was "honored by the esteem" in which the king held him, he was tired of Colbert and his constant carping and delays. Perrault's eleventh-hour criticisms of the Louvre had so incensed Bernini that he exploded on October 6: "If it costs me my life I intend to leave tomorrow, and I see no reason after the contempt that has been shown me why I should not take a hammer to the bust." Perrault was pardoned, the bust was spared, and two weeks later Bernini set off for Rome with lavish gifts and thanks from the king. No sooner had he left than his detractors began circulating rumors that he had groused about his compensation. Bernini responded in cadences of tactful indignation: "It is common knowledge," he wrote to Chantelou, "how great are the presents with which I have been honored by the king, and I may say that my labors have been more liberally rewarded in six months in France than in six years in Rome. But since I have been worthily presented with royal gifts, I must receive the myrrh of malevolent misrepresentation, having already tasted the gold of riches and the incense of honor in abundance. Time will reveal truth, as I have already discovered to my benefit in days gone by."[59]

"There comes a time when one should cease work, for there is a falling off in everyone in old age," Bernini had remarked while gazing at a late painting of Poussin's. To Chantelou's reply that industrious artists found it hard to do nothing and often kept working for their own amusement, Bernini, concurring, nonetheless warned that these late pieces "often did harm to their reputations." He arrived back in Rome shortly before his sixty-seventh birthday. Yet a slackening of pace and workload—much less his retirement—was nowhere in view. He designed an outdoor monument to the Chigi pope—not a fountain, such as he had created for Urban and Innocent, but an exotic landmark: an obelisk (symbol of the sun) raised on the back of an elephant (plate 34), a witty composite of pagan and Christian symbolism, of Alexander the Great and Alexander the pope. His erudite allusion to the latter's burning intellect was underscored by a lengthy inscription at its base, *sopra Minerva,* on the site of an ancient temple of the Roman goddess of wisdom. The monument was faithfully executed by Ercole Ferrata. But Alexander did not live to see it unveiled. The month before, in June 1667, his secretary of state, Giulio Rospigliosi, had succeeded him as Pope Clement IX.

On the very first day of his papacy, Clement sent

60. *Ponte Sant' Angelo* (with Bernini's angels and restorations). 1667–72. Rome

for Bernini "and bestowed on him heartfelt expressions of his love." Their friendship dated back to the reign of Urban VIII, when Bernini and Rospigliosi had collaborated on plays produced for the Barberini theater. Clement was old and frail—he was to reign only two and a half years—and he suffered from insomnia, which he sought to cure by having Bernini renovate the Belvedere fountain outside his bedroom window to produce a soothing gushing of water through the night. Unable to increase the flow, according to Baldinucci, Bernini resorted to a "new and ingenious" machine that simulated the sound of a fountain by a rotating wheel that struck a series of paper globes. It worked; His Holiness slept. When later awakened to Bernini's ruse, "the pope could not stop saying that Bernini's genius always expressed itself in little things as well as great." Summoning the impresario, he affected surprise: "Truly, Signor Cavaliere Bernini, we would never have believed that on the first day of our pontificate we would be deceived by you"[60]—an affable protest surely belied by their past joint ventures for the stage. Rospigliosi's memory could not have been so short.

As Alexander and Urban had before him, Clement regularly invited Bernini to dinner—"with the difference that he wished no other person present." They enjoyed the easy intimacy of old friends just a year apart in age. Bernini cherished these visits, which the pope reciprocated by calling in person on the Bernini household near Sant' Andrea delle Fratte. The water machine was an appropriate prelude for Clement's commission in 1667 to renovate and decorate the Ponte Sant' Angelo, the ancient bridge that provided—before Mussolini bulldozed his avenue through the Borgo—the main ceremonial approach to Saint Peter's. One evening in Paris, two years earlier, Bernini had taken a drive with Chantelou to the Pont-Rouge (today the Pont-Royal) near the Tuileries. Bernini stopped the carriage, got out, and spent "a good quarter-hour looking first from one side of the bridge and then the other." Turning to his companion, he remarked: "It is a beautiful view; I am a great lover of water; it calms my spirits."[61] He provided enduring proof at the Ponte Sant' Angelo, his last outdoor monument in papal Rome, by introducing iron grillwork into the redesigned parapets so that passersby could enjoy viewing the water below (fig. 60).

41

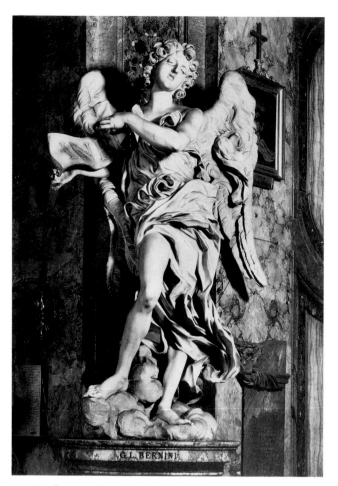

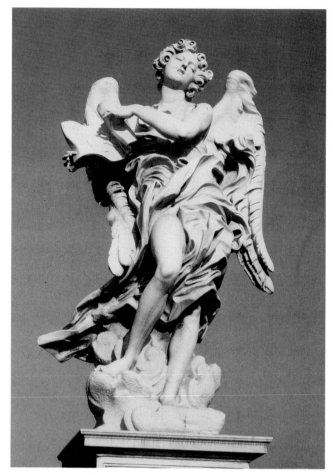

61. Gianlorenzo Bernini. *Angel with Superscription.*
1668–69. Marble, height c. 9′ (2.74 m). Sant' Andrea
delle Fratte, Rome

62. Gianlorenzo Bernini. *Angel with Superscription.*
1670–71. Marble, height c. 9′ (2.74 m). Ponte Sant'
Angelo, Rome

The commission befitted Clement's motto: *Aliis non sibi Clemens* — "Serve others, not thyself." His pontificate was marked by a conspicuous absence of nepotism; he built no family palace, amassed no fortune. A devoutly spiritual man, he gave the Romans bread (by lowering the tax on flour), not circuses. At home he attended to the poor; abroad he applied his considerable diplomatic skills to unify Catholic Europe in its defense against the Turks, and he settled the Jansenist controversy that threatened schism in France. Like Bernini, he regularly practiced the *Spiritual Exercises* of St. Ignatius. The third week of the *Exercises,* the meditations on Christ's Passion, provided the source for Bernini's penitential prelude for the pilgrims to Saint Peter's. Of the ten angels designed by the master, eight were assigned to members of the Bernini school: Raggi, Ferrata, Morelli, and other lesser lights. Bernini himself carved the final pair (figs. 61, 63; plate 35). When he saw these exquisite angels, Clement decided to keep them indoors, protected from the weather, and ordered Bernini to have his assistants carve copies for the bridge.

Determined to make a more direct contribution to the sacred work, Bernini secretly executed one of the replacements himself (fig. 62). According to Baldinucci, the pope—with feigned displeasure—remarked: "In short, *Cavaliere,* you wish to compel me to have yet another copy made."

Bernini carved no statue or commemorative bust of Clement, whose sole monument was a public work, not a personal glorification. But the king of France was not given to self-depreciation, and toward the end of 1669 Bernini was commissioned to undertake the equestrian statue of Louis he had conceived several years earlier for Trinità dei Monti (fig. 54). In his portrait bust (plate 33), Louis had been identified with Alexander the Great; on horseback, he was to be equated with Hercules at the summit of Virtue. "I have not represented King Louis in the act of commanding his armies," Bernini explained to a visiting Frenchman, "but in a state which he alone has been able to attain through his glorious enterprises."[62] For Bernini the glory proved elusive. Work dragged on until 1677, and

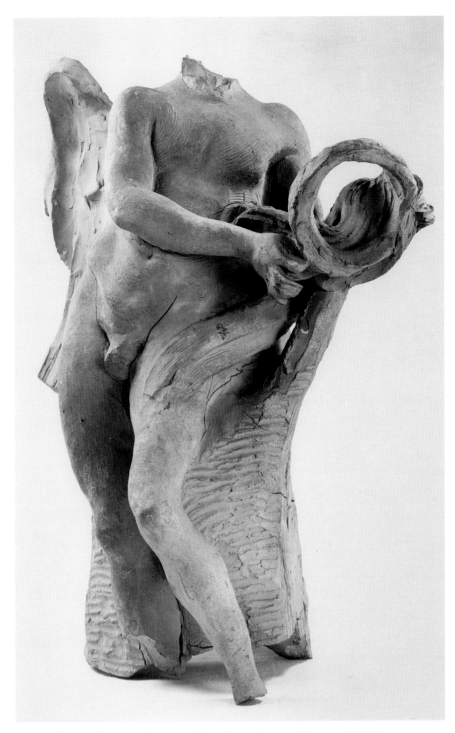

63. Gianlorenzo Bernini. *Bozzetto of Angel with Crown of Thorns.* 1668. Terra-cotta, height 13¼" (33.7 cm). Courtesy of The Fogg Art Museum, Harvard University, Cambridge, Mass.; Alpheus Hyatt and Friends of the Fogg Fund

for several years after its completion the statue remained in his studio. Bernini ruefully predicted that the French "will find little to admire." He underestimated their antipathy. Finally shipped to France after Bernini's death, it was summarily rejected by Louis and then was disfigured by Girardon into the legendary Marcus Curtius for the gardens at Versailles (fig. 64). Yet

Bernini's terra-cotta *modello* (plate 37) preserved in miniature his larger-than-life image of the king, an allegorical transformation of the earlier statue of Constantine (plate 32).

On a more intimate scale, Bernini distilled in his memorial bust of the physician Gabriele Fonseca the essence of piety (plate 36). His earlier designs for the

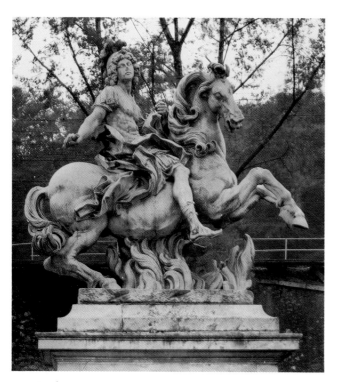

64. Gianlorenzo Bernini and François Girardon. *Marcus Curtius* (reworked *Louis XIV* statue). 1669–87. Marble. Musée National de Versailles et de Trianon

Fonseca chapel (c. 1663–64; fig. 65), a paraphrase of Sant' Andrea al Quirinale (plates 30, 31), established both the physical setting for the bust and its illusionistic concetto: Gabriele's posthumous participation in the Annunciation — through his namesake, Gabriel. This mystical communion of painting and sculpture evokes the concluding refrain of Fonseca's clutched rosary: "Pray for us sinners now and at the hour of our death."

On December 9, 1669, Clement IX died. "Mourned by Rome and the entire world," he was succeeded by the eighty-year-old Clement X (Altieri), who "because of his great age was unable to entertain the idea of building or adorning the city."[63] His family's chief preoccupation was to complete their palazzo next to the Gesù before the pope was called to his reward. Both of Clement's eventual commissions for Bernini at Saint Peter's were revivals of Chigi projects: Alexander VII's tomb (plate 39) and the Sacrament Chapel (plates 40, 41). This initial hiatus in papal assignments gave others access to Bernini's time and talent. For the Jesuits he performed in 1672 a labor of love: designs for his protégé Bacciccio to paint in the dome of the Gesù. Above the nave, Bernini's expanded conception of Bacciccio's ceiling fresco was to be framed — but not

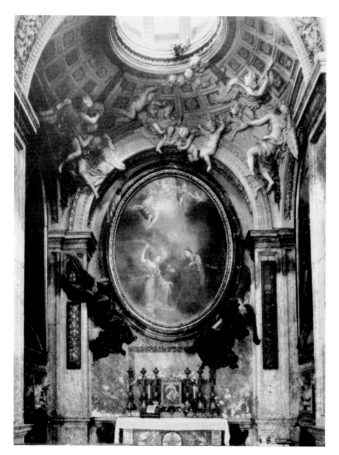

65. Gianlorenzo Bernini, *Fonseca Chapel.* Begun c. 1663–64. San Lorenzo in Lucina, Rome

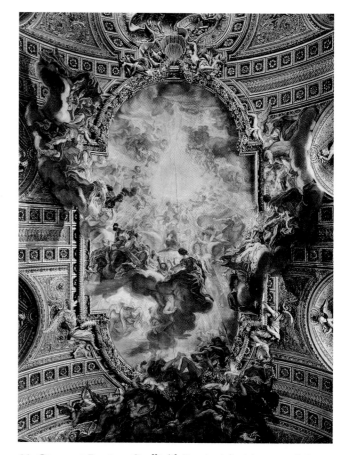

66. Giovanni Battista Gaulli (Il Bacciccio). *Adoration of the Name of Jesus.* 1674–79. Fresco. Il Gesù, Rome

contained—by a gilded molding held by Raggi's stucco angels (fig. 66).[64] At the center a blazing sun, the source of divine light, is adored by heavenly hosts, a late Baroque version of Dante's *Paradiso*. Angels, archangels, cherubim, and seraphim are joined by prophets, patriarchs, saints, and kings in hierarchic tiers projecting far above the illusionistically opened ceiling, while the damned—devils, demons, and heretics—tumble physically out of the picture as if to fall into the nave below. This violation of the picture frame, the interpenetration of real and fictive space, is of course Bernini's hallmark; it recalls his painterly sunburst over the *Cathedra Petri* (plate 29). His design for Bacciccio's dome fresco, *The Intercession of Christ and the Virgin,* was similarly anticipated by Bernini's recent painting of redemptive sacrifice, the *Sangue di Cristo,* which he had engraved (fig. 67) "to send out into the world" while keeping the original canvas for his private meditations.[65]

The theme of death and resurrection dominated Bernini's final works. He confronted the subject directly in his monument to the Blessed Ludovica Albertoni (plate 38), undertaken gratis in 1671 for the new cardinal-nephew. (It may have been part of the price Bernini paid to extricate his exiled brother Luigi from a sexual scandal—if so, it was an inspired fraternal atonement.) Bernini presented the beatified nun in a glowing conflation of ecstasy and death—a reflection of the Cornaro chapel that clarifies his deepening spirituality over the quarter century. The repose of Pope Alexander's soul was likewise conceived as a monumental triumph of faith over death (plate 39) at Saint Peter's, where Bernini surmounted yet another architectural obstacle—a sacristy door, now transformed into the symbolic portal of death, from which the winged skeleton emerges. From the very beginning of his pontificate, the frail Chigi pope had surrounded himself with reminders of mortality. In 1655 Bernini had designed his casket, which Alexander kept in his bedroom along with a marble skull and dinnerware decorated with "death's heads" for meals seasoned with ashes. Serene and elevated above his tomb, the pontiff kneels in prayer surrounded by Truth, Justice, Charity, and Prudence. We have traveled a long way, stylistically and conceptually, from Urban's tomb across the sanctuary: it is faith, not fortitude, that illumines Bernini's twilight masterpieces.

Beginning with his marriage at the age of forty, Bernini had rechanneled his youthful passions into an intense regimen of piety. He joined a Jesuit group devoted to the Blessed Sacrament. For the next four decades he went to daily mass at Sant' Andrea delle Fratte and concluded his working day kneeling before

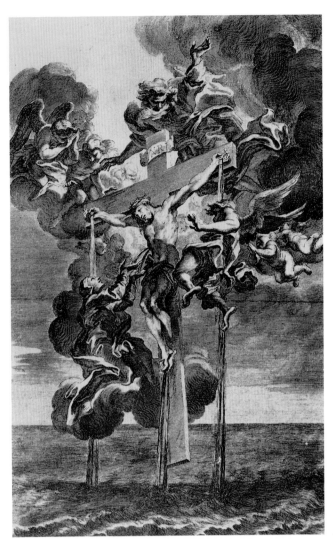

67. Gianlorenzo Bernini. *Sangue di Cristo.* 1670. Engraving by François Spierre, 17¹⁵⁄₁₆ × 10⅝″ (45.5 × 27 cm). Instituto Nazionale per la Grafica, Rome

the sacrament at the Gesù. He took communion at least once a week. The summation of Bernini's religious fervor—specifically his devotion to the Eucharist, graphically rendered in the *Sangue di Cristo*—was cast in bronze for his last great monument at Saint Peter's: the altar of the Blessed Sacrament (figs. 68, 69; plates 40, 41). Work on it began in 1673, the year his wife died; it was unveiled for the Holy Year 1675. For the last time Bernini combined elements of architecture, painting, and sculpture in an altarwork devoted to the central mystery of the Christian faith. Half a century earlier, in his first bronze altarwork at Saint Peter's (fig. 15; plate 13), he had composed architecture as if it were colossal sculpture; now he cast sculpture as architecture, a miniature temple-tomb.

For the Altieri palace Bernini designed garden statues and reliefs; six (the four seasons, plus Adam and Eve) were evidently finished in early 1673, but all have

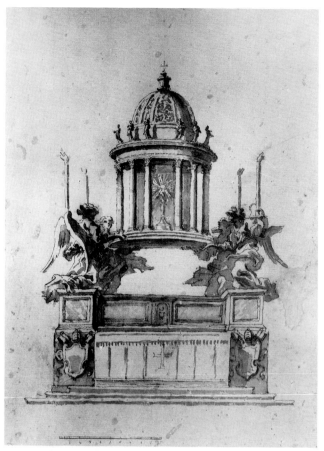

68. Gianlorenzo Bernini. *Drawing for Tabernacle.* c. 1673.
Pen and ink with wash, 14¹⁵⁄₁₆ × 10¼″ (38 × 26 cm).
The Hermitage, Leningrad

Saint Peter's was threatening to destroy Michelangelo's dome. Old age and frailty offered no immunity from envy and spite.

Bernini's last work in marble was an over-life-size *Bust of the Savior* (1679–80; fig. 70; plate 42), which the octogenarian carved both as a present for "his most special patron," Queen Christina of Sweden, and as a spiritual preparation for death. According to Domenico, "he wished to illustrate his life and bring to a close his practice of the profession he had conducted so well till then, by creating a work with which a man would be happy to end his days."[68] In France, Bernini had declared apropos of Poussin that "a man should know how to stop when he gets to a certain age." Yet naturally ambivalent about drawing the final line, to his son he asserted that "an artist excellent in design should not fear any want of vivacity or tenderness on reaching the age of decrepitude, because ability in design is so effective that it alone can make up for the defects of the spirits, which languish in old age." It is in this light

vanished.[66] The cardinal-nephew, Paluzzo Altieri, also commissioned a half-length bust of the pope and two studio replicas. His librarian saw Bernini at work on the original in May 1676; less than three months later the pope was dead and work on the bust was suspended. It remained in Bernini's studio and was eventually bequeathed to the cardinal. Clement's successor, Innocent XI (Odescalchi), was remarkable chiefly for his asceticism and puritanism. He railed against nepotism and had little use for the arts. Extremely prudish, he outlawed décolletage and even ordered stucco drapery to clothe naked Truth and Charity's breasts on Alexander's tomb—a typical response by the Innocent en route to sainthood. (Having restored Vatican finances and united Europe against a Turkish invasion, he was finally beatified in 1956.) But the "saint" was not a patron. Bernini spent his final years completing Alexander's tomb and the last months of his life repairing the Cancelleria palace, which was on the brink of collapsing. Over the objections of his sons, he climbed up and down scaffolds, "subjecting himself to work much too heavy for his advanced age."[67] Meanwhile the old rumors flared up that his early work at the crossing of

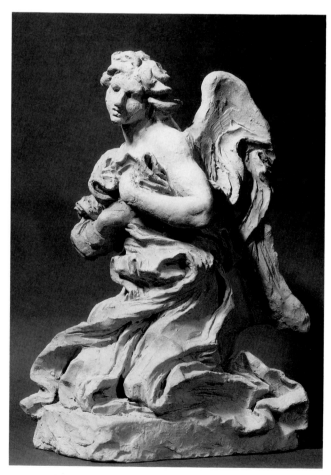

69. Gianlorenzo Bernini. *Bozzetto of Kneeling Angel.* 1673.
Terra-cotta, 13⅜″ (34 cm). Courtesy of The Fogg Art Museum, Harvard University, Cambridge, Mass.; Alpheus Hyatt and Friends of the Fogg Fund

that the conclusive—and most telling—strokes of the sculptor's chisel must be appraised.

Bernini approached his own death with no less preparation or imagination: "He thought of and discussed nothing else but his passing; not with bitterness and horror, as is usual with the aged, but with incomparable constancy of spirit and in using his memory in preparation for doing it well." Enlisting the aid of his nephew Father Filippo Marchese, an Oratorian priest, he admitted that this final step "was difficult for everyone since everyone took it for the first time." To the French courtiers he had insisted, "Let no one speak to me of little things." Now in accounting for his life he said he would have to "deal with a Lord who, infinite and superlative in his attributes, would not be concerned to count in pennies."

At the foot of his deathbed Bernini set up a makeshift altar for his *Sangue di Cristo,* the illustration of his continuous discussions with Father Marchese about the efficacy of Christ's sacrifice. Throughout the course of the fever, which lasted two weeks and was followed by an attack of apoplexy, his intellect remained undimmed. When paralysis struck his right arm, Bernini declared, "It is only right that even before death that arm should rest a little that worked so much in life." He had prearranged with his confessor a special language of expressions and gestures—of which he was the undisputed master—in case, as indeed it turned out, he lost the power of speech. Around his bed gathered his family; his favorite assistants, Mattia de' Rossi and Giulio Cartari; "and all his pupils." Moving only his eyes and left hand, he made himself understood "to the astonishment of all" and gave his final blessing to his nine surviving children, four sons and five daughters. After receiving the pope's benediction early on November 28, 1680, in his eighty-second year, "the great man died as he had lived, leaving it doubtful," Domenico concluded, "whether his life was more admirable in deeds or his death more commendable in devotion."

To his children he left in perpetuity his unfinished *Truth Unveiled* (plate 22); to the pope, a painting of Christ; to Queen Christina of Sweden, who had steadfastly refused to accept it as a gift, the *Bust of the Savior.* When Christina asked of Innocent, the eighth pope Bernini had served, the value of the artist's estate and was told 400,000 scudi (a fortune), she replied: "I would be ashamed if he had served me and left so little." His funeral in Santa Maria Maggiore was so crowded that the burial had to be postponed to the next day. His remains were interred under a simple stone pavement of that basilica where he had first been apprenticed to his father some seven decades earlier.

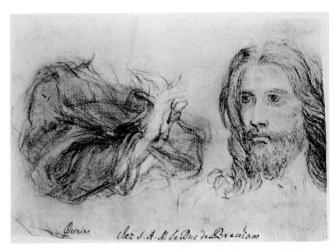

70. Gianlorenzo Bernini. *Study for Bust of the Savior.* 1679. Black chalk on paper, 6¾ × 10″ (17.1 × 25.4 cm). Instituto Nazionale per la Grafica, Rome

Bernini maintained that "he owed all his reputation to his star which caused him to be famous in his lifetime" and predicted that "when he died its ascendency would no longer be active and his reputation would decline or fall very suddenly."[69] His prophecy proved all too accurate. The final section of Baldinucci's biography, published two years later, was devoted to disproving the lingering charges that Bernini had endangered the dome of Saint Peter's. Already the classicizing tide of the late Baroque had begun to erode the maestro's pedestal. Within five years of Bernini's death, the rejection of his equestrian statue of Louis XIV (fig. 64) presaged the next two centuries of his falling star, which reached its nadir in the nineteenth century. The neoclassicist Johann Winckelmann could not forgive Bernini's violation of the "noble grandeur" of ancient sculpture; the Victorian John Ruskin considered him the epitome of bad taste. Yet there were others, less bound by academic theory, who willingly succumbed to his Roman magic—among these, Stendhal, Taine, and Zola. Even Jacob Burckhardt, the passionate partisan of Rubens, who felt compelled in principle to object to Bernini's painterly approach to sculpture, dubbed him "the man of destiny" for his vital transfusion of Baroque naturalism and emotionalism into marble and bronze.[70]

Bernini's reascendency is a modern phenomenon. Beginning in the early part of our own century, it gained momentum with the general reappraisal by art historians of the intellectual and creative vitality of the Baroque era. Together with those of Caravaggio and Rubens, Bernini's star today shines in the empyrean, far above the present currents of critical fortune.

TOMB OF GIOVANNI BATTISTA SANTONI

c. 1611–12
Marble, life-size
Santa Prassede, Rome

Like Mozart, Gianlorenzo Bernini was a child prodigy. Although the precise chronology of his early works remains speculative, his legendary precocity is demonstrably well founded. By Bernini's own (slightly exaggerated) recollection, he chiseled "at the age of six, a head in a bas-relief by his father"[1] — probably Pietro's *Assumption of the Virgin* in Santa Maria Maggiore (fig. 1). By eight, he said (ten, according to Domenico and Baldinucci), he had carved a head of St. John that was presented to Paul V. The skeptical pontiff, doubtless assuming that credit was due to papa Pietro, asked the lad to sketch a head on the spot. The pope was converted.

It was Bernini's power "to arrive at an exact likeness," his ability as a portraitist, that amazed the artists and patrons of his father's generation; members of the academy considered him "an incredible marvel." Baldinucci cited this commemorative marble head of Bishop Santoni as Bernini's first commission, carved by the time the budding sculptor "had scarcely completed his tenth year." Modern scholars generally placed it several years later, between 1613 and 1616, when Bernini was between the ages of fourteen and seventeen years, until Irving Lavin's discovery of the posthumous portrait bust of Antonio Coppola (fig. 6) and its contract of early 1612 established a benchmark for dating Bernini juvenilia and confirmed the claim to youthful virtuosity.[2] Lavin dated this official debut of Bernini the portraitist as early as 1610, when the donor, Santoni's nephew Giovanni Antonio, was named bishop of Policastro (April 26). Whether or not the memorial was occasioned by that ecclesiastical appointment, the carving surely preceded, if only by months, Gianlorenzo's more subtle articulation in the Coppola bust and may safely be dated from 1611 to early 1612. No doubt it was this very work that prompted the fathers of San Giovanni dei Fiorentini to employ Gianlorenzo, through his father, to memorialize Coppola. (Because he was legally under age and still an apprentice, all Gian-

lorenzo's early commissions had to be contractually assigned to Pietro; accordingly, attributions to his son rest on stylistic arguments, not documents.)

For all its immediacy, this bust was a posthumous portrait. Bishop of Tricarico and later chamberlain to Pope Sixtus V, Santoni had died in 1592 — six years before Bernini's birth. Unlike the "deathliness" of the Coppola bust, which was based on a wax death mask, Santoni's effigy is infused with vivacity, as it peers out of its oval frame with a slight turn of the neck. Bernini's bold exploitation of the frame solves the inherent problem of truncation, or "amputation," in such portrait busts by encouraging us to imagine the rest of the body behind the porthole. It prefigures, by a decade, the Vigevano (Santa Maria sopra Minerva) and the Montoya (plate 9) busts of the sculptor's maturity.

The finely chiseled details — the wrinkled texture of the skin, the furrowed brow and "crow's-feet," the sharply incised pupils, the subtly differentiated hair and beard, even the linear folds of the collar and cassock — find precedents in Pietro's oeuvre. But as compared with the latter's posthumous portrait of Pope Clement VIII in Santa Maria Maggiore, Gianlorenzo's is already set apart by its convincing naturalism, a reflection of his assiduous study not only of Hellenistic and Roman sculpture but also of the early Baroque painters Annibale Carracci and Caravaggio. The Mannerist wall epitaph, enframing both bust and memorial inscription, was designed by an anonymous architectural collaborator, but the three cherub heads are surely by Gianlorenzo. Their pudgy features reflect their high-relief counterparts in Pietro's *Assumption*, while their expressiveness anticipates their immediate mythological offspring (plates 2, 3).

Along the nave of Santa Prassede, an Early Christian basilica better known for its mosaics, Santoni's emerging head provides an unexpected encounter. It embodies the vigorous independence and self-assertion of a uniquely gifted apprentice on the eve of adolescence.

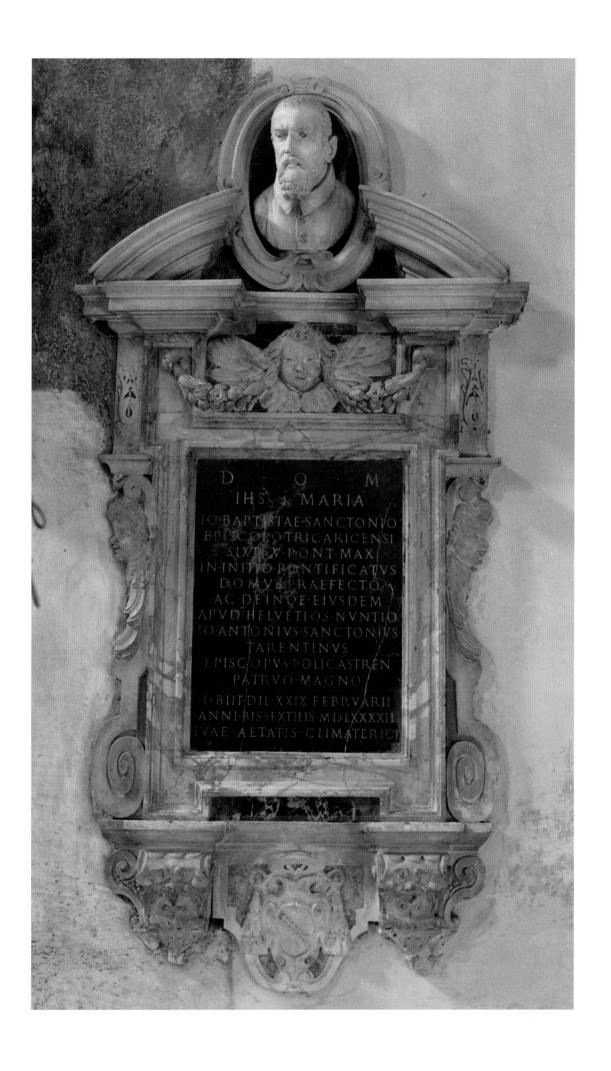

D O M

IHS ✦ MARIA

IO·BAPTISTAE·SANCTONIO
EPISCOPO·TRICARICENSI
SIXTI·V·PONT·MAX·
IN·INITIO·PONTIFICATVS
DOMVS·PRAEFECTO
AC·DEINDE·EIVSDEM
APVD·HELVETIOS·NVNTIO
IO·ANTONIVS·SANCTONIVS
TARENTINVS
EPISCOPVS·POLICASTREN
PATRVO·MAGNO

OBIIT·DIE·XXIX·FEBRVARII
ANNI·BISSEXTILIS·MDLXXXXII
SVAE·AETATIS·CLIMATERICI

THE GOAT AMALTHEA AND INFANT ZEUS WITH SATYR

c. 1611–12

Marble, height 17¾" (45 cm)

Galleria Borghese, Rome

PUTTO WITH DRAGON

c. 1613–14

Marble, height 22¾" (58 cm)

Collection of the J. Paul Getty Museum, Malibu

Bernini's earliest mythological sculpture, carved for Cardinal Scipione Borghese, was for centuries miscatalogued as a Hellenistic original. A tabletop piece, it derives from the Bacchic groups of *putti* at play that Pietro and company produced for private patrons. The classical composition was doubtless closely supervised by Pietro, but the "handwriting" is distinctively that of his precocious son. The Greek myths of Zeus' (Jupiter's) childhood, recorded by Hesiod, Apollodorus, and Hyginus and later Romanized by Ovid, offered a fitting subject for young Bernini's stylistic self-nurturing on the models of ancient sculpture. Zeus was the third son of Chronos and Rhea. Warned that one of his offspring would dethrone him, Chronos successively devoured his children, a fate that Rhea was determined to spare her infant Zeus by handing him over to the goddess Earth. Taken to Crete, the future lord of Olympus was nursed by the goat Amalthea. In gratitude, Zeus set Amalthea's image in the zodiac as Capricorn.

Bernini's beguiling configuration of infants and animal represents an inventive variation on that ubiquitous Roman pair, the brothers Romulus and Remus, nurtured by a wolf. Although scholars have traditionally identified Zeus' playmate as an anonymous satyr or faun, he may represent the infant Pan, who, according to one version of the story, shared his mother Amalthea's milk with Zeus, his "foster brother." (Although Pan was more commonly thought to be Zeus' grandson, via Hermes, Bernini's possible reference to the "foster brother" alternative is here reinforced both by the figure's prominence and by the overt Romulus-and-Remus parallel.) Zeus milks the goat as the little satyr raises his left arm to drink from a shallow shell. The polished surfaces and painterly approach to the circular composition reflect Pietro's tutoring, but the differentiated textures—Zeus' vine leaves, the satyr's rough

tufts of hair, the delicately carved strands of goat hair, and the domesticating collar and bell—all proclaim Gianlorenzo's handiwork. The blank eyes and firm chiseling of the faces evoke an antique authenticity. The nascent touch of the virtuoso is evident in the rendering of the milk about to spill over the shell and into the parted lips: it is just such a frozen moment, the instant before its consummation, that Bernini was to exploit in his mature masterpieces for Borghese.

This miniature tour de force is not included in Baldinucci's catalogue of Bernini's works, which consistently omits any mention of all such early *putti* groups and collaborative garden sculptures. First attributed to Gianlorenzo by the German historian Joachim von Sandrart (1675), it has been dated as early as 1609. The carpenter's invoice of 1615 for its pedestal sets the outside limit. Stylistically, a date from 1611–12, close to the Santoni and Coppola busts (compare plate 1; fig. 6), seems most plausible.[3] Its hard, "porcelain" finish and slightly awkward passages were soon to yield to a softer, Rubensian treatment in his *Putto with Dragon*, Bernini's precocious variation on the infant Hercules strangling a snake.

In place of the deadly serpent, Gianlorenzo substituted the benevolent dragon of the Borghese gardens, later celebrated in verse by the poet-cardinal Maffeo Barberini: "I do not sit as a guardian, but as a host to those who enter. This villa is not more accessible to its owner than it is to you."[4] Barberini, then legate to Bologna, may have commissioned the piece as a memento of his days at the villa; or perhaps it, too, was carved for Borghese, who later gave it to his friend. Whatever its origin, it provides a stepping-stone from the *Amalthea* to the more sensual statues of Bernini's adolescence and confirms the ancient adage *Ex ungue leonem*: "The lion may be told by its claw."

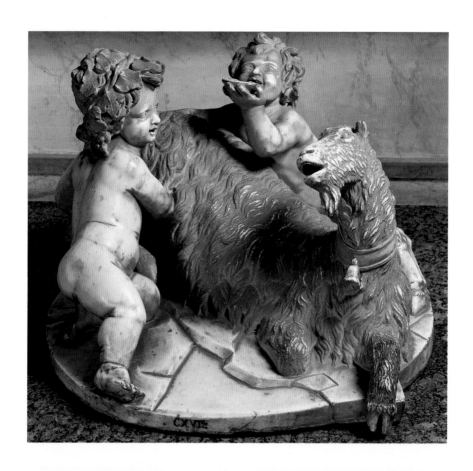

ST. SEBASTIAN

c. 1616–17
Marble, height 39" (99 cm)
Thyssen-Bornemisza Foundation, Lugano

Pope Paul V prophetically hoped that the young Gianlorenzo would prove "the Michelangelo of his age." His earliest religious sculpture, the *St. Lawrence* (1615–16; fig. 8), was a demonstrative variation on Michelangelo's Vatican *Pietà*. Yet Bernini was not content to emulate the High Renaissance model: he revived the pose of the dead Christ to illustrate, with Baroque extroversion, his patron saint's fiery death on a gridiron. Carved a year or so later, Bernini's second Michelangelesque essay, the *St. Sebastian*, offers a more meditative transformation of its Renaissance sources. Raising the figure toward the vertical axis, Bernini added a reference to a second Michelangelo *Pietà* (Cathedral, Florence), which was then on view in Rome. A similar fusion of *Pietàs*—also for a *St. Sebastian*—was anticipated by Domenico Passignano's 1602 painting of St. Sebastian's body being retrieved from the Cloaca Maxima. A decade later, Maffeo Barberini chose Passignano to paint that subject as the altarpiece of the small side chapel of St. Sebastian adjoining the Barberini chapel then under construction in Sant' Andrea della Valle.[5] Gianlorenzo may have undertaken his sculptural St. Sebastian—perhaps on speculation—as his own contribution to the chapel, dedicated in December 1616, which housed his father's *John the Baptist* (fig. 9).

The Roman centurion Sebastian was condemned by the Emperor Diocletian in A.D. 287 to be shot with arrows by his fellow soldiers, the price of his Christian faith. (According to the *Golden Legend,* he was revived by St. Irene and eventually clubbed to death, his body thrown into the Roman sewer.) The popular subject offered to painters and sculptors the opportunity to render a heroic nude. Bernini edited the usual profusion of protruding arrows to two (with a second pair, an iconographic footnote, on the ground) in order to emphasize the saint's theological identification with

Christ and the formal allusion to the *Pietà*. Even the background tree has been pruned into a paraphrase of the cross, while the drapery suggests the shroud.

The unusual pose of a seated Sebastian may derive from early Caravaggesque paintings, such as Nicholas Regnier's *St. Sebastian* (c. 1615; Dresden). But the prominent rock evokes traditional images of the dead Christ, such as Passignano's *Pietà* of 1612 for Cardinal Scipione Borghese. At the same time, Sebastian's pose lends support to the theory that Gianlorenzo used for his sculpture a marble block already roughed out by Nicholas Cordier for a seated *John the Baptist* and intended for the Barberini chapel. At Cordier's death in 1612 both the commission and the unfinished block passed to Pietro Bernini, whose *John the Baptist,* carved from a *new* block and installed in 1615, significantly prefigures Gianlorenzo's *Sebastian.*[6] (Cordier's own *St. Sebastian* for the Aldobrandini chapel in Santa Maria sopra Minerva may, in turn, have been a recarving of an unfinished Michelangelo, thus completing the cycle of associations.) Gianlorenzo not only clarified his father's ambiguously poised figure, but he has clearly overtaken him in anatomical persuasiveness. Both suggest precedents in Caravaggio's *Baptist* (Nelson Gallery, Kansas City) and ultimately in the *Laocoön* (fig. 5), but the sensuousness of Gianlorenzo's saint finds closer analogies in the *Pietàs* of Annibale Carracci and the *Sebastians* by the Flemish painters Regnier (Gemäldegalerie, Dresden) and Rubens (Galleria Nazionale, Rome), executed during their sojourns in Rome a few years earlier.

Bernini's under-life-size marble offers a youthful model, as it were, of his blending of High Renaissance, Hellenistic, and early Baroque traditions. It is hardly surprising that Maffeo Barberini, returning to Rome in 1617, chose to keep the piece for his collection—and, no doubt, his private devotion.

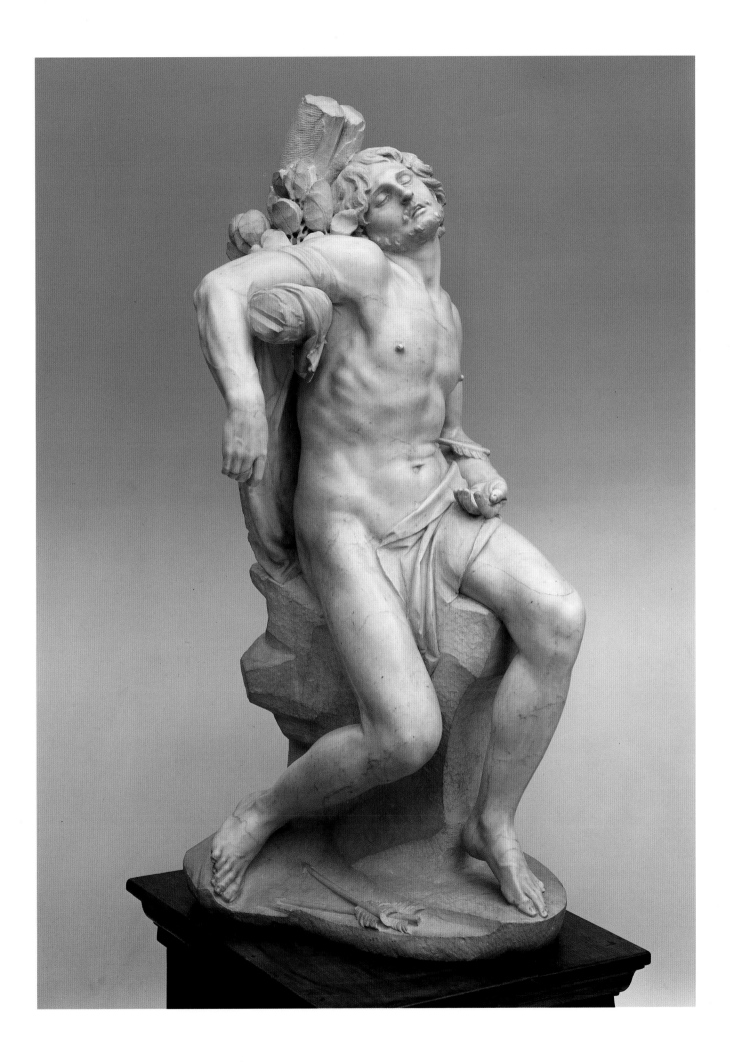

FAUN TEASED BY CUPIDS

c. 1616–17
Marble, height 52″ (132 cm)
The Metropolitan Museum of Art, New York

Omnia vincit amor—"Love conquers all." Bernini's spirited struggle between the *amori* (or cupids) and a faun (one of the goat-man Pan's retinue) is a buoyant translation of Virgil's epigram into marble. This recently discovered, undocumented showpiece marks a turning point in Gianlorenzo's development during his apprenticeship. It represents an ambitious reach beyond the *St. Lawrence* (fig. 8) and *St. Sebastian* (plate 4) toward a complex, multifigured composition. Evolving from Pietro's Bacchic garden groups, his final under-life-size piece germinated in the rich soil of antiquity.

As in the contemporaneous *St. Sebastian,* the vertical and primary axis is defined by a tree trunk. No longer the backdrop for a Christian martyrdom, the tree becomes the locus of an overtly pagan contest between eternal (or celestial) love, symbolized by the cupids, and carnal lust, embodied in the extended faun who overreaches himself: he breaks a branch that is laden with love's fruits (figs and grapes) and defended by a cherubic pair whose heavenly source may be found in Pietro's *Assumption of the Virgin* (fig. 1). One pushes back the faun's vine-crowned head while the other holds on for dear life. Below, a third *putto* tumbles over a panther, reaching for its tail as the Bacchic beast extends its neck to feast on a cluster of grapes. In counterpoint, a panther's skin is draped over the lowest stump of the dead trunk on which the faun precariously supports himself. On the ground the salamander, a final Bacchic symbol, completes the ensemble of untamed nature.[7]

From the Renaissance onward the contest between heavenly and earthly love was celebrated by poets and painters alike, from Petrarch to Ariosto, Titian, and, above all, the Carracci, whose Farnese ceiling (fig. 2) displays a series of symbolic tussles between competing aspects or degrees of love—bestial, human, and divine.[8] Here as there, the underlying meaning is playfully profound; the allegorical *concetto* in no sense inhibits the joyous re-creation of antiquity. It is precisely this felicitous union of form and symbol that anticipates Bernini's mature works, both sacred and profane.

The relative roles of father and son in conceiving and executing such collaborative pieces remain conjectural. Pietro doubtless helped to block out the virtuoso configuration; its serpentine arrangement betrays its Mannerist heritage by presenting a succession of views, no one of which is solely satisfying—a grand sculptural tease befitting its subject. Yet its dynamism and joie de vivre clearly spring from Gianlorenzo's imagination and were shaped by his hand. Models for the faun's head are found in Pietro's oeuvre, for example the *Priapus* herm (1616; fig. 7) erected alongside its companion *Flora* in Borghese's garden. A midcentury guidebook credited the carving of their prominent "fruit and flowers" to Gianlorenzo; indeed, the marble fruit to which his faun aspires is worthy of a Caravaggio still life. If the *putti's* faces still reflect their Mannerist ancestry, their firm bodies belong entirely to the next generation.

Long after his death, Gianlorenzo's early tour de force was still displayed in his house. Yet neither Domenico nor Baldinucci mentions it. Possibly Bernini—his own severest critic—deemed it flawed and, for the record, passed over in silence this private memento of his tutelage. (Baldinucci's list, we recall, omits all such early collaborations.) There are, to be sure, technical shortcomings: one cupid is supported by a strut from the faun's armpit; the left arm of the tumbling tot below is abbreviated at the elbow. Yet its tactile virtuosity suggests that this may have been the very essay that prompted Cardinal Borghese to commission in 1618 the projection of Gianlorenzo's classical vision into his first full-scale mythology (plate 6).

AENEAS, ANCHISES, AND ASCANIUS

1618–19
Marble, height 86⅝″ (2.2 m)
Galleria Borghese, Rome

According to Baldinucci, Gianlorenzo conceived his first life-size sculpture for Scipione Borghese "somewhat in the manner of his father" but executed it with "a certain approach to the tender and true." Beginning with Sandrart's in 1675, attributions have wavered between father and son until the conclusive discovery of documented payments to Gianlorenzo in October 1619.[9] He began work in 1618—he was not yet twenty—and completed it shortly before his admission to the artists' Guild of St. Luke. As in the *Faun Teased by Cupids* (plate 5), Pietro probably contributed the vestiges of Mannerist torsion and the technical "engineering" of the precarious instability that critics have misconstrued as youthful tentativeness on Gianlorenzo's part. This delicate balance reflects, in fact, not weakness in design but Gianlorenzo's faithful interpretation of the classical text.

The subject, from book two of the *Aeneid* (954 ff.), is the prelude to Aeneas' founding of Rome: his escape, with his aged father, Anchises, and his young son Julius Ascanius from the burning city of Troy. Following Virgil, Bernini's Anchises carries the *penates* ("household gods")—a sculpture within a sculpture—and sits on a "tawny lion's skin" across Aeneas' shoulders; its fleecy quality and slashing folds recall Pietro's *Baptist* (fig. 9). The religious significance—Aeneas' embodiment of *pietas*, or piety—is reinforced by the figural quotation of Michelangelo's *Risen Christ* (Santa Maria sopra Minerva, Rome) for Aeneas. Anchises and Ascanius in turn descend from the ancient *Borghese Seneca* and antique cupids, respectively, while Aeneas' physiognomy and deeply chiseled hair derive from Hellenistic and Antonine heads in the Vatican and Borghese collections.

The theme of sacred transference from Troy to Rome prefigures the subsequent succession of Roman piety by Christianity, a favorite theme of Renaissance humanists that here provided poetic justification for the cardinal's gallery of pagan masterpieces. As the mythical ancestor of the Latin race, Aeneas was considered the father not only of imperial Rome but also, by extension, of its papal successor. While the precise identification of Scipione with Aeneas, as one scholar has proposed, seems farfetched (his aged uncle Paul V would hardly have approved of *his* implicit identification with Anchises), the emphasis on familial devotion may indeed connote the cardinal's well-founded gratitude for his adoption as papal nephew.[10] Ascanius' lamp suggests the familiar emblem of Christian charity while it further illuminates Bernini's fidelity to Virgil: "We journey through dark places," Aeneas recounts, "and I . . . am terrified by all the breezes, startled by every sound, in fear for son and father." Bernini conveyed that fear through the varying expressions as Aeneas "peers through the shades" and Ascanius follows "with uneven steps." Raphael had introduced a similar configuration in his *Fire in the Borgo* fresco in the Vatican Stanze, which was adapted by engravers to illustrate the Virgilian flight; a more proximate example was Barocci's *Flight from Troy* in Borghese's own gallery. Bernini was less pedantic than his predecessors: he shows neither Ascanius holding Aeneas' right hand nor Anchises being carried, piggy-back, over the neck and shoulder. Yet no artist before Bernini had so effectively translated into visual form the poet's description of psychological yet heroic apprehension. The terrors may be imagined by the viewer who confronts this calculatedly unstable grouping: a spiral ascent from infancy to manhood to venerable decrepitude. The extraordinary contrasts of skin textures, the variegated effects of age on flesh and bone and sinew, reveal Gianlorenzo's uncanny ability to manipulate stone as if it were dough. This marble metamorphosis of the three ages of man marks the threshold of his professional maturity.

NEPTUNE AND TRITON

c. 1620–21
Marble, height 71¾" (182.2 cm)
Victoria and Albert Museum, London

The English painter and academician Sir Joshua Reynolds, upon acquiring this piece in 1786, wrote, "I have made a great purchase . . . reckoned Bernini's greatest work. It will cost me about 700 guineas before I get possession of it. I buy it upon speculation and hope to be able to sell it for a thousand." After five years the price was raised to 1500 guineas. But in the end, Sir Joshua's executors had to sell it at a loss—for 500 guineas. After a century and a half of English winters in Lord Yarborough's garden, it finally found shelter in 1950 in the Victoria and Albert Museum.[11]

Bernini's first fountain sculpture was commissioned about 1620 by the old papal nephew of Sixtus V, Cardinal Alessandro Peretti-Montalto, to complete the decoration of the fountain and fish pond designed by Domenico Fontana for his late uncle's Villa Montalto. It was probably finished and in place by 1621, two years before the cardinal's death. Opinion as to the precise subject of this aquatic mythology has fluctuated among scholars. Baldinucci misidentified Neptune's companion as the fisher Glaucus. Sir Joshua, correctly recognizing Neptune's supportive son Triton (with conch shell), associated the pair with the famous "Quos Ego" from Virgil's *Aeneid* (I, 190–220), when the wrathful lord of the seas stills the winds and waves to allow the passage of Aeneas' ships to Rome. Modern scholars have counterproposed two episodes in Ovid's account of the Great Flood: the moment when Neptune strikes the earth with his trident in order to unleash the waters and drown mankind (*Metamorphoses I*, 283–84), or alternatively, its conclusion as he sets aside his trident and bids Triton to sound his conch to signal the ebbing of the flood (I, 330ff.).[12]

Both reinterpretations are belied by Bernini's iconography. Since Neptune stands on a shell (chariot motif) gliding on the water from which his son emerges, the moment can hardly be *pre*-Flood; yet the fury with which he thrusts his trident defies Ovid's description of "laying it aside." Neptune's hair and drapery both evoke a raging storm, which artfully sweeps the billowing folds into the shape of a dolphin. Bernini has clearly distilled the more popular Virgilian episode into an image of the god's absolute dominion over the tumultuous waters—a fitting symbol to crown a papal garden that at every turn proclaims the taming of nature. As in all his subsequent fountains, Bernini transmuted his narrative source into an allegorical emblem with personal, even dynastic, reverberations. Here it recalls both the Montalto pope's construction of new Roman aqueducts and his ruthless—though no less beneficial—reestablishment of order by quashing anarchy and banditry in the papal city. Virgil compares Neptune's effect on the waters to a "rebellious rabble" becalmed by "a man remarkable for righteousness and service" who "controls their passion by his words and cools their spirits." This imagery, an appropriate epitaph for the papacy that had laid the foundations for Baroque Rome, was equally suited to the civilizing aspect of a humanist's garden.

Bernini here varied the father-and-son configuration of his recently completed *Aeneas* (plate 6) by inverting the generational and gravitational emphasis. While the son again provides a sculptural support for the father, who here rises above Triton's neck and shoulders, the virility and power have shifted upward. Neptune's stance, with one arm reaching across the muscular torso, is the mirror image of Aeneas'. Bernini's visual sources included not only Florentine fountains of Neptune, such as Stoldo Lorenzi's in the Boboli Gardens, but also prints after Polidoro da Caravaggio's lost *sgraffiti* of Neptune in the Quirinal Palace, which were soon to contribute to Bernini's *Pluto* (plate 8).[13] Forging a link between the first two Borghese sculptures, Neptune takes a giant stride forward from the residual Mannerism of the *Aeneas, Anchises, and Ascanius* to the arresting, High Baroque frontality of the *Pluto and Proserpina*. Though Sir Joshua's investment proved unprofitable, his aesthetic instinct here hit the mark.

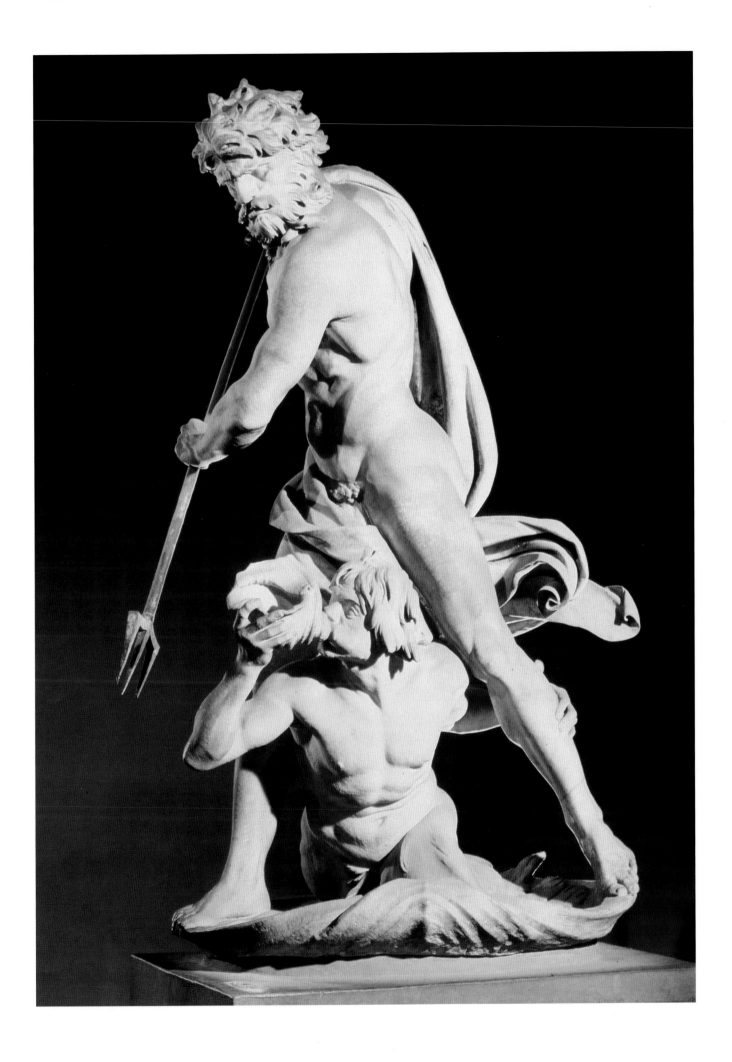

PLUTO AND PROSERPINA

1621–22
Marble, height 100⅜" (2.55 m)
Galleria Borghese, Rome

Bernini's second mythological group for Scipione Borghese was begun after the cardinal-nephew's fall from power in February 1621 and his replacement at the papal court by Cardinal Ludovisi. The initial payment was made in June 1621; the sculpture was finished the following summer. In Ovid's *Metamorphoses* (V, 385ff.) Ceres' daughter Proserpina, goddess of spring, was trying to gather more flowers than any of her companions when "Pluto saw her and loved her and bore her off—so swift is love." In his High Baroque interpretation of this "divine rape," Bernini illustrates not the usual episode of sudden abduction—there is no sign of Pluto's chariot or the scattered flowers—but the climax of Proserpina's crossing the border into Hades, guarded by the three-headed Cerberus and delineated by the pitchfork at Pluto's feet. The sculpture itself transgresses the boundaries of stone.

Bernini's impassioned choreography incorporates a virtual compendium of sources, both Renaissance and Hellenistic. His initial preparatory drawing—his earliest known "first thoughts" for a sculpture—represents a variation on Giambologna's bronze *Hercules and Antaeus* (Institute of Art, Chicago).[14] Refining the configuration, he characteristically substituted psychological tension in place of a purely physical struggle—in Domenico's words, an "admirable *contrapposto* of tenderness and cruelty." Proserpina's outflung gesture is a quotation from Giambologna's more famous *Rape of the Sabines* (fig. 12). Pluto, like his predecessor Neptune (plate 7), reflects prints after Polidoro da Caravaggio and such antiquities as the Capitoline *Hercules and Hydra*, excavated a year earlier (1620), the *Laocoön* (fig. 5), and the *Torso Belvedere*.[15] But the primary influence on Bernini's pictorial treatment, the lens through which he viewed classical antiquity, was the Farnese ceiling. Carracci's "sculptured" *atlantes* (fig. 2), his revision of an antique mastiff into Paris' dog, and the juxtaposition of

Glaucus and Scylla, another divine rape—all these Bernini transposed from the painter's colorful contrast of male and female bodies into tactile persuasiveness. The indentation of Pluto's fingers pressing Proserpina's thigh additionally conjures up Rubens's *Rape of the Daughters of Leucippus* (Alte Pinakothek, Munich) in its ordering of skin tones, musculature, textures, and sensuous flesh.[16] The pathos of Proserpina's silent cry and tear-stained face pays tribute also to Guido Reni, as it evokes the ancient Niobes. The arresting effect was originally enhanced by its placement against the wall, as if a painting had emerged through high relief and into the round. Bernini has finally discarded all traces of the Mannerist *figura serpentinata* (fig. 12; plate 5) in his exploitation of a dramatic, dominant viewpoint that anticipates his final Borghese sculptures (plates 10, 11).

Proserpina's abduction was found on Roman sarcophagi as an allusion to the soul's abrupt transport at death. Beyond its sensual, surface delights, Bernini's marble may embody a similar *concetto*. Its original base featured moralizing verses by Cardinal Barberini: "Oh, you who, bending, pick the flowers of the earth, heed the one who was carried to the dwelling of the wild Pluto." While to modern eyes the cleric's gloss may appear alien to the lusty physicality of the piece, seventeenth-century viewers—especially Roman cardinals—delighted in such provocative juxtapositions: a visual feast that provided food for thought. Soon after its completion Borghese presented it to his rival, Cardinal Ludovisi, who was also an insatiable collector of antiquity. If Borghese secretly enjoyed the irony of his gift of a rapacious *memento mori*, it was not at the sculptor's expense, for Ludovisi rewarded Bernini "no less generously than if it had been made expressly for him."[17] Nor was it to be at Borghese's. Within a few months the Ludovisi pope would be dead and succeeded by Scipione's poetic colleague, Maffeo Barberini.

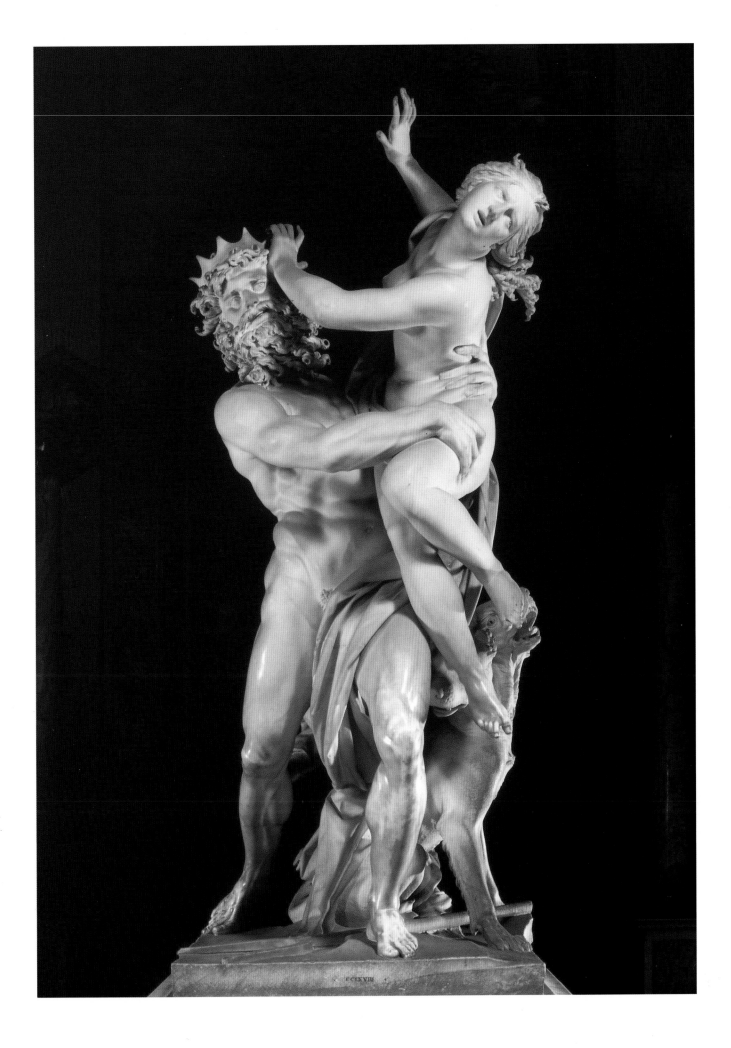

BUST OF PEDRO DE FOIX MONTOYA

1622–23
Marble, life-size
Santa Maria di Monserrato, Rome

Bernini's papal busts of Gregory XV (fig. 13) earned the young sculptor a knighthood at the ripe age of twenty-two. The virtuoso portraits carved during Ludovisi's pontificate (1621–23) show a series of variations on themes struck a decade earlier in the Coppola and Santoni busts (fig. 6; plate 1). Their vivid naturalism transcends the monochrome medium. To Bernini the chief challenge was to create the impression of color—indeed, of life itself—through pale stone. "If someone whitened his hair," he explained years later, "his beard, his eyebrows, his lips, and, if it were possible, the pupils of his eyes, and showed himself in this state to those who were accustomed to see him every day, they would have difficulty in recognizing him." When a man faints, he added, "the pallor that spreads across his face makes him almost unrecognizable, and it is often said, 'He doesn't look like himself.'"[18] No such charge could be leveled against his bust of the Spanish cleric and jurist Pedro de Foix Montoya, which was commissioned in late 1622 for his tomb in the church of San Giacomo degli Spagnoli, from which it was transferred in the late nineteenth century to the refectory of Santa Maria di Monserrato.[19] At Montoya's death in 1630 the tomb—designed by Orazio Turriani—was still under construction, but the bust, perhaps still in Bernini's studio, had long been finished: according to both Domenico and Baldinucci, *Cardinal* Barberini had admired it—that is, before August 1623, when he became Pope Urban VIII.

Though he was not the author of the architectural setting, Bernini clearly designed his bust in view of its intended frame, from which it gracefully emerges—a refinement of the device he had introduced in the Santoni epitaph. Not only does the sweeping curve of the *mantelletta* camouflage the truncation, it effectively ties the bust to the tomb with the bow of Montoya's sash overlapping the marble pedestal. This clever sculptural flourish prompts the viewer to complete, in the mind's eye, the rest of the deceased's body behind the oval oculus. In exploiting the dramatic effects of chiaroscuro, Bernini achieved the optical equivalent of hues. "In order to imitate nature," he noted, "it may be necessary to add that which is not there. . . . Sometimes in a marble portrait in order to represent the dark which some people have around their eyes, one must hollow out the marble and in this way obtain the effect of color."[20] The phenomenal contrasts of textures and surfaces are especially evident in the hollowed cheeks, the thick, bushy moustache and trimmed beard, the furrows of the forehead, and the crow's-feet at the eyes. In place of Paul V's blank eyeballs emulating ancient statues (fig. 10), Montoya—like his current pope, Gregory XV (fig. 13)—is given sharply drilled irises that penetrate the viewer's space.

For his definitive "speaking portraits" of Cardinal Borghese (plate 19) and Louis XIV (plate 33), Bernini sketched his princely subjects as they casually moved about and engaged in conversation. "To be successful in a portrait," he later claimed, "a movement must be chosen and then followed through. The best moment for the mouth is just before or just after speaking."[21] Unlike Gregory's, Montoya's lips, overshadowed by the moustache, are not shown parted; yet the immediacy of his expression is fully communicative: the effigy speaks through its eyes, the "windows of the soul." At its unveiling, Baldinucci records, the bust was considered so lifelike that an admiring cardinal exclaimed, "It is Montoya petrified!" At this moment Montoya himself entered the room, whereupon Cardinal Barberini reportedly went up to him and announced, "This is the portrait of Monsignor Montoya," then turned to the marble: "*This* is Montoya."[22] Like its mythological counterparts (plates 8, 10) undertaken during the brief pontificate of Gregory XV, Bernini's noble bust reveals at first glance the peerless technique of the new *cavaliere*.

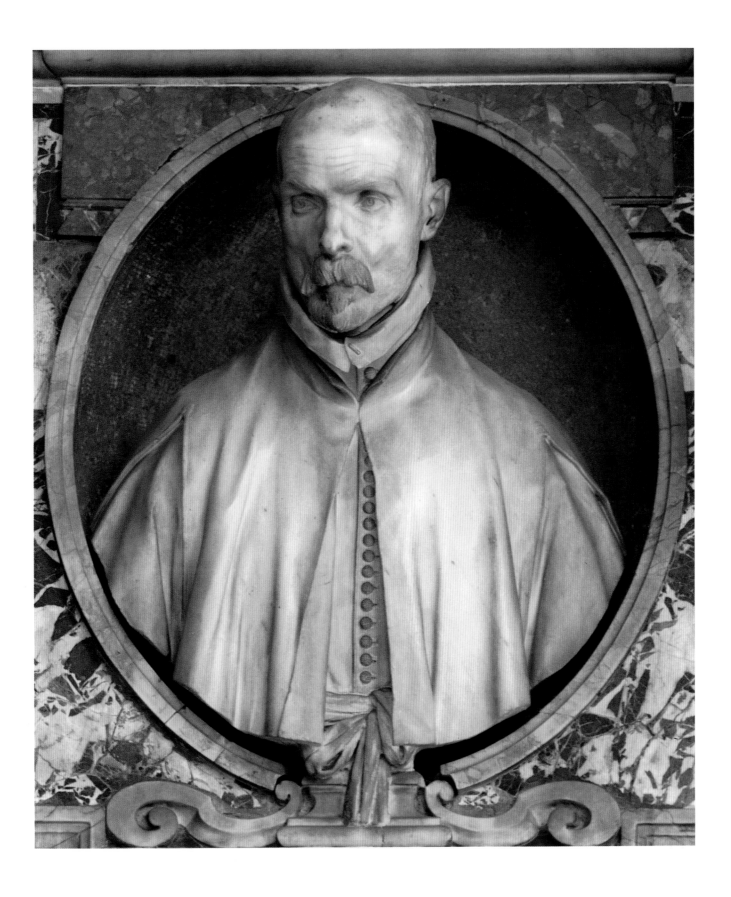

APOLLO AND DAPHNE

1622–25
Marble, height 95⅝″ (2.43 m)
Galleria Borghese, Rome

The second Ovidian masterpiece Bernini created for Cardinal Borghese offered, for the first time in monumental, freestanding sculpture, a literal metamorphosis—Daphne's transition from flesh into laurel. Begun in 1622, shortly after the completion of the *Pluto and Proserpina* (plate 8), work was suspended for a year (1623–24) while Bernini carved his *David* (plate 11). The group was completed in 1625.

Daphne was Phoebus Apollo's first love—"not through blind chance, but Cupid's savage spite," Ovid explains (*Metamorphoses* I, 453ff.). In revenge for Apollo's taunts, Cupid demonstrated his fateful marksmanship by firing two arrows: the first, sharp and gold-tipped, which incites love, struck Apollo; the second, blunt and lead-tipped, wounded Daphne and precipitated the course of unrequited love. The woodland nymph fled "swifter than the wind's breath." About to be overcome by the smitten sun god, she cried out to her father, the river god Peneus: "Change and destroy this body which has given too much delight." At once "her limbs grew numb and heavy, her soft breasts were enclosed in delicate bark, her hair was leaves, her arms were branches, her speedy feet rooted and held, and her head became a treetop. Everything was gone except her grace, her shining." Apollo claimed the laurel as his sacred sign, the leaves of which thereafter crowned none but poets and victors.

Before Bernini, only painters had dared tackle these verses. Adapting the *Apollo Belvedere,* he brought the Hellenistic statue to life, transposing its static bow-wielding Apollo *alexikakos* ("warder-off of evil") into both the victim of Cupid's bow and the personification of divine pursuit. This revision epitomizes Bernini's quintessentially Baroque treatment of his classical models.[23] Like Rubens, he used them as springboards for his soaring variations on ancient themes. Daphne's frozen cry—like Proserpina's, a petrified echo of a Guido Reni protagonist—evokes the transience of the climactic

moment as the hard marble yields to branches, bark, roots, and laurel leaves. Perhaps it was for carving these vegetal details that Bernini made use of his new assistant Giuliano Finelli, whose forte was painstaking drill-work.[24] Yet every essential aspect, from the initial conception to the final polish, confirms the master's vision and virtuosity—a display unsurpassed in the history of sculpture. We may ponder which metamorphosis was the more miraculous, the god's or the sculptor's.

Originally, Bernini controlled the viewer's experience of his most pictorial creation to date by placing the marble against a wall, opposite his *Aeneas, Anchises, and Ascanius* (plate 6). Its relocation at the center of the room permits present-day visitors to move freely around it, but with an uneasy sense of having wandered backstage during a captivating performance. Initially, upon entering the room, one approached the sculpture from behind, seeing only Apollo's backside, which resembled Carracci's fleeing Acis (fig. 2).[25] Gradually the object of the chase came into sight. Yet this sequential revelation in no way undermined Bernini's exploitation of a single dominant view. Quite the opposite: its purpose was to intensify the impact when one finally confronts the ensemble face-on.

As he had done for the *Pluto and Proserpina,* Cardinal Barberini composed verses to inscribe on the base—this time as a poetic "cure" for Cardinal de Sourdis's misgivings about such an erotic display in a cardinal's villa: "Whoever in love pursues the delights of a fleeting form fills his hand with leaves and plucks bitter berries." Yet in hindsight Barberini's Latin admonition against the pursuit of ephemeral beauty underscores Bernini's sensual achievement: the tactile delights of the transfigured marble are far from fleeting. By the time of its completion, moreover, the moralizing poet had been crowned—not with Apollo's laurel but with a papal tiara.

64

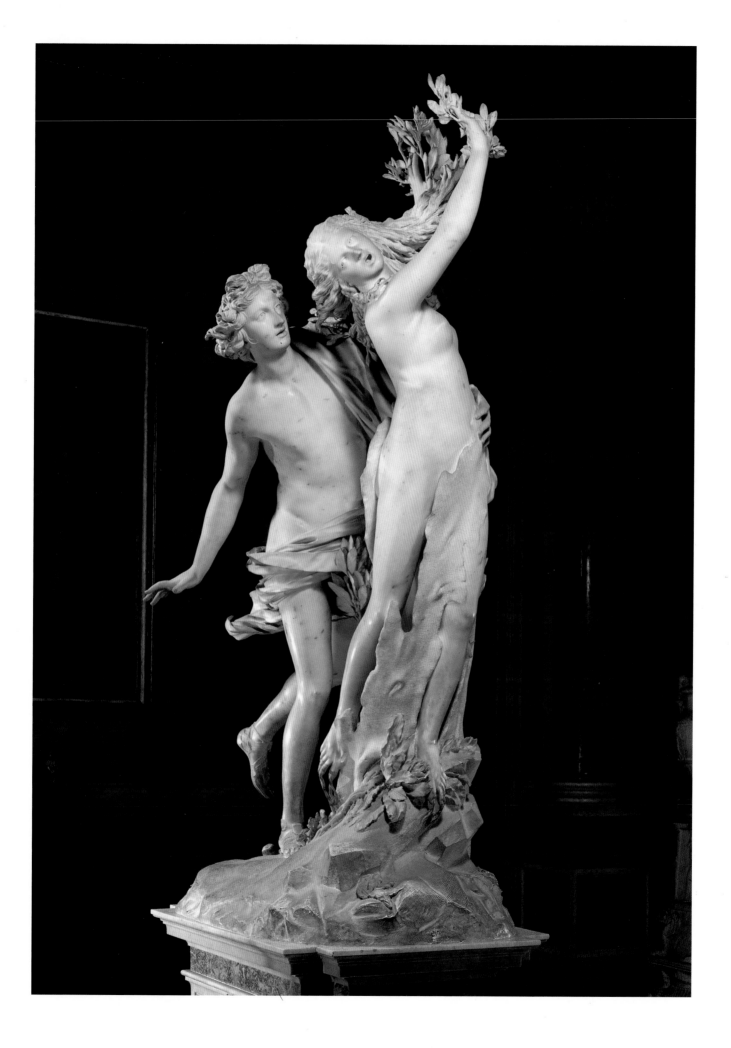

COLORPLATE 11

DAVID

1623–24
Marble, height 67" (170 cm)
Galleria Borghese, Rome

Bernini's fourth and final life-size sculpture for Cardinal Borghese illustrates his own metamorphosis of an iconic Renaissance tradition into a Baroque assault on the senses. Its literary source was biblical, not Greco-Roman—a vital injection of Old Testament virtue into the cardinal's pagan pantheon. Bernini received his first payment for the sculpture in July 1623; by January 1624 the stone mason was paid for the pedestal. According to Baldinucci, it was finished in seven months.

This David is thoroughly liberated from its Renaissance forebears. Bernini emulated neither Donatello's triumphant boy victor (Bargello, Florence) nor Michelangelo's posturing adolescent (Accademia, Florence). His hero is full-grown and fully engaged—both physically and psychologically—as he takes aim and twists his tensed, muscular body a split second before slinging the stone, grasped in his left hand. The Olympic stance evokes two ancient masterpieces: Bernini has reinterpreted Myron's classically balanced and static *Discobolos* in the light of the *Borghese Warrior,* which stood nearby in the cardinal's gallery. Once again Carracci provided the catalyst for this Baroque reformulation. The *contrapposto* of David's tense, wound-up body about to spring loose was derived from the Farnese ceiling, where the cyclops Polyphemus prepares to hurl a rock at the doomed youth Acis (fig. 2). Bernini adapted the pose of Annibale's giant (who was also a shepherd, with goatskin pouch slung over his shoulder) in an ingenious reversal of roles: it is a giant that Bernini's youth will kill with a stone.

Unlike the preceding Borghese ensembles (plates 6, 8, 10) David stands alone, a solitary statue. But Goliath is implicitly envisioned directly behind the viewer, whom Bernini for the first time engages in the denouement. The statue penetrates—and psychologically "charges"—our own space: we are tempted to duck. It is the *anticipation* of violent action that heightens this confrontation as David's latent power is momentarily arrested. His pursed lips, knitted brows, and the "terrible fixity" in his eyes express both the biblical text (1 Sam. 17) and Bernini's own features. As in preparing the *St. Lawrence* (fig. 8) and the *Damned Soul* (fig. 11), he again posed before a mirror, this time to imitate and reflect in marble "the rightful wrath of the young Israelite."

The mirror was held by none other than Cardinal Barberini, soon to become pope, in emulation of such princely patrons as Alexander the Great and the Emperor Charles V. Perhaps the poetic footnote, David's lyre (symbol of the author of the Psalms), was prompted by the cardinal-poet to whom the association of literary creation with spiritual heroism was habitual.[26] Bernini later included the lyre beside David wrestling a lion in his illustrated title page for Barberini's poems (fig. 23). Yet Bernini's final narrative sculpture for the cardinal's villa required no inscribed verses; the lyre tactfully features its *patron's* emblem, the Borghese eagle, which, before the modern additions to the base, extended beyond the plinth and into the viewer's realm. Also at David's feet, Saul's discarded cuirass provided a symbolic sculptural underpinning—like Neptune's Triton (plate 7) or Pluto's Cerberus (plate 8).

According to the Jesuit theologian Robert Bellarmine, David personified both the ideal ruler and the totality of the virtues—justice, mercy, piety, love, service, and suffering.[27] As a prefiguration of the Church Triumphant, victorious over her enemies, the biblical hero offered an especially potent emblem for the former papal nephew, whose uncle's reign affirmed the restoration of the Church's spiritual and temporal authority after the battles of the Reformation. In its embodiment of confidence and resolve, Bernini's *David* is also an anticipation of future conquests by the young *cavaliere.* A milestone in the development of psychological and spatial power released through his chisel, it is a revealing self-portrait.

66

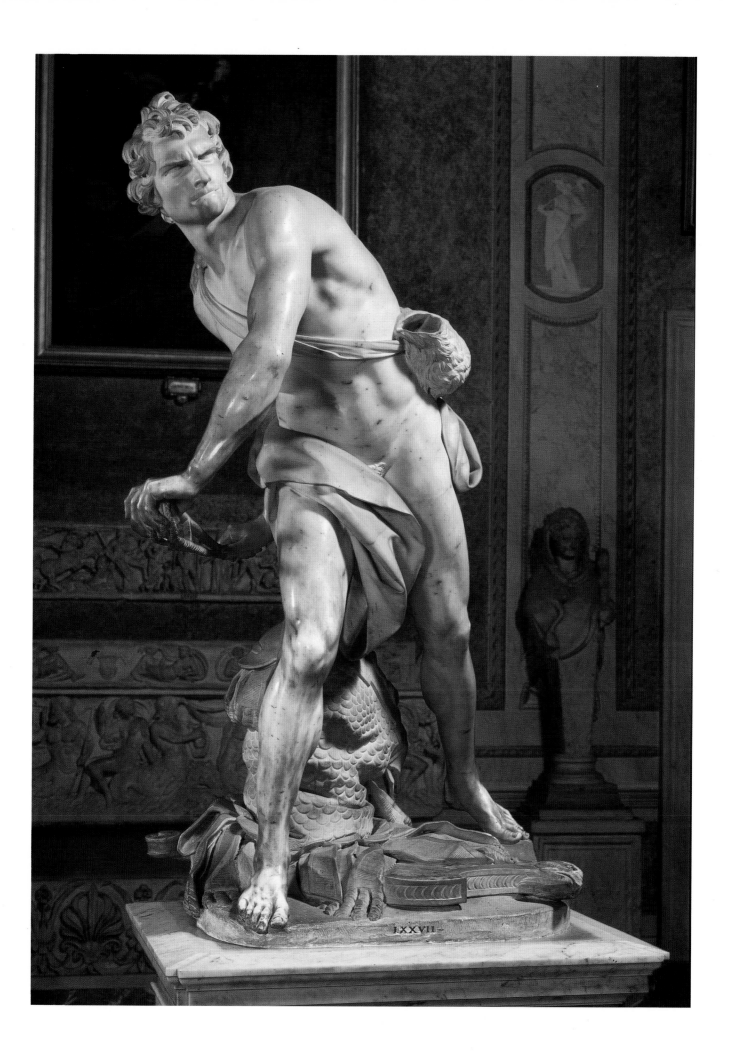

ST. BIBIANA

1624–26
Marble, height 7′10½″ (2.4 m)
Santa Bibiana, Rome

The first of Bernini's papal commissions combining architecture and religious sculpture was for a modest basilica dedicated to the Early Christian virgin and martyr Bibiana (Vivian), whose body was unearthed in March 1624 during some minor renovations by workmen who had noticed "a very great fragrance and odor" in the middle of the altar.[28] In July, Pope Urban came to venerate the relics, and the next month he commissioned Bernini to redesign the facade and interior and to carve a statue of Bibiana for the new altar. The celebration of Early Christian saints in art and architecture underscored the Counter-Reformation thesis that the historical primacy of the Roman Catholic Church was grounded—both spiritually and literally—in the sacrifices of the ancient Christian martyrs.

If the facade (fig. 14)—Bernini's first architectural effort—amounted to a variation on Maderno's for Saint Peter's, his treatment of the sanctuary was a vertical (and spiritualized) transposition of the sculpturally defined space of the *David* (plate 11). St. Bibiana is commemorated not "in the odor of sanctity," a marble corpse to be venerated like Stefano Maderno's *St. Cecilia* (Santa Cecilia in Trastevere, Rome), but at the emotionally heightened moment before her martyrdom. Leaning on the column to which she will be tied and executed with lead-tipped thongs, she raises her right hand and face heavenward in ecstatic anticipation of her divine consummation. (In her left hand is the martyr's palm of victory.) Her ethereal pallor is juxtaposed with the dark, scalloped niche.

Bibiana's beatific expression, an adaptation of both the early *St. Lawrence* (fig. 8) and *Blessed Soul* (fig. 11), finds its sublime source in Guido Reni's saints with upturned eyes—a leitmotif of Baroque altarpieces. But her serene acceptance of death is clothed with the passion of a fervent soul. Her body engulfed and dematerialized by the tumultuous folds of her dress, only

her raised right leg and glimpses of her classically sandaled feet suggest the underlying anatomy. Here in his first fully draped figure, Bernini's Baroque treatment of fabric completes the image of sensualized spirituality. Yet this expressive abstraction is rooted in such naturalistic details as the rocky soil at her feet and the leafy plant that springs from it. As with the *Apollo and Daphne* (plate 10), Giuliano Finelli is said to have assisted the young maestro: perhaps his hand (and drill) may be detected in the delicate leaves, the staccato ripples of the sleeves, and the wisps of hair. The chief source for Bibiana's enlivened garments was Rubens's Early Christian martyr *Domitilla* (fig. 30) in the Chiesa Nuova.

Bibiana's drapery anticipates its full-blown development through Bernini's *Longinus* (plate 14), *St. Teresa* (plate 25), *St. Jerome* (fig. 50), and *Ludovica Albertoni* (plate 38). Likewise this initial altarwork foreshadows his subsequent exploration of light and spatial relations. The saint's gesture and gaze are more than pious formulas. Like David's, they are directed through the viewer's space to their object—in this case to a painted God the Father in an "opening" of the sanctuary vault. To the right an illusionistic window is similarly frescoed with music-making angels. At the upper left a deeply recessed (semiconcealed) *actual* window supplies the natural light that Bernini channels into the symbolic medium of divine illumination: the intrusion of the metaphysical into the viewer's surroundings, the sculptor's realization of Caravaggio's chiaroscuro in three dimensions.

By the time the statue was completed and unveiled in 1626, Bernini had undertaken a far more ambitious commission to mark the burial place of a Christian martyr: the *Baldacchino* erected over the tomb of St. Peter. In hindsight *St. Bibiana* appears diminutive. She is, in fact, a life-size statue—his last. Thereafter Bernini's religious sculptures exceeded the human scale.

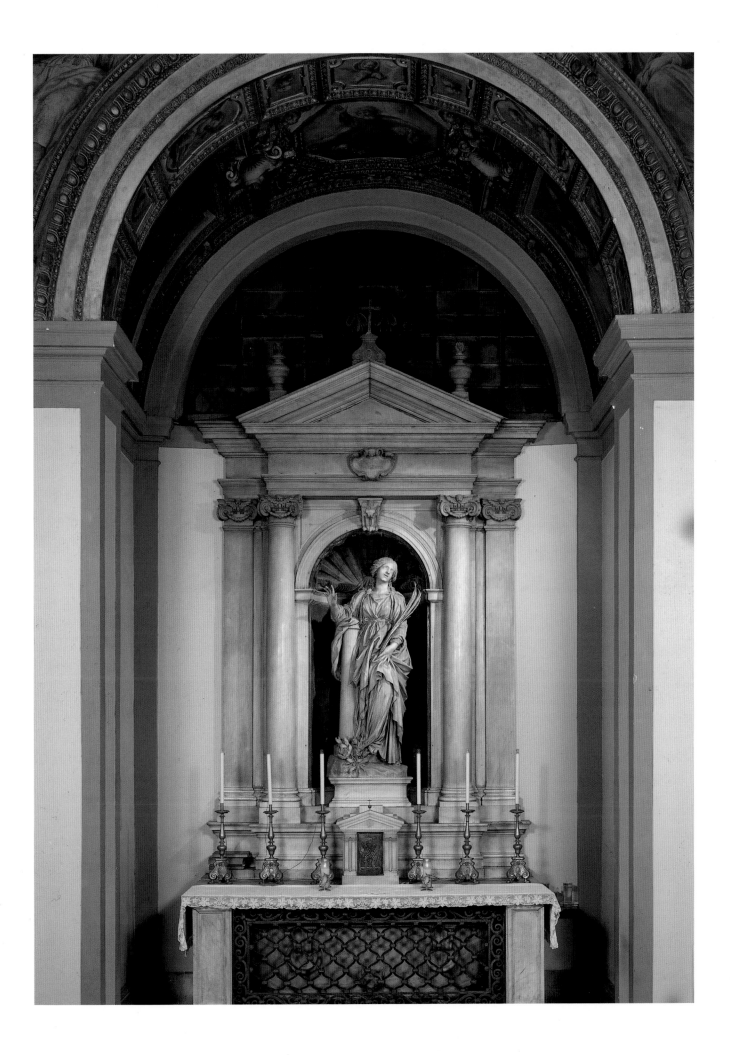

BALDACCHINO

1624–33
Bronze on marble pedestals, height c. 93'6" (28.5 m)
Saint Peter's, Rome

Bernini's commissions at Saint Peter's spanned half a century. The first was to erect a towering landmark over Rome's most sacred shrine: the tomb of the apostle Peter beneath the papal high altar. In the original fourth-century church, both tomb and altar were enshrined in a ciborium of Solomonic columns, so-called because of their legendary importation by the emperor Constantine from the ruins of Solomon's Temple in Jerusalem, where they had adorned the Holy of Holies, or Tabernacle of the Most High. Bernini's chief task was to design a liturgical, commemorative structure that would neither be dwarfed by the colossal proportions of the new basilica nor be nullified by the vast void under Michelangelo's dome. His inspired solution was to fuse architecture and sculpture in a revolutionary manner, to create a hybrid out of a traditional (permanent) columned ciborium and a festive (ephemeral) baldachin of gold cloth.[29]

To achieve the necessary scale Bernini imitated and greatly magnified in bronze the marble Solomonic columns. The dark metal, highlighted with gilt, provided a colorful contrast to the cool whites of the surrounding marble walls, which he later embellished with eight of the original Constantinian columns (fig. 19). Work began in the summer of 1624; at the canonization of Elizabeth of Portugal in 1625, for which Bernini designed the ceremonial backdrops, a full-scale wooden model was already in place. Originally the columns were to be crowned by a huge bronze Risen Christ (fig. 15). This enlargement of a motif from sacrament tabernacles became the central figure of Bernini's *concetto,* or symbolic program, for the crossing of Saint Peter's: a tripartite drama arising from Christ's sacrifice on the altar (crucifix), through his resurrection (statue), and culminating in his heavenly enthronement as judge (dome mosaic). But because of its insupportable weight, the statue was ultimately replaced by a cross and globe symbolizing Christ's universal victory. Through the evocative power of his symbolic architecture Bernini transferred Jerusalem—the site of both the Jewish Temple and Christian salvation—to Rome.

According to a memorandum of 1627, Bernini "worked continuously with his own hands for three years . . . in sunshine and in rain," supervising the casting at the furnaces "with great risk to his own life."[30] Among his collaborators was Maderno's young assistant Francesco Borromini, who doubtless contributed his engineering prowess to Bernini's triple scroll-like volutes connecting each of the columns with the crown. These High Baroque flourishes evoke the sensation of soaring up into the dome. This climactic fusion of sculptural architecture is also a triumph of illusion: necessarily lightweight, both the volutes and canopy are made of wood thinly plated to appear as solid as the bronze columns and the four angels who miraculously suspend it from garlands. The entire structure rises as high as the Palazzo Farnese, or a modern eight-story building. Among the papal sources of bronze was the portico of the Pantheon, a looting that occasioned the famous pasquinade comparing the Barberini to barbarians.

One of the largest items of expense—twice the cost of gold for the gilding—was the vast quantities of beeswax needed for the casting. Urban must have enjoyed the irony in this purely functional item, for the columns themselves had been redesigned and adorned with Barberini bees and suns; even the eucharistic vines of the ancient originals were replaced by laurel branches to honor the poet-pope. From top to bottom—from the four huge bronze bees around the globe to the eight Barberini escutcheons at the base of the columns—the *Baldacchino* proclaims the glory of Peter's Baroque successor. Of all Urban's commissions none so epitomized the aspirations of his reign as this dynamically soaring tower of energy, a bronze emblem of papal power that seemingly triumphs over the laws of nature and suspends gravity. It was unveiled on June 29, 1633—a week after Galileo had been silenced.

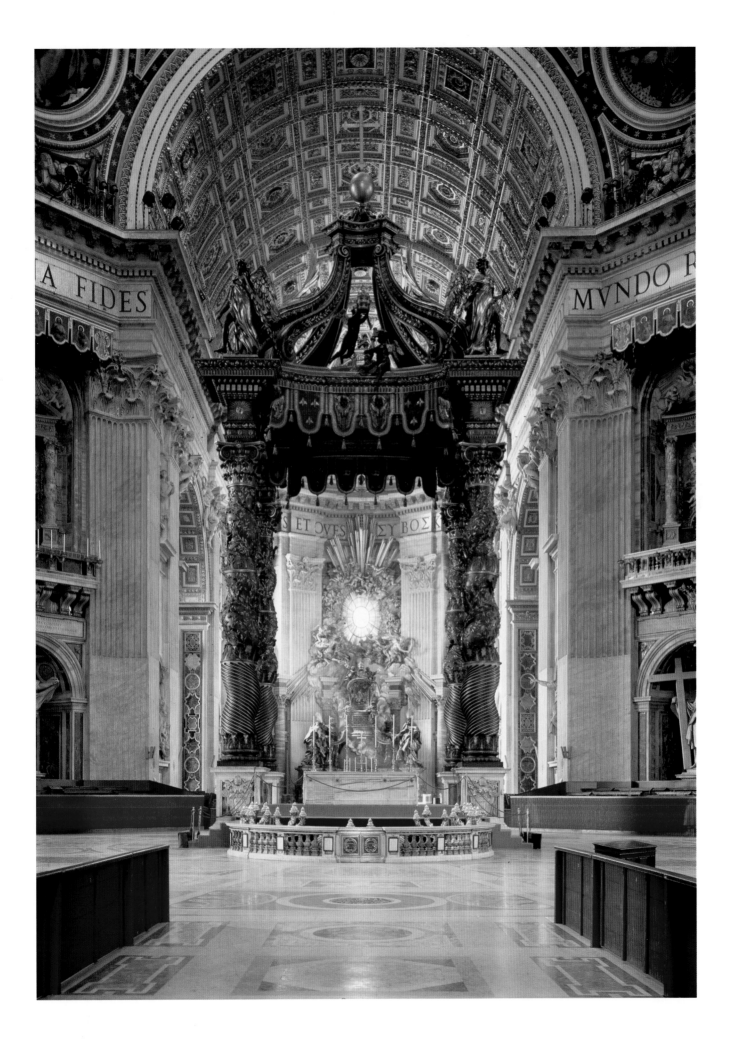

ST. LONGINUS

1629–38
Marble, height 14'6" (4.4 m)
Saint Peter's, Rome

In 1627, with the casting of the *Baldacchino* well under way, Pope Urban decided to add to Bernini's commission the decoration of the four surrounding piers. Colossal statues of saints were wanted to monumentalize their respective relics. Bernini supplied preliminary models. Only the *Longinus* was his own creation from start to finish: *Andrew* (fig. 16), *Veronica* (fig. 17), and *Helen* were carved by his collaborators Duquesnoy, Mochi, and Bolgi, respectively. Originally, the diagonally paired saints were designed to react contrapuntally to the drama incorporated in the first design for the *Baldacchino,* the two women directing the viewer to the sacrifice on Calvary (altar) while the men looked upward to the Risen Christ (fig. 15). Though he had to replace that statue with a cross and globe, Bernini nonetheless retained a dramatic unity by reinterpreting the saints' gestures as varying responses to the Crucifixion and by redefining the spatial crossing of Saint Peter's as the New Calvary.[31]

The Roman centurion Longinus, having pierced the crucified Christ with his lance, stands bareheaded, his plumed helmet at his feet. At the moment of his conversion he looks up to the cross and confesses: "Truly this man was the Son of God." Enshrined beneath a concave relief illustrating his airborne relic (fig. 19), he looms almost three times life-size. Between 1629 and 1631, when a full-scale stucco model was finally set in place for inspection, Bernini developed his emerging conception of this extroverted convert through a series of *bozzetti,* malleable clay sketches that he worked up with amazing speed: the German historian Joachim von Sandrart recalled seeing *twenty-two* of them in Bernini's studio. A comparison between the final marble and the sole surviving *bozzetto* (fig. 18) reveals Bernini's typical progression from an initial classical formulation. Carved between 1635 and 1638, the definitive marble conveys an impassioned, High Baroque appeal to the senses. Longinus throws out his arms in imitation of the cross at which he gazes; the stance recalls the telling gestures of Caravaggio's saints at the moment of divine revelation.[32]

This statue is composed of no fewer than four blocks of marble, an assemblage that Michelangelo would have condemned as the work of a cobbler, not a sculptor; he believed that a sculpture should remain true to the original block of stone from which the figure has been "liberated"; it should be able to roll downhill undamaged. No principle could be further from Bernini's Baroque vision: Longinus's fully extended gesture thrusts into the viewer's realm—like the confrontational *David* (plate 11). On the magnified scale of Saint Peter's, Bernini adapted his technique to exploit the natural effects of raking light against the marble. He left it roughed by grooved strokes of the chisel in order to simulate varying textures of skin and fabric when viewed from a distance—the blurred, shimmering surfaces that a painter achieves with broken brushstrokes. As in his *St. Bibiana* (plate 12), he conveyed the internal reverberations of the soul by drapery that engulfs the saint's classical body in a most unclassical, indeed supernatural fashion.

When, contrary to their creator's intentions, the statues were rearranged—*Longinus* being transferred to the northeast pier—both the diagonal pairings and Bernini's conceptual unity were compromised. Even so he succeeded in transforming, both aesthetically and iconographically, the crossing into the spiritual center of Saint Peter's—the first of Bernini's sacred spaces that, coordinating sculpture and architecture, embrace the viewer.

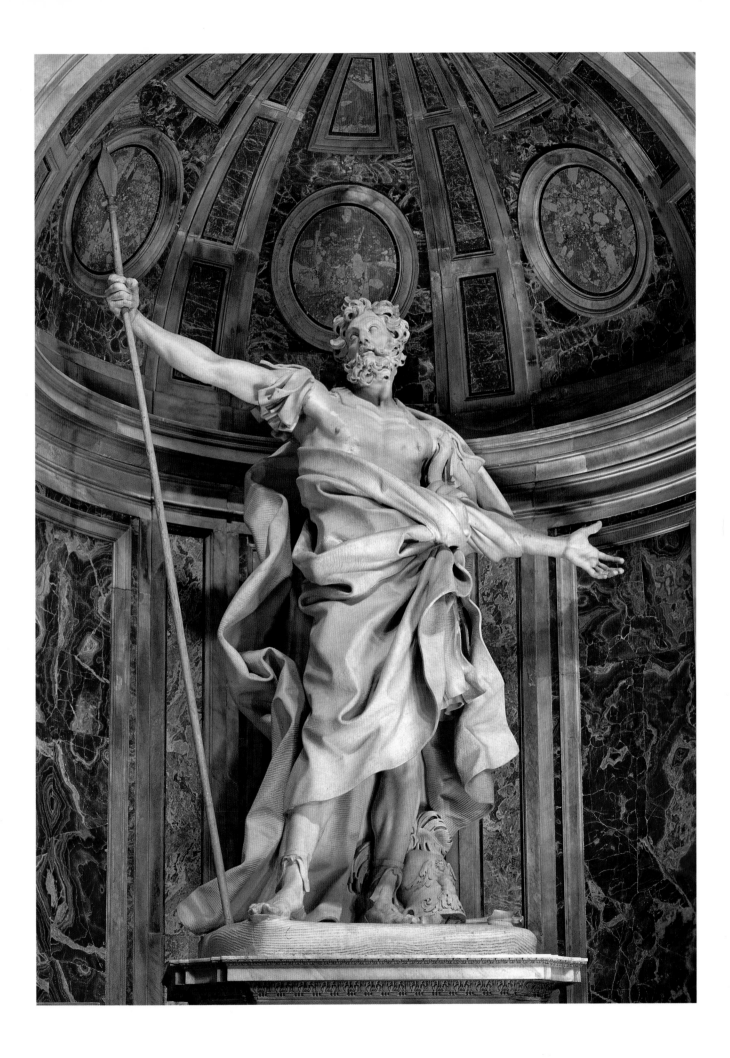

BARCACCIA

1627–29

Travertine

Piazza di Spagna, Rome

Rome is a city of Baroque and neo-Baroque fountains. Their fantastic confluence of sculpture, architecture, allegory, and water may be traced to Bernini. His first fountain, the *Barcaccia*—or "Old Boat"—in the Piazza di Spagna, was, like the *Baldacchino,* a hybrid. It converted an engineering necessity into an allegorical virtue. The low pressure of the Acqua Vergine limited the potential height of the water spouts so that, as Baldinucci explains, "any effect of richness or magnificence would be difficult to achieve." Into a graceful oval basin constructed in 1626 under his father's aegis, Gianlorenzo introduced his broad and low *Barcaccia,* which supplies both fountain and intermediate basins. From its several spouts, ranging from two emblematic suns to four cannon, the water gushes forth.

The idea of designing a fountain in the form of a ship dates back to ancient Rome; more immediate precedents were to be found at the Villa d'Este in Tivoli, the Villa Aldobrandini at Frascati, and in the Vatican gardens. Bernini made the motif, a blend of architecture and sculpture, into "some sort of giant fish."[33] Its meaning is proclaimed at each end, for this vessel has *two* bows, each of which is emblazoned with the Barberini papal escutcheon of three large bees, symbols of industriousness and divine providence. From the Barberini suns, which face each other and the central spout, the fresh water of "enlightenment" fills the vessel and overflows into the basin.

The ship was a hallowed symbol of the Church, the "vessel of salvation," equated with St. Matthew's storm-tossed boat with Christ and his apostles on the Sea of Galilee. (The "nave," the area of a church that holds the congregation, derives its name from the Latin *navis,* ship.) At the beginning of Urban's reign a plan was submitted for enshrining St. Peter's tomb and high altar in the form of a large ship, with the papal throne at its helm. Instead, the pope gave St. Peter—and himself—the *Baldacchino* (plate 13), while Bernini adapted that naval *concetto* in his first Urban fountain. The pope was so pleased that he supplied the poetic text: "The papal war machines shoot forth not flames, but waters sweet that quench the fires of war."

Located on the site of the ancient *Naumachiae,* or staged naval battles, outside the Spanish embassy, at the foot of the French church of Trinità dei Monti (fig. 54), and within sight of the Roman missionary headquarters (the Propaganda Fide), this militant fountain signaled Urban's temporal aspirations for the Catholic cause in Europe, together with an early end to the Thirty Years' War. In that arena Urban would prove unsuccessful, though not for lack of effort. The papacy had already been stripped of its diplomatic strength by the rising nation-states. Yet in the spiritual realm he succeeded in steadily pursuing the Church's mission in the turbulent wake of the Reformation.

As a contemporary guidebook explained Giotto's *Navicella* at Saint Peter's: "The ship bobbing on the water is a mystic symbol of the Church, which, though constantly attacked by enemies of the Faith, does not sink." Through similar imagery Bernini's *Barcaccia* confirms the parable. Three centuries of repaving the piazza have further raised the street level, yet the vessel remains afloat, a source of refreshment. In modern times its early misattribution to the elder Bernini has been revived because of documents showing payments to Pietro. But until his death Pietro was the aqueduct's "architect"; before succeeding his father in that post Gianlorenzo served as "secretary." Official payments were made accordingly, but throughout their collaboration there can be no mistaking whose imagination and unity of conception marks the first of Baroque Rome's landmark fountains.

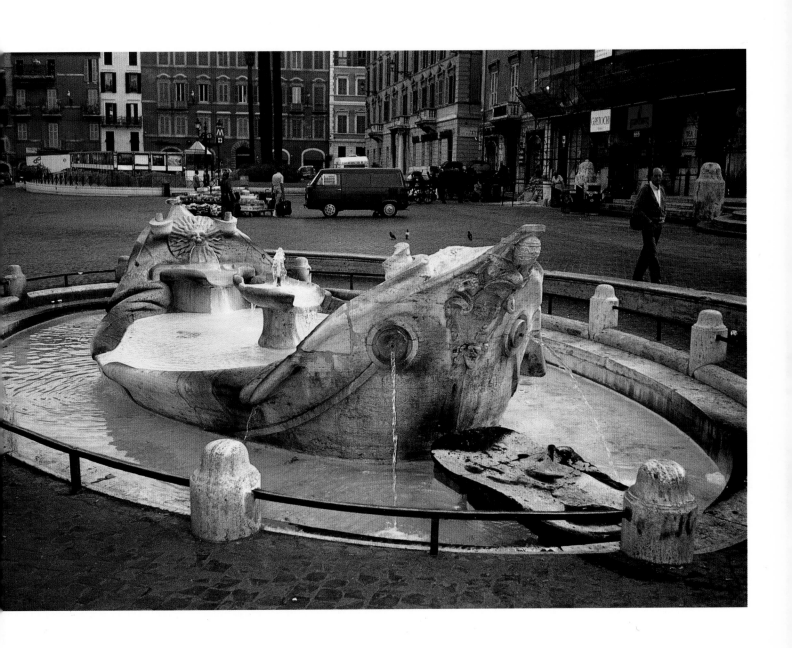

STS. ANDREW AND THOMAS

1627
Oil on canvas, 24¼×30¾" (61.5×78.1 cm)
National Gallery, London

DAVID WITH THE HEAD OF GOLIATH

c. 1630–35
Oil on canvas, 25¾×29⅛" (65.5×74 cm)
Galleria Nazionale (Palazzo Barberini), Rome

Soon after the accession of Pope Urban VIII, who was determined to produce "another Michelangelo," Bernini studied painting under Andrea Sacchi "to gain experience in handling color."[34] Though the primary purpose of this effort was to prepare for his frescoing of the benediction loggia at Saint Peter's, Bernini reportedly painted some 150 to 200 pictures during his career. Of the 10 percent that have come to light, most are small oil studies of heads, or half-length figures.

The tactile, sculptural qualities of Bernini's oil sketches characterize the earliest documented example, *Sts. Andrew and Thomas,* which hangs in the London National Gallery, together with its pendant by Andrea Sacchi, *Sts. Francis and Anthony Abbot.*[35] At the left the old apostle Andrew, whom Christ had called to become a "fisher of men," displays his glistening symbol. Its naturalism suggests the humble genre scenes of Annibale Carracci, from whom Bernini had already drawn far loftier subjects. Pointing to an open folio, perhaps the apocryphal *Acts of Andrew,* Andrew turns to speak to his younger companion, St. Thomas, who holds one of his symbols, a carpenter's square. Bernini charges this *sacra conversazione* with telling gestures and expressions. As a painted parallel to his marble "speaking likenesses," it anticipates both the bust of Scipione Borghese (plate 19) and the sculptured group portraits of the Cornaro family (plate 24), who similarly turn toward each other in holy conversation. The deeply chiseled drapery folds and the pairing of the figures also foreshadow by three decades the bronze church fathers beside the *Cathedra Petri* in Saint Peter's (plate 29). Perhaps even Gianlorenzo's teacher benefited from his pupil, for reflections of Bernini's gravely animated discourse appear in Sacchi's *Vision of St. Romuald* altarpiece (1631–32; Vatican Gallery).

Painted a few years later, Bernini's virtuoso *David with the Head of Goliath* reveals the influence of the early Poussin as well as of Guercino.[36] (Although proposed dates for this picture have ranged from 1625 to 1650, its style suggests 1630–35.) Following the Borghese *David* (plate 11) Bernini revived the hero for two black-and-white engravings he designed as title pages for Urban's *Poemata.* The first (1631; fig. 23) illustrates David killing a lion; the second (1638) portrays him as king and psalmist, playing his harp. But it was in full color that Bernini represented the conclusion of his Borghese drama: the moment immediately after the victorious shepherd boy has beheaded the giant felled by his sling. David's head and torso suggest a variation on both Michelangelo's and his own earlier marble.

This second David turns to look over his shoulder as he displays his grisly trophy to the Philistines, "whereupon they fled." Posing in front of the mirror, the sculptor has depicted himself as hero, unlike Caravaggio, in whose *David* (Borghese Gallery, Rome) that troubled painter gave his own visage to the decapitated Goliath. Bernini conveys the gesture of triumph through patchwork chiaroscuro reminiscent of Guercino and through a flourish of drapery that accentuates the muscular contours of the torso. David's drapery and expressive facial features anticipate those of the young companion to the Bible's "second Saul" (the future apostle Paul) in Bernini's *Conversion of Saul* altarpiece, which he designed in 1635 for the Propaganda Fide. At the same time, David's three-quarter profile, open mouth, and fixed gaze hark back to Bernini's head of St. Thomas. Taken together, these two revealing canvases establish in their technical and imaginative bravura the standard against which future attributions of paintings to the maestro may be measured.

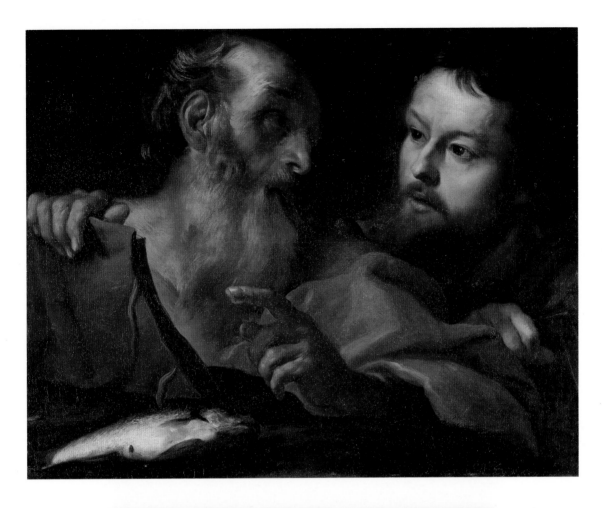

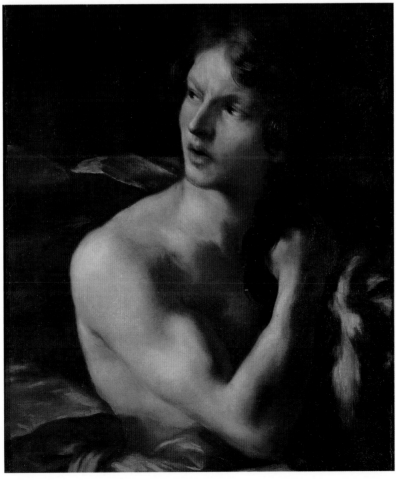

TOMB OF URBAN VIII

1627–47
Marble and bronze, twice life-size
Saint Peter's, Rome

Like Julius II, Urban VIII commissioned "his Michelangelo" to design and carve his papal tomb. It took Bernini a full twenty years, by which time he had thoroughly transformed his Renaissance prototypes into a Baroque tableau vivant and subordinated them to a poetic *concetto* in which winged Death assumes —literally—the central role. "Death, be not proud, though some have called thee mighty and dreadful, for thou art not so. . . ." In tune with Donne's sonnet, Bernini's shrouded Death is reduced to a scribe, who commemorates Urban's name in gold on a book of marble "touchstone." The bronze effigy above, larger than life, extends an eternal benediction. In one of his poems Urban had written that "Death spreads out its black wings. . . . However gloomy death cannot extinguish a renowned name. That which is fragile perishes, but the shining child of Virtue, imperishable Glory, flourishes forever." By a visual conflation of skeletal Death and winged Time, Bernini incorporated a double compliment to the papal poet.[37]

Designed as a pendent to Della Porta's tomb of Paul III across the apse—together recalling Michelangelo's Medici tombs—this memorial combines a bronze effigy with a pair of marble Virtues to create a polychromatic pyramid. But unlike Della Porta's lifeless reclining figures, Bernini's sensuous Virtues stand in vivid contrast with the dark bronze sarcophagus, a painterly chiaroscuro that imparts animation. Like the paired saints ensconced at the crossing (fig. 16; plate 14) they illustrate his formula of *contrapposti,* or dynamic juxtapositions. He links the active with the contemplative, the extroverted with the introverted—the paired qualities that epitomize the deceased pope.

Below the raised arm of benediction, Caritas (Divine Love) gathers an infant to her breast (originally bare, later draped by the prudish Innocent XI) as she looks lovingly at her other grief-stricken child. Opposite, leaning on her book and the scroll-like volute of the sarcophagus, Justice gazes mournfully to heaven; she displays her emblematic sword while overshadowed *putti* hold the judicial fasces and scales. Her inner life is expressed by a profusion of swirling drapery. If Caritas's preferred place (at Urban's right hand) is grounded in theology—man's hope for salvation rests on divine love, not justice—her features reveal a more intimate origin: they belong to Bernini's *inamorata,* Costanza Bonarelli (plate 20). This *Caritas* has been called a "marble Rubens," and indeed the vibrant naturalism of these figures within a tiered allegorical construction may itself represent Bernini's adaptation of Rubens's sculpturesque title pages.[38] At first Urban's name was to have been inscribed on a decorative cartouche, then on a scroll by a skeletal scribe, and finally in a book whose wavy pages defy the petrified medium. By this typically Baroque paradox Bernini's monument invokes Horace's dictum that words are more permanent than bronze. Here, that gilded metal of the skeleton, sarcophagus, and papal statue defines the vertical axis from grave to apotheosis.

Like the *Baldacchino,* Urban's tomb is decorated with Barberini bees. The three large heraldic ones have alighted on the sarcophagus and pedestal. The far smaller, naturalistic bronze bees on the legs and lid of the sarcophagus may signify the "odor of sanctity" of this pope whose reputation was already in need of restoration. Bernini's sculptural epitaph extols his patron's immortality, proclaiming through its inversion of usual imagery the transience of death. In this "stupendous work," as Baldinucci described it, Bernini challenges our common perception of illusion and reality, of death and life. One thinks of the apostle Paul's triumphant cry, "Death, where is thy sting?" Or, as John Donne concluded, "One short sleep past, we wake eternally, and Death shall be no more: Death, thou shalt die."

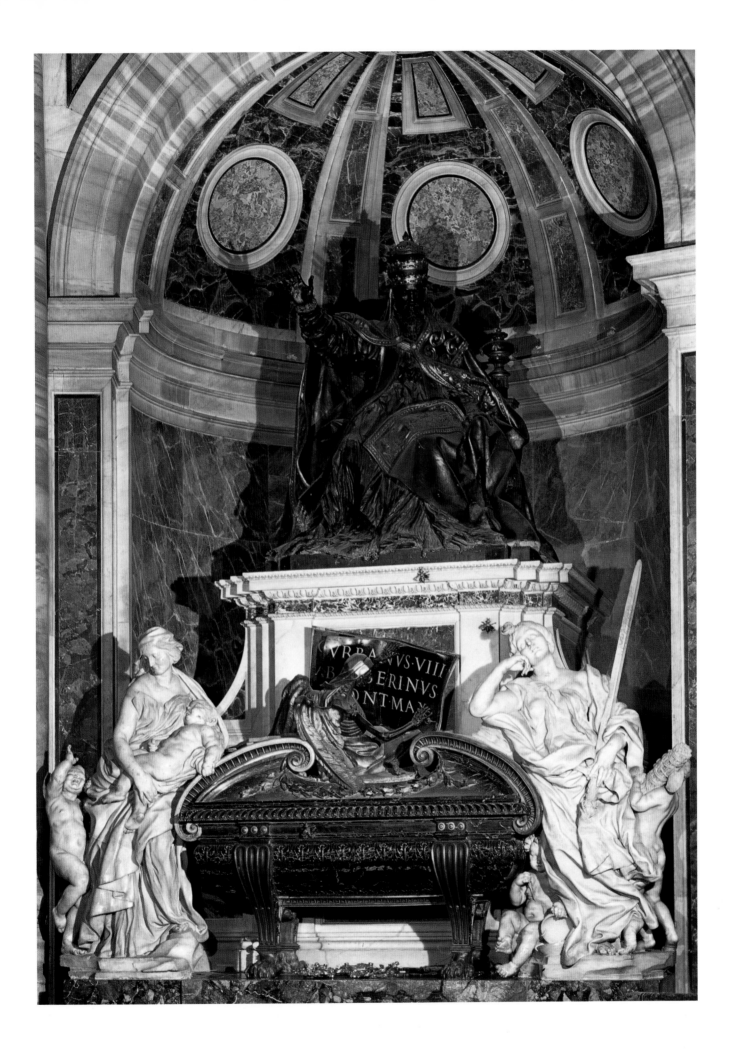

BUST OF SCIPIONE BORGHESE

1632
Marble, height 30¾" (78 cm)
Galleria Borghese, Rome

As papal nephew, Scipione Borghese had enjoyed the fruits of papal nepotism to the fullest. Born Scipione Caffarelli, he was elevated to the rank of cardinal at the age of twenty-seven and given the family name by his uncle Pope Paul V in 1605. During the sixteen years of Paul's reign Scipione amassed more titles and offices than any of his predecessors—papal *camerlago* (treasurer), administrator of the papal states, prefect of diplomatic correspondence, head of the papal courts, archpriest of the Lateran, head of the Vatican Library, plus assorted abbacies and posts yielding a princely income. His early patronage of Bernini generated those splendid mythological groups that still dominate his Roman villa (plates 6, 8, 10). His hospitality toward the future Urban VIII proved no less providential, for in late 1632 that pope allowed his sculptor-architect time off to carve Borghese's portrait. Within a year, the *cardinal padrone* would be dead—but not before Bernini had captured his vivacity in this "speaking likeness," the most engaging of its era, perhaps of all time.

Records of payment in December 1632 and January 1633 confirm the stylistic evidence that its High Baroque conception belongs to the decade of the *Longinus* (plate 14) and the bust of *Costanza Bonarelli* (plate 20), whose informality it prefigures.[39] Shortly before its completion Bernini noticed a flaw in the marble, straight across the forehead. He nonetheless finished it, then ordered a new block, and with lightning speed—whether in "fifteen days" (Baldinucci) or "three" (Domenico)—carved a copy that he hid behind a cloth during the unveiling of the original. Borghese tried bravely to conceal his dismay that so magnificent a portrait was flawed. "Pretending to be unaware of the cardinal's disappointment, since relief is more satisfying when the suffering has been most severe," Bernini deliberately prolonged the agony through small talk before suddenly unveiling the second version to Borghese's unbounded delight.

The dramatic scene of its unveiling corresponds to the bust's very conception: it is a conversation piece. Just as the actively turned shoulder suggests the rest of a living body, so too the incisive pupils and the open mouth evoke a speaking model. Typically, Bernini's two versions are not identical: the unifying simplification of drapery in the second (fig. 28) provides greater emphasis on the face—and, in turn, helps conceal a minor flaw running through the *mozzetta*. Less penetrating and extroverted, it has an aura of pensiveness and shows Bernini's disdain for copying himself, rather than the speed with which he performed his encore. The vibrant drawing (fig. 26), Bernini's only surviving sketch for a portrait bust, illustrates his method as Domenico describes it: "He did not wish his sitter to sit still but rather to move and talk naturally, since by this means, he said, his beauty could be seen as a whole, . . . adding that when in life a man stays immovably still he is never as like himself as when he is in movement." The parted lips, a motif first applied a decade earlier to the bust of Gregory XV (fig. 13), recall the fleeting expressions of Caravaggio's genre subjects and Domenichino's *Cumaen Sybil*, the latter in Borghese's own gallery. On this score Bernini may owe no less a debt to Rubens and Van Dyck, whose application of calculated casualness transformed the art of formal portraiture. Within the Secret Archives of the Vatican Library is a fresco illustrating the young cardinal Scipione Borghese in animated conversation with his uncle. In his marble paraphrase Bernini projected such an encounter into a third dimension that instantly engages the viewer and evokes an audible response.

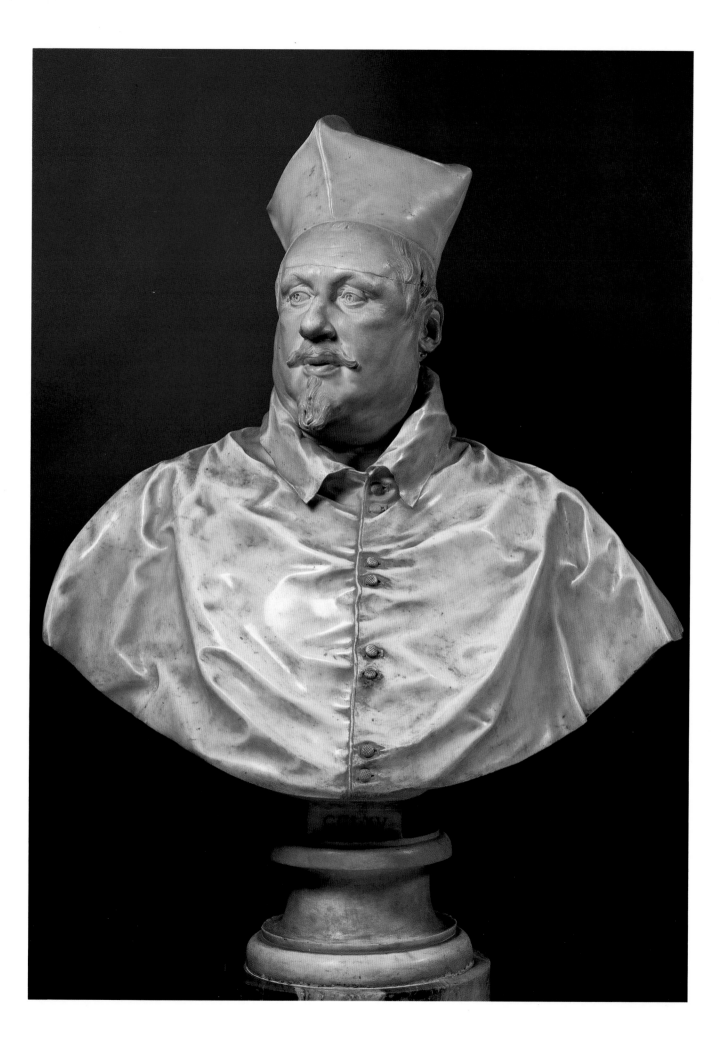

BUST OF COSTANZA BONARELLI

c. 1636–37
Marble, height 28⅜″ (72 cm)
Museo Nazionale, Florence

Bernini was as private as his art was public. Unlike Rubens and Rembrandt, whose intimate portraits of spouses and children provide records of the artists at home, Bernini left us no comparable glimpses into his private life—with one notable exception, this striking portrait bust of his mistress Costanza Bonarelli, who has been dubbed "a Latin sister" of both Rubens's young wife, Helène Fourment, and Rembrandt's Saskia.[40] The alluring subject was the wife of one of Bernini's assistants, Matteo Bonarelli, who started working for him in 1636 and collaborated on his crystalline monument to the Countess Matilda (fig. 29). There is nothing classicizing, much less chilly, about the bust of Signora Bonarelli. According to a contemporary letter, Bernini was *fieramente inamorato:* the marble surface reflects the inflamed passion of its creator.

Carved about four years after the bust of Scipione Borghese, this one looks like an oil sketch in the round. The torso has been severely abbreviated, leaving just enough of the filmy open chemise to provide a touch of décolletage. We may compare it with the contemporaneous—and complete—image of Bernini's favorite model in the role of Caritas (Divine Love!) for the tomb of Urban (plate 18). The lively, disarming directness of the expression evokes the body and spirit of this passionate woman. She looks to one side, lips parted, her matted hair drawn back into a bun. Spontaneity and vivacity are caught in the responsive flash of the eyes. This device anticipates by a century and a half the refreshing informality of Jean-Antoine Houdon's sculpted portraits.

Bernini's affair ended badly. "Either jealous of her, or because love is blind, or for some other reason carried away," the otherwise candid Domenico hedges, Bernini publicly insulted Costanza's husband—so seriously that the pope himself had to exculpate the offender. At Urban's urging the sculptor decided to marry, choosing for his wife a beautiful woman eighteen years his junior, Caterina Tezio; she bore him eleven children and predeceased him after thirty-four years of marriage. He gave away the bust of Costanza, but he evidently kept a double portrait of himself and his paramour, after tactfully dividing it. In 1639, the year of his marriage, Bernini presented the bust to Monsignor Bentivoglio, who in turn gave it to the duke of Modena. By 1645 it was in the grand-ducal collection in Florence, where it remains to this day. Proud as Bernini was of his Florentine heritage, it seems serendipitous that although that city preserves but two of his smaller masterpieces, these are personal and equally ardent: one illustrating the holy passion of his patron saint (fig. 8), the other the object of his own all-too-human passion.

Three decades later, the sixty-six-year-old *cavaliere* warned a handsome young Frenchman "to take good care not to abandon oneself to pleasure." In his own case, Bernini explained, "God had put out his hand to save him" from his "fiery temperament and a great inclination to pleasure in his youth." He had not allowed himself to be carried away: "Like a man in midstream held up by gourds, he might sink sometimes to the bottom but would rise to the top again immediately."[41] However he viewed it in retrospect, Bernini's pyrotechnical bust of his mistress marks the pinnacle of Baroque naturalism in portrait sculpture by this seventeenth-century Pygmalion.

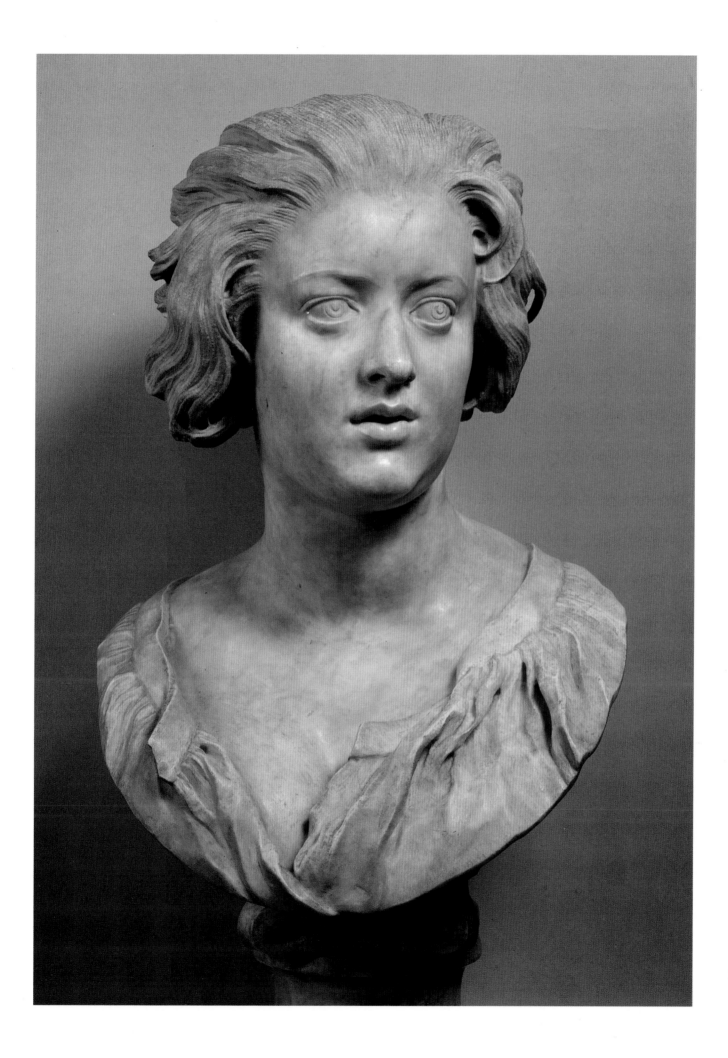

COLORPLATE 21

TRITON FOUNTAIN

1642–43
Travertine, over-life-size
Piazza Barberini, Rome

"It was always Bernini's opinion that in designing fountains the good architect had to give them significance, or at least an allusion to something noble, whether real or imagined." Baldinucci cites as an example "the beautiful fountain in the Piazza Barberini, made from his design and by his chisel." Begun in 1642 and finished in 1643, a year before Urban's death, Bernini's *Triton* looms outside the papal family palace as a civic monument to his patron. Its visual sources not only spring from Bernini's own first fountain sculpture, the *Neptune and Triton* (plate 7) of two decades earlier, but may also be traced to two Vatican fountains: Stefano Maderno's *Fontana dell' Aquila* and another rustic ensemble with Triton by Nicholas Cordier (destroyed). What is unprecedented — though foreshadowed by his *Barcaccia* (plate 15) — is Bernini's total liberation of the fountain from an architectural context. Its allegory is embodied in purely sculptural forms arising from the water: four dolphins supporting a double (open) scallop shell on which a single kneeling deity raises yet another shell as the ostensible source of the spouting water. The imagery is multilayered and erudite, as befits its creator and his patron.

According to Ovid's *Metamorphoses* (I, 330ff.), Neptune's son emerged from the sea and blew his conch to signal the end of the Great Flood and the restoration of benign order: "Summoned from far down under, with his shoulders barnacle-strewn, Triton loomed up above the waters, the blue-green sea-god, whose resounding horn is heard from shore to shore. Wet-bearded Triton set lip to the great shell, as Neptune ordered, sounding retreat, and all the lands and waters heard and obeyed." Bernini reinforced the papal allusion by Urban's centrally placed escutcheons — with crossed keys and tiara crowning the trio of bees — one on each side. The Triton itself harks back to the *Tritone canorum* (singing Triton) described in Francesco Bracciolini's celebratory poem "The Election of Pope Urban VIII." At the same time it was an established Renaissance emblem of "literary immortality," here aptly commemorating a pope whose published poetry had featured allegorical title pages by Bernini and Rubens. The Barberini bees mean at once industry and divine providence, while the dolphins, their tails wrapped around the papal keys, refer to the beneficence of Urban's reign.[42] These symbolic notes in no way undermine the organic unity of Bernini's invention or the visual clarity of his confluent iconography. The carved crescendo rises toward its sparkling apex of gushing water, which was even more resonant in its original rustic setting outside the Palazzo Barberini. (Even today, with the Hotel Bernini as its backdrop, it competes successfully with the cacophony of motor traffic.) The role of the column of water was from the start a sculpturesque feature: in one preparatory drawing Bernini alluded to Urban's strong French ties by a triple jet in the form of a fleur-de-lis.

At its completion in August 1643, "the water was raised three times to full height, and allowed to run off, and the jets were adjusted." The excess supply, seemingly consumed by the open-mouthed dolphins, was channeled into Bernini's more pedestrian and utilitarian *Fountain of the Bees* across the piazza. (Bernini was awarded the income from part of the run-off water, an apt bonus.) Erected in the clouded twilight of Urban's pontificate — with the papal treasury and Roman economy severely drained by the War of Castro — Bernini's *Triton* still sounds a refreshing finale three centuries later for the pope and patron of the High Baroque.

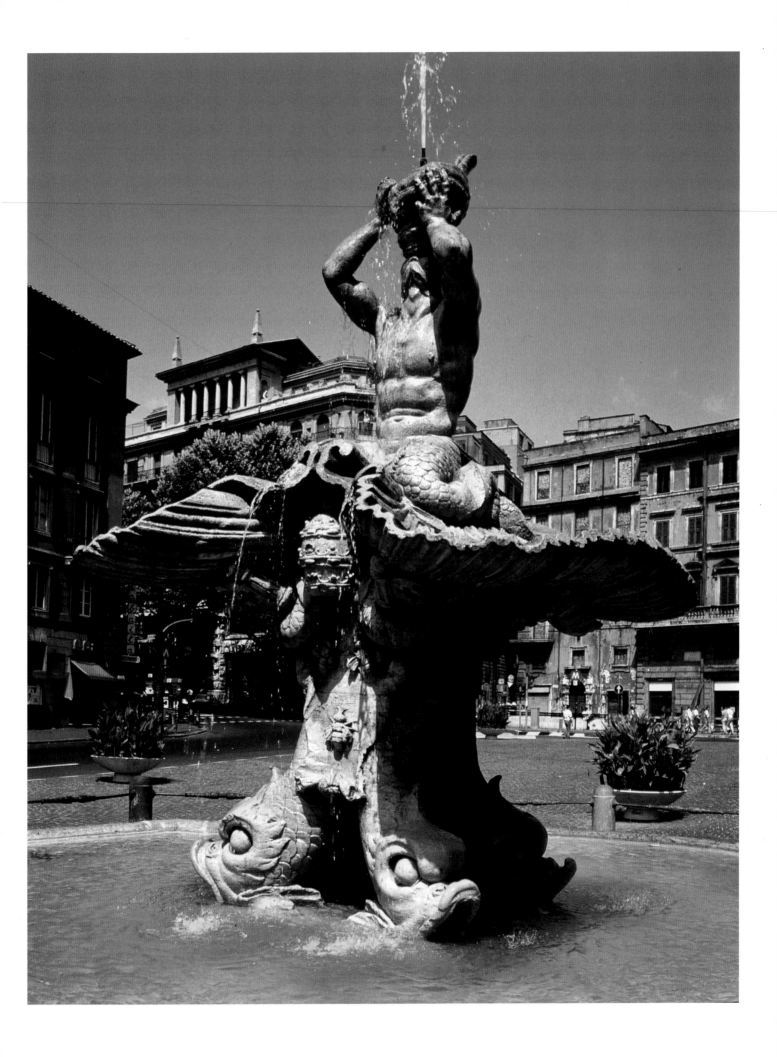

COLORPLATE 22

TRUTH UNVEILED

1646–52
Marble, height 9'2¼" (2.8 m)
Galleria Borghese, Rome

Veritas filia temporis —"Truth is the daughter of Time." During the Reformation and Counter-Reformation both sides illustrated this phrase in the conviction that time would reveal the truth of their religion. In 1641 Cardinal Richelieu of France commissioned from Poussin the ceiling painting *Time Uplifting Truth* to glorify his own political achievements. Having been humiliated in February 1646 by being ordered to dismantle his bell tower at Saint Peter's, Bernini likewise sought vindication in this hallowed formula about truth. In his initial design (fig. 33), probably intended for a painting or print, Truth reclines on a globe and looks up, startled, as her aged father, Time, flies in to undrape and reveal her splendor. Bernini later transcribed this *concetto* into sculptural shape. He gave Truth, through several pen-and-ink sketches, a seated posture, her flying drapery pulled back by Father Time, who was to be carved from a second block of marble.[43] An allegorical counterpart to Teresa (plate 25), this smiling Truth is transfigured as she gazes at the agent of her heavenly revelation. Like the early St. Sebastian, she is seated on a rocky base, here an allusion to Psalm 85: "Truth shall spring forth from the earth." Her left foot rests on a small globe, the world over which, according to Cesare Ripa's *Emblemata*, both Truth and Time preside. In her right hand she displays her glowing attribute, the sun: its description was perhaps intended as a pointed reference to the recently deceased Pope Urban's emblem.

According to a contemporary report, Bernini began work on the sculpture immediately after the unveiling of Urban's tomb in February 1647. The same year Bernini's friend Gian Paolo Orsini, Duke of Bracciano, wrote to Cardinal Mazarin, Richelieu's successor in France, that in view of its beautiful model he ought to buy the finished marble. (Only if Bernini came along with it, replied the shrewd Mazarin.) By 1652 Truth was

finished; yet her father was still confined within the second, unhewn block: "Whether dissuaded from the work by the ire of that same Time, who, inconstant by nature, refused to be eternalized by the hand of Bernini, or for some other serious occupation, it remained excavated in vain, a useless stone," according to Domenico. In France, in 1665, Bernini explained that he intended Time's gesture to convey the "meaning"—Truth's elevation to her heavenly realm. Simultaneously he planned to illustrate the destructive power of Time ("which in the end ruins or consumes everything") by supporting the marble figure on a base of overturned columns, obelisks, and tombs. Without these ruins the marble god could not remain airborne—"even though he has wings," he jested.[44] As both savior and destroyer, Time recalls the ambiguous skeleton on Urban's tomb (plate 18) while anticipating Time's final conflation with Death as an emblem of resurrection on the tomb of Alexander VII (plate 39).

In his later years the sculptor enjoyed quoting a quip bandied about Rome that "Truth was to be found only in Bernini's house." The Duc de Créqui considered the statue the "perfection of beauty"; Bernini himself considered Truth "the most beautiful virtue." Yet her expressive, elongated body is strangely unclassicized. A deliberate departure both from antique sources and from Bernini's earlier canon of feminine perfection, she embodies a new ideal that prefigures the spiritualized attenuation of his late style. "He who does not occasionally breach the rules never transcends them," said Bernini. Applying this maxim to his most revealing personification of artistic truth, he bequeathed her to his firstborn heirs in perpetuity, so that, as his will explained, "all my descendents may remember that . . . one must always work with Truth since, in the end, she is discovered by Time."

86

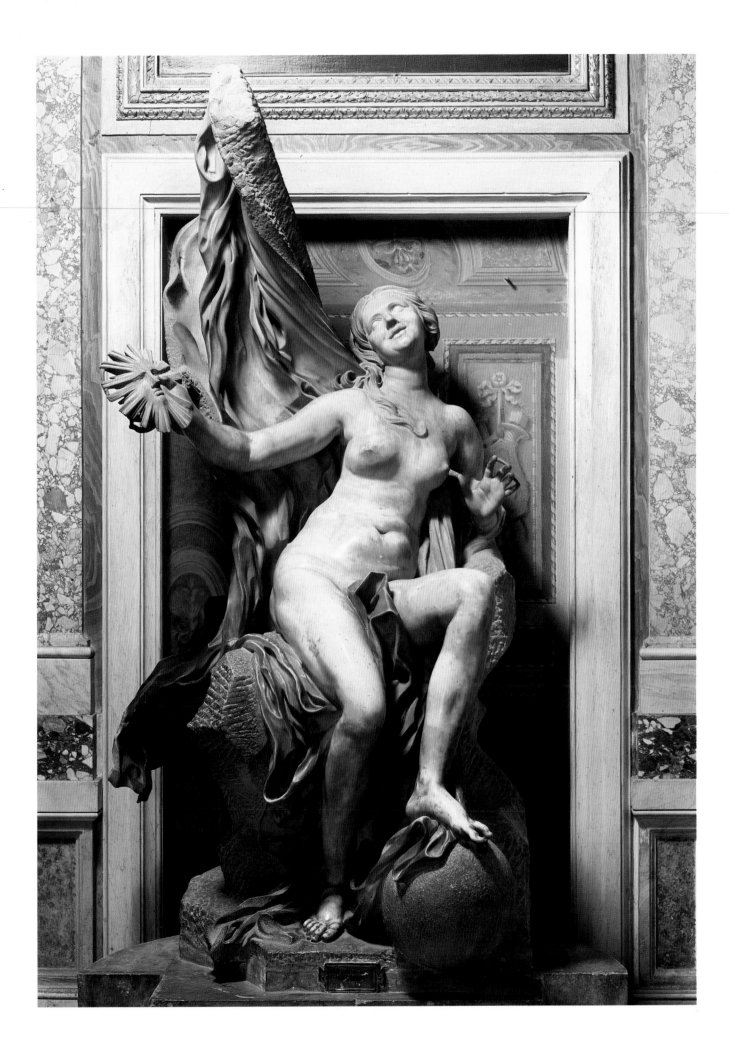

MARIA RAGGI MEMORIAL

c. 1647
Marble and gilded bronze
Santa Maria sopra Minerva, Rome

In a vivid example of his painterly *contrapposto,* Bernini suspended from the stark gray pier of a Gothic church his colorful and thoroughly Baroque reinterpretation of a Roman funerary wall monument. Descended from a Genoese noble family, Maria Raggi (1552–1600) was widowed at the age of eighteen and became a Dominican nun. Arriving in Rome in 1584, she lived an exemplary life of rigorous prayer and fasting under the tutelage of the Dominicans of Santa Maria sopra Minerva, where her two sons eventually became priests. Famous for her miraculous cures and mystical experiences—including the receiving of stigmata—Maria soon attracted a cult of devotion; the process of her beatification, begun in 1625, quoted an eyewitness account of her deathbed vision of Christ: "Her eyes fixed on the altar . . . she extended her arms as if wishing to embrace someone, and she immediately closed them in the form of a cross on her breast . . . then she raised her head and fixed her eyes in the oratory and repeatedly proffered the sweet name of Jesus. . . . At the last, with admirable peace and quiet, she gave up her spirit to the Creator, leaving all those present consoled by so happy a death."[45] Her definitive memorial was funded several decades later by a relative, Cardinal Ottaviano Raggi (d. 1643), whose executor, Lorenzo Raggi, oversaw its design and installation soon after he became cardinal in October 1647. Assisting in the final carving was yet another (if unrelated) Raggi—Antonio.

Bernini recast ancient motifs into a kind of *Liebestod,* the ecstatic consummation of the soul with Divine Love. The *putti*-borne portrait derives from the *imago clipeata* of Roman and Early Christian sarcophagi, a symbol of the soul's heavenly transport, which Bernini's assistants were then applying to the piers of Saint Peter's to commemorate the early popes. Initially Bernini doubled the ancient provenance by raising Maria's hands to display her stigmata in a gesture of an Early Christian *orans.* In the end he suppressed any indication of the wounds—probably because they had not been officially confirmed by the canonization process. Instead, with arms folded and pressing her breast, her gesture conveys both eucharistic adoration and her mystical death. Like Teresa's (see plate 25), Maria's eyes are shown half-closed in an ecstatic swoon. The hovering cross, defying gravity, supports the windswept drapery. The latter, at once a funerary hanging and a medieval "cloth of honor," is animated into an abstraction of the soul's ascent.

Bernini's translation of the *imago clipeata* into an apotheosis of the portrait medallion ultimately derives from one of the most celebrated Early Baroque altarpieces in Rome: Rubens's *Madonna di Vallicella* (fig. 4). Bernini had earlier combined the elements of drapery, cross, and an oval portrait medallion borne aloft by winged Death in the Alessandro Valtrini memorial (1639; San Lorenzo in Damaso, Rome). By substituting fleshy *putti* for the skeletal *memento mori,* he made of Maria's framed portrait an icon of the candidate for sainthood and more generally of the ideal Christian death. The commingling of suffering and bliss reminds us of his early sculptured martyrs, saints Lawrence, Sebastian, and Bibiana, while it prefigures, in gilded relief, the full-bodied expression of his *St. Teresa.* In its combination of polychromatic materials to reflect progressive levels of reality, this comparatively modest memorial provides the hinge between the tomb of Urban VIII (plate 18) and the Cornaro chapel (plate 24), the one completed, the other begun in that pivotal year 1647, when Bernini set to vindicate himself through his new conception of Truth.

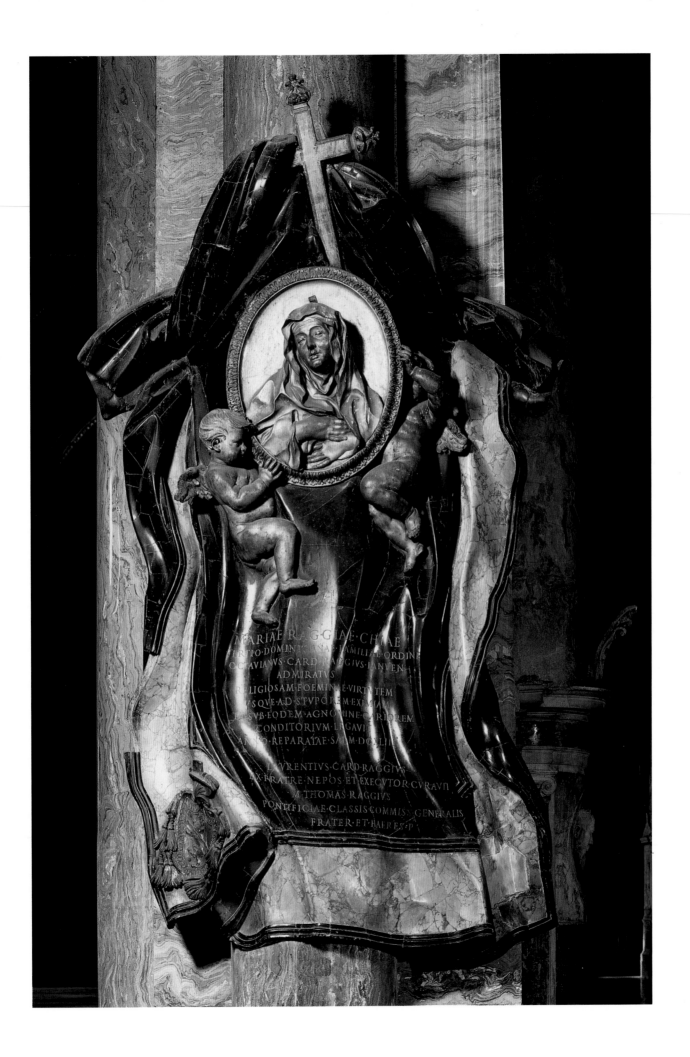

CORNARO CHAPEL

1647–52

Marble, stucco, gilded bronze, and fresco
Santa Maria della Vittoria, Rome

According to his earliest biographers, Bernini was "the first to attempt to combine architecture, painting, and sculpture in such a way that together they make a beautiful whole (*un bel composto*)." To this end, he would "bend the rules without actually breaking them."[46] This unification of the fine arts is clearly Bernini's own concept. Though he wrote no treatise, he left a brilliant illustration of his theoretical views and their fulfillment in the left transept of Santa Maria della Vittoria. There in 1647 Cardinal Federigo Cornaro commissioned a memorial chapel for his illustrious Venetian family, which had supplied six cardinals and a doge. Opened to the public in 1651, the chapel was completed in the following year.

Cornaro's close ties with the Discalced Carmelites and his special devotion to their founder gave rise to the central subject (plate 25), Teresa's vision of an angel piercing her heart with the flaming arrow of Divine Love, which had been cited at her canonization in 1622. This white marble altarpiece, executed by Bernini's own hand, is enshrined within polychromed decoration that transforms the shallow chapel into a multilevel depiction of heaven. Elaborating on a theme he had introduced a few years earlier in the Raimondi memorial chapel (fig. 31), Bernini grouped the eight Cornaros four on a side—spanning two centuries—and shows them discussing and meditating about an apparition set deliberately beyond their sight lines: "Blessed are they that have not seen, yet believe." His triptych arrangement recalls Rubens's *Ildefonso* altarpiece (Kunsthistorisches Museum, Vienna), which Bernini may have known through its engraving. The animated "donor portraits" are set against illusionistic reliefs of colonnaded and vaulted transepts (or perhaps heavenly corridors—they are surely not theater boxes, as commonly described) directly above the wooden doors of Death. Two colorful roundels of inlaid marbles in the pavement show skeletons arising from the crypt. In the vault above, frescoed clouds and angels spill over the architectural fabric of the chapel and stucco illustrations of Teresa's life—one more metaphysical intrusion into the viewer's space. The heavenly aura, painted by Bernini's collaborator Abbatini, is realized below by sunlight passing through tinted glass before materializing into gilded bronze shafts. These descend upon the cloud-borne Teresa and angel in a metamorphosis of reflected light, "the shadow of God." The bronze altar relief of the Last Supper at the worshiper's level marks the eucharistic significance of the re-created miracle. The transubstantiation of earthly matter into divine substance completes the meaning of Bernini's *bel composto*.

Sculpture and painting are complemented architecturally by the tabernacle in which Teresa's transverberation is exposed, suggesting a gleaming Host suspended in a bejeweled monstrance. With its hidden source of filtered light, this miniature temple, a transverse oval surrounded by Corinthian pilasters and crowned by a coffered dome, anticipates the full-scale temple of Sant' Andrea al Quirinale (plates 30, 31). Through the interplay of concave and convex shapes, the pediment of heaven's portal bows outward as if in response to the force within. The divine text, recorded by Teresa and here spun into the timeless shape of illusion, is inscribed on a banderole held by angels above the entrance: *Nisi coelum creassem ob te solam crearem* — "If I had not created heaven I would create it for you alone."

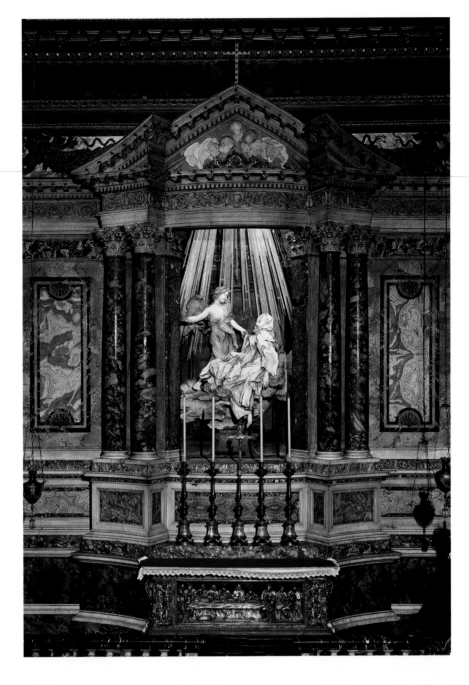

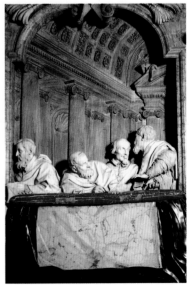

ECSTASY OF ST. TERESA

1647–52
Marble, height c. 11'6" (3.5m)
Santa Maria della Vittoria, Rome

Within a columned aedicula of variegated marbles, Bernini admits the viewer to an intimate vision of the sixteenth-century Spanish mystic Teresa of Avila: the moment at which the beautiful young angel has withdrawn his golden arrow from her breast. Filled with the love of God, Teresa swoons, unconscious, elevated on a cloud, her lips parted, her limp hand dangling at her side. As befits the founder of the Discalced (unshod) Carmelites, she is barefoot; but there is nothing naturalistic about the flood of drapery that expresses the turbulence of her soul, while the angel—pure spirit, though perhaps modeled after Bernini's firstborn son—is similarly dematerialized in folds that crackle like flames. Nor do Teresa's features conjure up that indefatigable founder of sixteen convents who declared that "God walks among the pots and pans." There is nothing mundane about Bernini's depiction of her mystical transport; his hard marble effects an irresistible seduction of the senses.

Bernini's artistic combining of the spiritual and the sensual has elicited mixed responses down the centuries, especially from the neoclassicists and the prudish Victorians. Taine and Stendhal raised critical eyebrows at what they considered unabashed eroticism. Even in his own day an anonymous diatribe accused Bernini of "dragging that most pure virgin not only into the third heaven, but into the dirt, to make a Venus not only prostrate but prostituted."[47] Yet the great majority of the clergy applauded his achievement wherein he "conquered art." Those who were scandalized simply missed the point: Bernini has faithfully translated into three dimensions the saint's own words in her autobiography. They had been read aloud at her canonization ceremony: "Beside me, on the left, appeared an angel in bodily form. . . . He was not tall but short, and very beautiful; and his face was so aflame that he appeared to be one of the highest rank of angels, who

seem to be all on fire. . . . In his hands I saw a great golden spear, and at the iron tip there appeared to be a point of fire. This he plunged into my heart several times so that it penetrated to my entrails. When he pulled it out I felt that he took them with it, and left me utterly consumed by the great love of God. The pain was so severe that it made me utter several moans. The sweetness caused by this intense pain is so extreme that one cannot possibly wish it to cease, nor is one's soul content with anything but God. This is not a physical but a spiritual pain, though the body has some share in it—even a considerable share."[48]

Since the early Church fathers and their allegorizing of the Old Testament's erotic "Song of Songs," the vocabulary of earthly love had been understood as the best approximation of the incomparable, ineffable ecstasy of mystics in total communion with God. Just as such an encounter was couched in physical terms, so Bernini fused in the sculptural ensemble of angel, saint, and billowy cloud (all carved from a single block of stone) several layers of meaning drawn from episodes in Teresa's life. His three key innovations in representing Teresa—her reclining pose, her elevation on a cloud, and the infusion of sensuality—allude, respectively, to her death ("in ecstasy," as reported), her frequent levitations (usually following communion at Mass), and her mystical marriage with Christ (whom she addressed, in her last words, as "spouse").[49] Once again Bernini's literary source was Urban VIII, whose liturgical hymns to Teresa called her transverberation "a sweeter death" and the saint herself a "victim of love" who heard "the voice of her Spouse" beckoning her to "the wedding feast of the Lamb," where she was to receive her "crown of glory." It was left to Bernini, who credited God alone as the author of his inventions, to merge traditional iconography, orthodox theology, and human experience into a unified image of Divine Love.

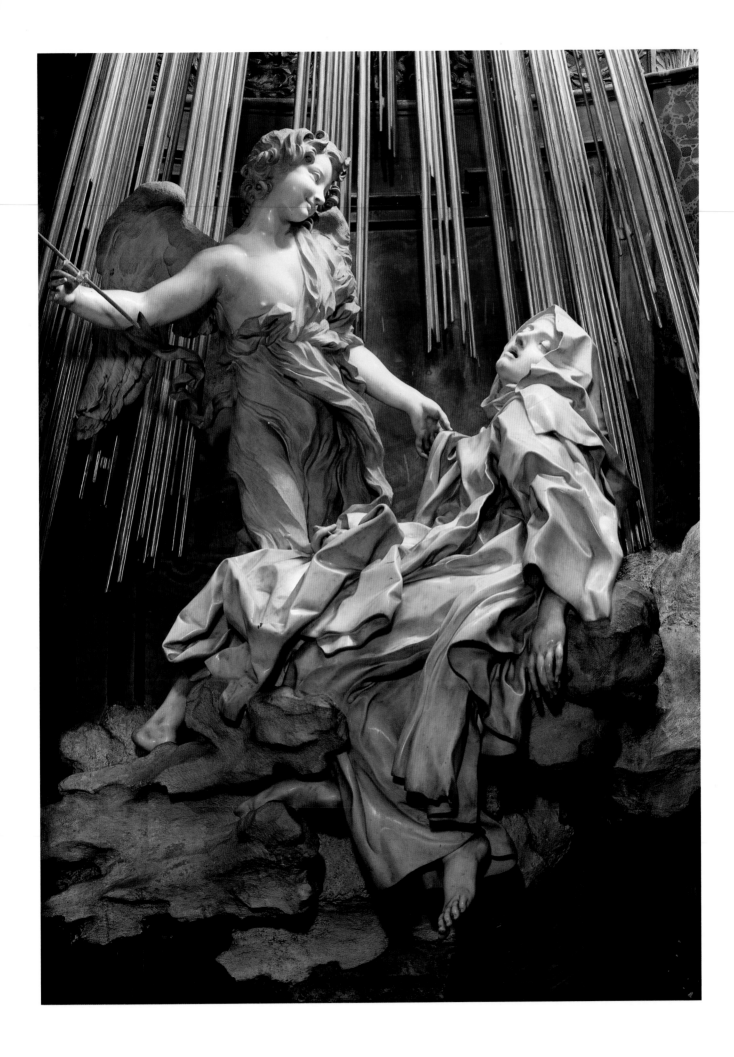

FOUR RIVERS FOUNTAIN

1648–51
Marble and travertine
Piazza Navona, Rome

Bernini's most famous fountain was commissioned by a most unlikely patron—Innocent X, who had ordered the demolition of the artist's bell tower at Saint Peter's. At first Francesco Borromini, the newly favored architect, was asked to design a fountain for the Piazza Navona featuring the recently unearthed Egyptian obelisk. But he was soon displaced by his former employer, thanks to the intervention of Innocent's nephew-in-law Prince Ludovisi, who persuaded Bernini to design a model on speculation and then tricked the pope into admiring it, at which point the commission was a foregone conclusion.

Pope Sixtus V had erected obelisks throughout Rome as Counter-Reformation monuments. The pagan monoliths were crowned by the cross to symbolize the universal dominance of the Catholic faith. Standing on a rocky mountain hollowed out in apparent defiance of gravity, the Pamphilj obelisk was "personalized" by the pope's emblem, the "Innocent" dove of peace carrying an olive branch in its beak. From the mountain spring the four great rivers of the world, each representing a continent. From the vantage point of the Pamphilj palace entrance, the Danube (Europe) straightens the papal escutcheon as he gestures with wonder at the obelisk. At his right the Ganges (Asia) reclines like a Michelangelo *ignudo*, holding a long oar that alludes to the river's vast navigable length. On the opposite side the Nile (Africa) is shown with head shrouded, since its source was then unknown. Finally, the startled Rio de la Plata (America) looks up, his hand in front of his face—not, as Romans have long jested, in horror of Borromini's facade of Sant' Agnese but, like the blinded Saul on the road to Damascus, shielding his eyes from the obelisk that symbolizes the blazing light of the Faith.

Bernini preceded the fountain by a series of draw-ings and *bozzetti* (fig. 34). The muscular river gods, reminiscent of Carracci's Farnese *atlantes* (fig. 2), were executed by his assistants Raggi, Poussin, Fancelli, and Baratta. Bernini himself is said to have carved the wildlife—horse, lion, palm tree, crocodile, fish (an open-mouthed drain), and even a fanciful version of an armadillo. The mountain was composed of interlocking travertine blocks; the multilayered symbolism was equally dovetailed to exalt the peace of the Pamphilj reign (dove) resting on divine illumination (obelisk) and dominating the four corners of the world (rivers). The imagery evokes Paradise equally well, the Four Rivers springing from it, or again, the recession of the biblical Flood (compare Barberini's *Triton* fountain, plate 21) heralded by the return of the dove to the Ark. This last was the very subject of a display of fireworks in the Piazza Navona to celebrate Innocent's election in 1644. Indeed, Bernini's fountain became the occasion of a ritual flooding during the hot summers, resulting in a festive lake (*Lago di Piazza Navona*), at the abatement of which a feast was laid out for the refreshed Romans.

Allegorical inscriptions were added to the base by the Jesuit scholar Athanasius Kircher, whose book *Obeliscus Pamphilius* was published in the Holy Year 1650. The symbolic weightlessness of Bernini's *concetto* conformed to Kircher's erudite account of ancient views of the obelisk as the *digitus solis,* or "finger of the sun."[50] The gushing streams served a double function: a tectonic foundation akin to flying buttresses for Bernini's tiering of the four elements (water, earth, fire, and air) and, at the same time, a visible, even audible feature that gave the work life. While Innocent's political aspirations remained unfulfilled, Bernini's permanent elevation of the ephemeral transformed the pope's piazza into Rome's perennially festive center.

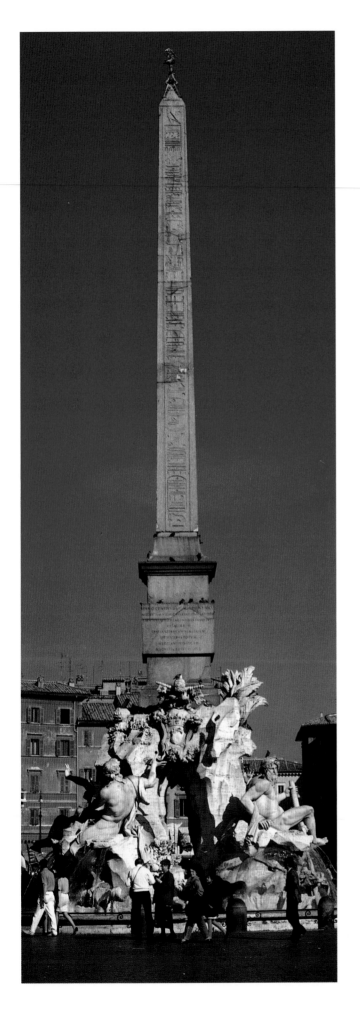
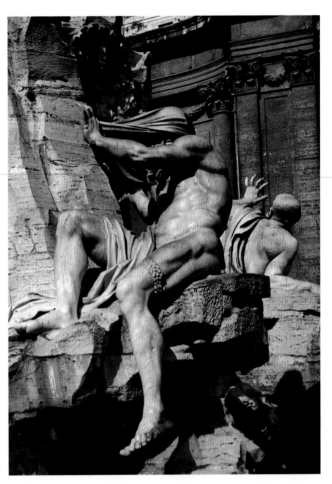
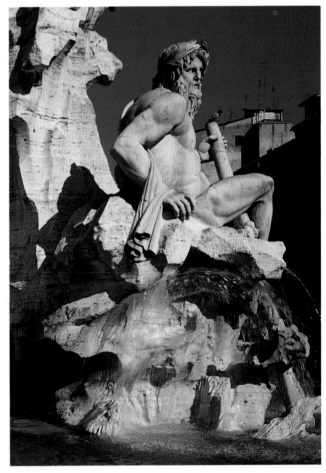

DANIEL AND HABBAKUK

1655–61

Marble, over-life-size

Santa Maria del Popolo, Rome

It was said of Fabio Chigi that he "delighted in architecture ever since his youth." Raised to the College of Cardinals in 1652, he commissioned Bernini to renovate the family burial chapel in his titular church of Santa Maria del Popolo. Designed by Raphael, two of the four niches in this domed *tempietto* had been filled by Lorenzetti's *Jonah* and *Elijah,* Old Testament prefigurations of Christ's Resurrection and of the Virgin's Assumption, themes that Bernini underscored in his floor mosaic of a resurrected skeleton (fig. 38). Rearranging the statues, he filled the two empty niches by pairing Daniel and Habbakuk. He carved the *Daniel* in two years, 1655–57; the *Habbakuk* was finally set in place in 1661.

Bernini's subject, chosen by the learned Vatican librarian Lucas Holstensius, appears in the third apocryphal addition ("Bel and the Dragon") to the Book of Daniel.[51] Absent from the Hebrew Bible but included in St. Jerome's Vulgate edition, it had been declared canonical by the Council of Trent. (The only Greek manuscript was, significantly, preserved in the Chigi library.) While Daniel prayed for deliverance from the lions' den to which he had been condemned by the Persian king, an angel appeared to Habbakuk, who was taking a basket of bread to field hands, and miraculously carried the old prophet "by the forelock" to deliver the loaves to Daniel. The story gave Bernini yet another opportunity to flout gravity, this time through a beautiful angel—itself "lifted" from the Cornaro chapel (plate 25). The angel points across the chapel to Daniel, who with raised hands gazes heavenward in supplication. By introducing this powerful axis across the viewer's path from entrance to altar, Bernini transformed Raphael's classically balanced Renaissance space into a stage for his High Baroque drama. The diagonal pairing of the statues fulfills Bernini's original intention for the niches surrounding the *Baldacchino* under Michelangelo's dome. Here, as there, the themes of burial, resurrection, and the Eucharist underlie the program. Daniel's liberation "from the deep pit and the mouth of the lion" was invoked in the Requiem Mass as a sign of salvation through the sacrament; Bernini reinforced the eucharistic significance by Habbakuk's prominent bread basket with fringed cloth.

Through Bernini's preparatory drawings (see fig. 39) and terra-cotta *modello* (Vatican Library), the *Daniel* evolved from its Hellenistic source, the *Laocoön* (fig. 5). Bernini's transformation of the pagan priest-victim into the Old Testament prefiguration of Christ epitomizes his working methods: ancient sculpture serves as a springboard.[52] Laocoön's twisting torso is reversed and elongated into an expressive spiral, complemented by the flamelike swirl of drapery (compare fig. 43). Daniel's leonine hair, upturned head, and parted lips, like those of Longinus (plate 14), derive from Hellenistic portrayals of the dying Alexander. As in Bernini's medal of 1659 honoring Alexander VII with an illustration of "Androcles and the Lion," the joyous outcome fulfilling Daniel's prayer is shown by an unexpectedly tamed lion that licks its intended victim.

As at the Cornaro chapel, the seasoned impresario controlled the viewer's sequential experience of the spatially coordinated drama. Approaching the chapel, one first glimpses the gesticulating Habbakuk and angel. Then, after entering the sanctuary between the zone of death (the burial crypt, fig. 38) and the dome of heaven, can the viewer turn back to behold the narrative climax at the right of the entrance, where Daniel in turn directs our gaze upward to the mosaic of God the Father in the cupola, the divine source of light.

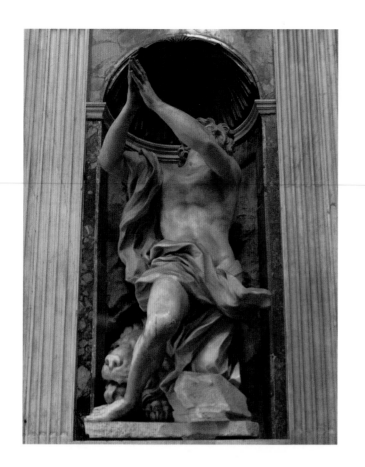

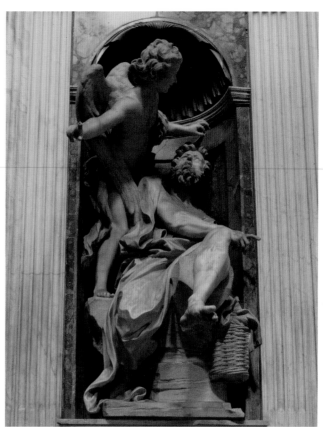

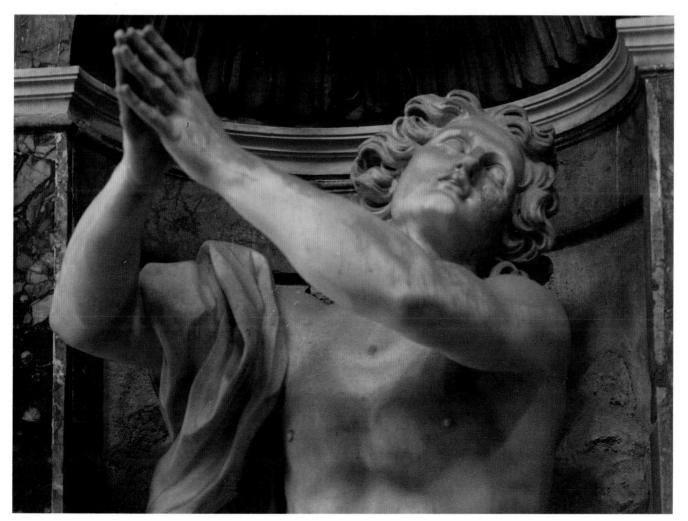

COLONNADE

1656–67
Travertine, height 64′ (19.5 m)
Piazza di San Pietro, Rome

In the summer of 1656, Alexander VII commissioned Bernini's sacred overture to Saint Peter's: the *Colonnade*. By the time of its completion eleven years later, it comprised some 284 freestanding travertine columns, four deep, crowned by 90 colossal statues—an outdoor pantheon of Catholic saints assembled in the Heavenly Jerusalem to greet the approaching pilgrims. It owed its complex evolution to the intimate collaboration between architect and pope. The first plan was trapezoidal, recalling Michelangelo's piazza on the Campidoglio. Then circular and square alternatives were weighed before Bernini submitted, in March of 1657, an oval plan that he tactfully credited to the pope. The transverse oval was an inspired solution to providing assembled crowds unobstructed views of the windows from which the pope gave his blessing to the city and the world (*urbi et orbi*). One window was above the main entrance of the basilica; the other, in the papal apartments at the right. Triple passageways accommodated liturgical processions and sheltered pilgrims from sun and rain. Bernini himself described his *concetto* as the arms of Mother Church "stretching out to receive Catholics, so as to confirm them in their faith, heretics to reunite them with the Church, and infidels to enlighten them in the true faith."[53] The ninety sculptural witnesses constitute Bernini's vastest undertaking as an impresario, here supervising a team of ten assistants, whose leader, Lazzaro Morelli, alone carved a total of forty-seven of the travertine saints.

By subtly adjusting the relative proportions of the colonnade and the facade, Bernini optically corrected the latter's excessive width (the bell towers being absent) and "made it appear taller by contrast," as he explained. The trapezoidal forecourt (*piazza retta*) converging with the oval "pinchers" illusionistically narrowed Maderno's facade, while the blank Ionic entablature above stout Doric columns—a bold architectural solecism—provided a horizontal sweep that accentuated, by juxtaposition, the rising church. He emphasized the long axis of the oval by flanking the obelisk at the center with two fountains like candelabra beside a triumphal crucifix. These are colossal counterparts to the liturgical fixtures he was then designing for the altars inside Saint Peter's. The colonnade suggests a *plein air* church, like his contemporaneous Sant' Andrea al Quirinale (plates 30, 31), each enfolding its congregation beneath the dome of heaven (fig. 40).

Originally the piazza was to be closed by the so-called *terzio braccio,* or third arm, at the far end opposite the facade. Bernini later decided to set it back to allow an entrance court through which to come upon the full sweep of the oval. Owing to the state of papal finances, it was never built. Centuries later, Bernini's opening up of the piazza at the end of narrow, congested streets was nullified by Mussolini's bulldozing a grandiose "conciliatory" avenue to connect the Vatican with the secular city across the Tiber—a boon only to tour buses. Bernini's ingenious invention, a structure that was simultaneously open and closed, was called in the pope's own diary a "*teatro.*" Contemporary writers compared it to ancient amphitheaters, particularly the oval Colosseum. The Venetian ambassador, while criticizing the pope's untimely extravagance, begrudgingly dubbed it "an achievement to recall the greatness of ancient Rome." His successor, less forgiving of the cost ("over a million scudi"), dismissed it as a "catastrophic mistake."[54] In defense Alexander argued that it had subsidized the Roman economy by creating jobs—and this time, in contrast to the family palaces or villas erected by his predecessors, for a *public* project. Its seventeenth-century epithet, *theatrum mundi* ("world theater"), best defines the overwhelming inclusiveness of Bernini's architectural embrace, as well as the expansive catholic vision of its creator.

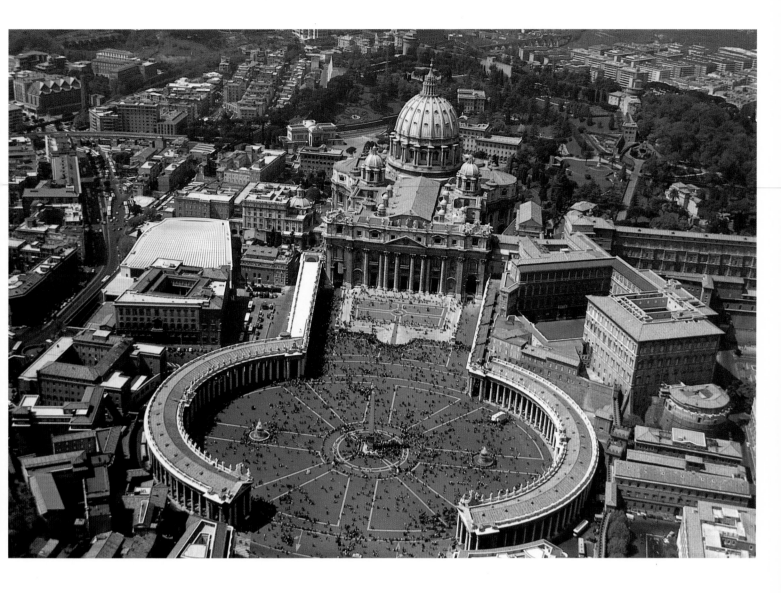

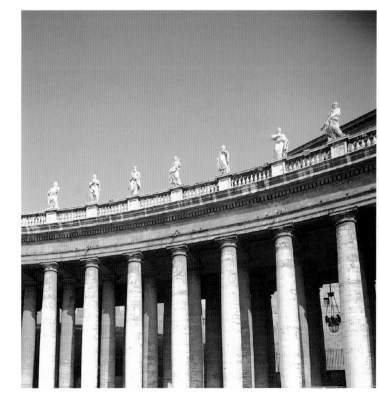

CATHEDRA PETRI

1657–66

Gilded bronze, stucco, marble, and glass
Saint Peter's, Rome

Like the *Baldacchino,* Bernini's second great altarwork in Saint Peter's, the *Cathedra Petri,* was conceived as a giant papal shrine—in this case for the ancient throne (*cathedra*) of Peter, the first pope. In the 1630s, Urban VIII had the "original" (which, in fact, dates from the ninth century) encased in a gilded reliquary above the altar of the baptismal chapel. Bernini's first design (fig. 41) for its relocation in the apse, decreed by Alexander VII in 1656, was to complement, triptych-like, the two flanking tombs of Paul III and Urban VIII; the "empty throne" of Peter was supported on the shoulders of four church fathers, like the bronze tabernacle carried by angels in Santa Maria Maggiore. In lieu of the papal escutcheon, an archangel carrying Peter's keys breaks through the architecture in a blaze of gilded glory. His second design (fig. 42) both magnifies and spiritualizes the patriarchal supports. As by divine intervention that surpasses human engineering, the church fathers emerge from the confining niche and effortlessly raise the throne on scroll volutes. Above, the dove and sunburst of the Holy Spirit are flanked by two kneeling angels; later displaced by an expanded stucco Gloria, they would eventually be revived for the Sacrament chapel (plate 40). In 1660, after a full-size wooden model was unveiled in the apse and was criticized as too small by Andrea Sacchi, among others, Bernini enlarged it again. This time its scale was determined by the *Baldacchino,* which he reinterpreted as a colossal frame for his pictorial amalgam of bronze, stucco, marble, and light. The viewer first experiences the *Baldacchino* and *Cathedra Petri* as a single composition that unites the apostle's tomb (and papal altar) with the apostle's throne.[55] As in the Cornaro chapel and Sant' Andrea, natural light is transmuted into gilded shafts as the Holy Spirit becomes the agent of creation. Bernini converted a previously awkward window into the radiant focal point of his triumphal finale in the apse. A golden oval, its very shape proclaims its creator.

On closer inspection, the painterly vision is seen as colossal sculpture. The four Church fathers—Augustine, Ambrose, Athanasius, and John Chrysostom—bridge west and east as they raise the symbol of Catholic unity on patriarchal fingertips. With only the flimsiest ribbons linking them to the solid volutes of the chair, their ostensible support is theological, not physical: St. Augustine turns in classical *contrapposto,* a heavy tome of his writings balanced on his thigh. Contrapuntal gestures and crackling drapery enliven these massive and venerable pillars of Christendom. Five meters high, they were the largest bronze figures to be cast since antiquity—in fact, Augustine's mold broke during the first try in 1661. Two years later they were completed, and work began on the throne itself. Its central relief—"Feed my sheep," Christ's charge to Peter—reinforces the sacramental bridging of heaven and earth by the Eucharist, through which Peter's successors fulfill the divine commission. Against Protestant rejection and Jansenist undermining of papal power, Bernini enveloped the relic of Roman primacy in an apotheosis that dissolves the boundaries of art and suspends the laws of nature.

The line between solid sculpture and ephemeral illusion is blurred. Two robust *putti* hold the triple crown over the chair, itself adorned with androgynous angels a generation removed from their precursors on the *Baldacchino.* It is a pyrotechnical feat subordinated to a pervasive *concetto,* from piazza to apse: "Through the sacred seat of the blessed Peter," Pope Leo the Great had proclaimed a millennium earlier, "hast thou Rome become head of the world." At the twilight of papal power, Bernini recast that ancient claim into a tangible miracle.

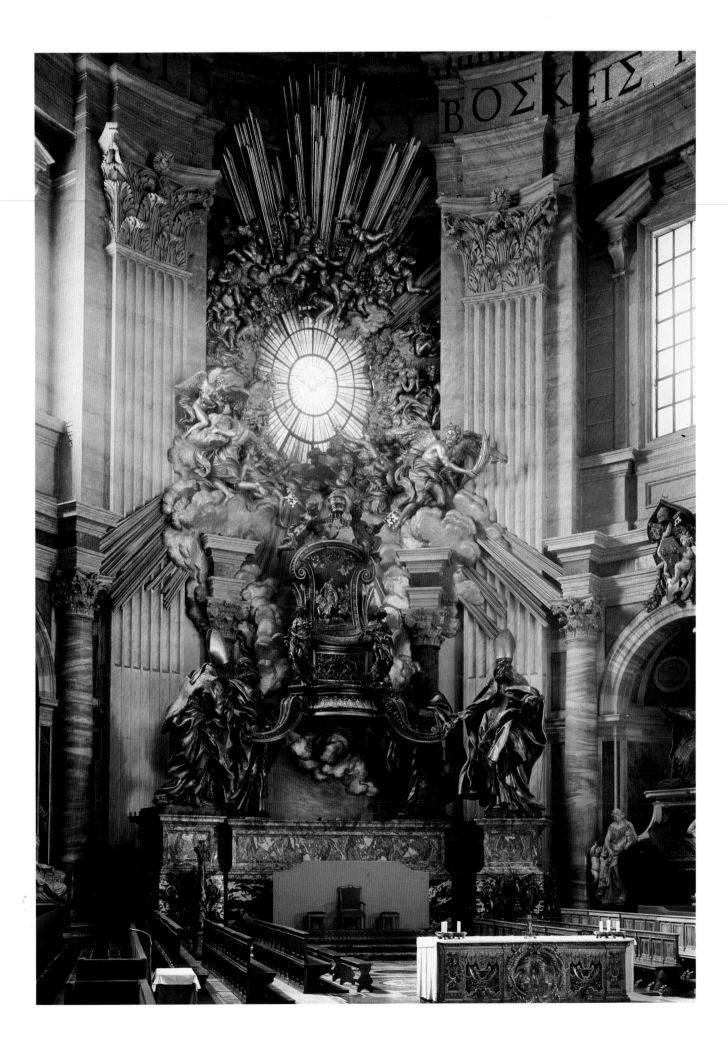

SANT' ANDREA AL QUIRINALE

1658–70
Rome

"Princes must build grandly, or not at all." Bernini's architectural credo that "buildings are the mirrors of princes" was adopted wholeheartedly by Alexander VII, who left his enduring mark on the urban landscape of Rome, where the Chigi star-capped mountains are deservedly as ubiquitous as the Barberini bees. During the construction of the *Colonnade*, Alexander gave his blessing to a much smaller, but no less magnificent adaptation of an oval plan for the church of Sant' Andrea, opposite the papal palace on the Quirinal. The Jesuit fathers had earlier sought to erect a novitiate church there, designed by Borromini, but Innocent X had vetoed it, preferring an unspoiled view from his windows. When Innocent's nephew Prince Camillo Pamphilj offered to pay for its construction, Alexander, realizing that the church might simultaneously serve as a chapel for his household, nodded approval; then, as his diary reveals, he began his collaboration with Bernini on the design. The source of funds guaranteed a sumptuousness that the Jesuits' vow of poverty could not otherwise have justified. The result is a flawless jewel in Rome's Baroque crown.

Following the Renaissance theorists Alberti, Serlio, and Palladio, Bernini believed that the "most perfect" forms for churches were domed structures — squares, circles, octagons, ovals, and the like. Since the Jesuits required five functioning altars, he proposed alternative designs based on a pentagon and a transverse oval, with the long axis running parallel to the street. Exploiting the shallow building lot, the latter plan not only took care of practical requirements as at the piazza (figs. 40, 45) but set the stage for Bernini's dynamic solution to the perennial conflict between form and function in centrally planned churches — how to reconcile the balanced domed space with the thrust of the axis from entrance to altar, or how to coordinate the geometric symbolism with the liturgical requirements of celebrating the Mass.

According to the art historian Heinrich Wölfflin, the oval was the distinctive Baroque shape; Bernini exploited its "tense proportional relationships" through a range of applications from portrait medallions to a piazza. In the 1630s he had introduced a transverse oval in his chapel of the Three Magi in the Propaganda Fide, where the longer axis extended into side chapels, as though a domed Greek-cross plan (like Michelangelo's at Saint Peter's) had been stretched into an oval. At Sant' Andrea, Bernini terminated that axis with a pilaster at each end, thereby reinforcing the sense of the domed enclosure. The earthly and heavenly zones are distinguished by the color contrast of the inlaid marble pavement that mirrors the ribs superimposed over the golden, light-suffused dome. The continuous architrave that outlines the oval space separates the zones and forms a divider between the fluted pilasters and the ribs of the dome, which, separated by bright windows at the base, converge at the lantern. (Bernini's typical overlapping of ribs and hexagonal coffers was his classicizing variation on a motif of Pietro da Cortona's.) As his plans evolved from his "first thoughts" of 1658 to their amplification of the 1660s, Bernini transformed the classical interior into a stage for a sacred opera. An enlargement of the Cornaro chapel, this *bel composto* of architecture, sculpture, and painting filled an entire church. The interior integration of spaces was united by the *concetto* of the death and apotheosis of Andrew, the patron saint (plate 31). Having passed through the portal into a small vestibule, the worshiper immediately confronts a luminous space spiritually charged by Bernini's narrative program.[56]

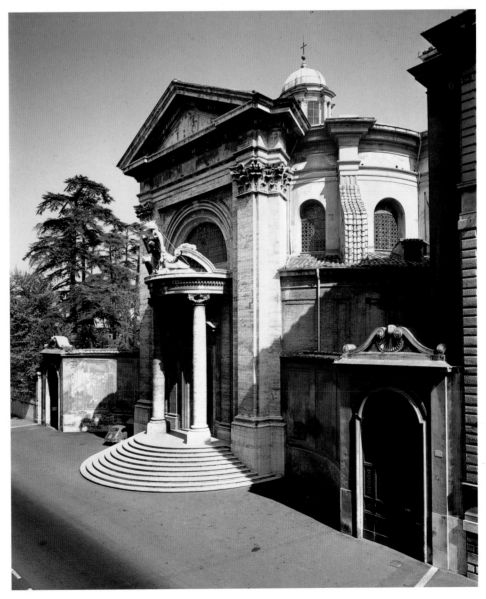

APOTHEOSIS OF ST. ANDREW

c. 1662–70
Oil on canvas, gilded bronze, and stucco.
Sant' Andrea al Quirinale, Rome

Directly opposite the entrance, pairs of massive rose-colored Corinthian columns serve as a Palladian screen for the sanctuary. This "frontispiece," as it was called in contemporary accounts, provides a frame for the miracle displayed above the altar (compare the *Baldacchino*'s framing of the background *Cathedra,* plate 13). The triumphal threshold between the sanctuary, reserved for the clergy celebrating the Mass, and the main body of the church symbolizes, as in Teresa's columned tabernacle (plate 24), the open portal of heaven. Sant' Andrea has, in Rudolph Wittkower's penetrating analysis, "two spiritual centers," each with its own source of light.[57]

In the sanctuary, where the sacrifice of Calvary is renewed in the Mass, Bernini's altarpiece, painted by his assistant Guglielmo Cortese, shows the apostle and martyr Andrew at the moment before death. He looks up from his cross to the outstretched arms of God the Father, frescoed in the lantern above. Gilded bronze shafts and stucco angels, as in the *Gloria* at Saint Peter's, sacralize natural light. According to the *Golden Legend,* Andrew had survived for two full days preaching from his cross when Aegeus, the Roman proconsul who had originally condemned him, relented and returned to take him down. Refusing to descend alive ("Already I see my King awaiting me in heaven"), Andrew prayed for death and the final reunion, whereupon "a dazzling light from heaven enveloped him. . . . When it finally vanished he breathed forth his soul." Bernini's rendering of the medieval legend breaks out of the picture plane and into the viewer's realm. Through a passage scooped out of the classical pediment, Andrew's white, cloud-borne soul (executed by Antonio Raggi from Bernini's model) ascends toward the dove of the Holy Spirit in a second oval lantern, ringed with stucco cherubs and crowning the main dome. On the windows below, eight reclining fishermen (Andrew was enjoined to be "a fisher of men") provide a background chorus for the solo saint soaring toward the center of heaven.

As at Ariccia, where Bernini's *concetto* of the Virgin's Assumption (fig. 48) integrates the dark sanctuary and the luminous dome of the circular church, his bifocal drama encourages the worshiper to participate in the saint's spiritual consummation. Its narrative force, matching that of St. Ignatius's *Spiritual Exercises,* was aimed at the Jesuit novices for whom the elevated Andrew was the model preacher and martyr. By subordinating the classical forms to a clearly unclassical fusion of spaces and media, Bernini reconciled the Renaissance ideal of the hollow-form church with its liturgical function. The interior integration is prefaced in the facade by an inviting interplay of convex and concave forms. Just as the dominant aedicula of giant pilasters corresponds to the triumphal gateway of the sanctuary, so the concave walls announce the oval church beyond. At the top of the steps (originally only three) a semicircular, columned porch derived from Pietro da Cortona's Santa Maria della Pace provides a base for the donor's escutcheon. The normally frugal Prince Pamphilj wanted the small church to "rival the most magnificent buildings in Rome." Confronted with soaring expenses, he told the workers: "You must do whatever Cavaliere Bernini orders, even if all my substance goes in the process." For himself, Bernini refused payment. It was a labor of faith, and he was uniquely rewarded. Years later he explained to Domenico, who had been surprised to find his father alone in the church, "This is the only piece of architecture for which I feel special satisfaction from the depth of my heart; often when I need rest from my troubles I come here to find consolation in my work."[58]

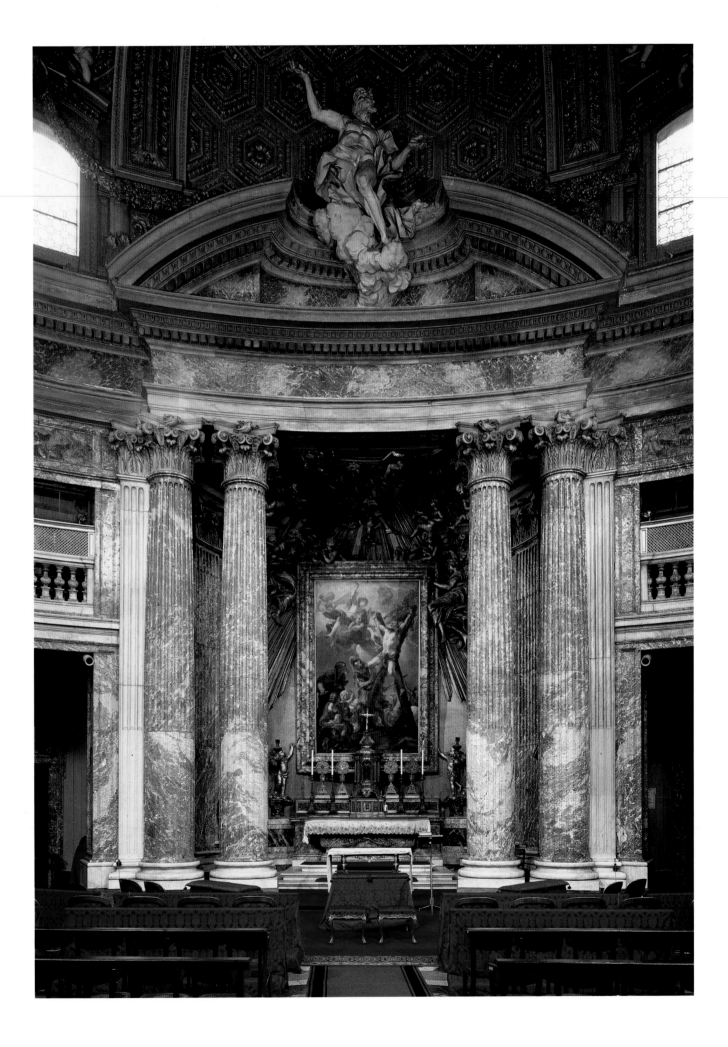

CONSTANTINE

1654–70
Marble and painted stucco
Saint Peter's, Rome

The emperor Constantine's embracing of the Cross forever altered relations between the Christian Church and the imperial state. According to Eusebius, his watershed victory over Maxentius at the Milvian Bridge in A.D. 312 was preceded by a vision of a glowing cross and the words *In hoc signo vinces* — "By this sign you shall conquer." In gratitude, Constantine endowed the major Early Christian basilicas, from the Holy Sepulchre in Jerusalem to Saint Peter's in Rome. The subject, not surprisingly, was a papal favorite. Epic treatments ranged from Giulio Romano's Vatican frescoes to the Barberini tapestries begun by Rubens and completed by Pietro da Cortona (Philadelphia Museum of Art).

In 1654, Innocent X commissioned Bernini to design a monument to Constantine in Saint Peter's, to be paired with the *Countess Matilda*. Unabashed papal propaganda stressed the tribute that Caesar's successors owe to Peter's. The first payment was dated October 29, the feast day of Constantine's entry into Rome; the equestrian imagery of the rearing stallion, a symbol of victory derived from Leonardo, was equally triumphal.[59] In Bernini's earliest surviving drawing (Academia, Madrid), the steed whirls around toward the viewer approaching along the basilica's right aisle. In a subsequent sketch (Museum, Leipzig), Constantine's face is a tracing of Bernini's river god Rio de la Plata, in the Piazza Navona fountain, who is likewise converted by a vision of blazing light (see plate 26).

Work was suspended following Innocent's death in 1655; by the time it resumed in 1662, his successor, Alexander VII, had chosen a more prominent site at the foot of the Scala Regia, the turning point for foreign dignitaries proceeding from Saint Peter's to ascend the ceremonial staircase to the pope's quarters. The overarching themes of Constantine's submission and contributions to the papacy were proclaimed in the two stucco reliefs that bracket the landing — his baptism and his founding of Saint Peter's. The emperor's conversion was cast into high relief by sunlight streaming in from a lunette behind a hovering cross and inscribed banderole. Since the scale of Bernini's statue had been fixed by its first, confining location, he introduced a stucco cloth-of-honor to fill the empty wall. Fringed and painted with gilded brocade, its shimmering chiaroscuro conveys the miraculous nature of the vision, while the background baldachin suggests the tent, pitched on the Vatican hill, in which the sign had appeared to Constantine in a dream. The cross-currents of drapery — Constantine's blows backward, while the backdrop sweeps forward — reinforce the sensation of suddenly arrested motion. The juxtaposition of this brightly lit scene with the two dark doors in its base suggests a funerary monument (see fig. 36; plate 39) proclaiming the ultimate triumph over death.

After another interruption during Bernini's visit to France in 1665, the statue was finally completed, two popes later, in 1670. With typical attention to historical detail, Bernini based Constantine's bearded face on a hand-copied passage from Nicephorus's *Ecclesiastical History*. The stirrup-less feet conform to the ancient *Marcus Aurelius* on the Capitoline. But these scholarly references failed to stem the hostile criticism leveled against Bernini's blending of Baroque naturalism and expressive distortion. "Buried in a niche as if lurking in ambush," wrote one anonymous wag about Bernini's emperor, who was likened to a groom, a satyr, a St. Francis receiving the stigmata, even "an ape on a camel." The marble horse was dubbed "a triumph of marzipan and meringue."[60] Yet there were prominent admirers. Hearing favorable reports, Colbert asked Bernini to design Louis XIV's equestrian statue and make him resemble the Constantine — an ironic compliment. Through the *Constantine*, Alexander VII had sought to reaffirm the preeminence of spiritual over temporal powers; in the latter, he had already been eclipsed by the Sun King.

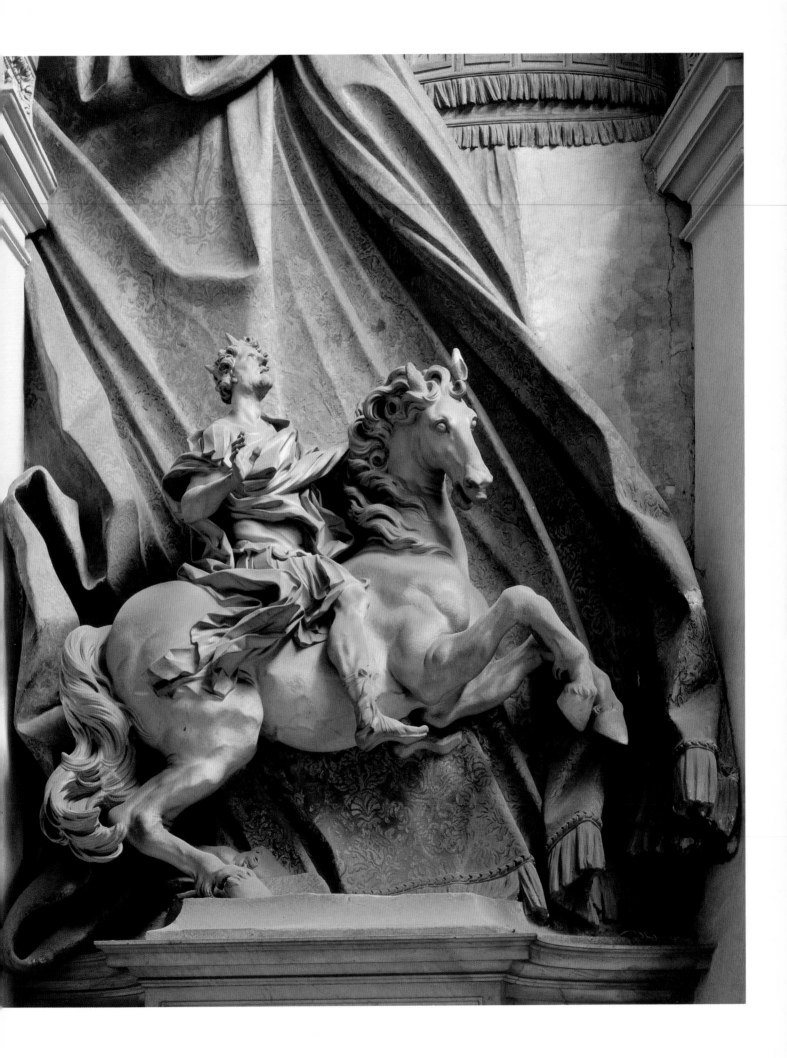

BUST OF LOUIS XIV

1665
Marble, height 31½" (80 cm)
Musée National de Versailles et de Trianon

"The image of a king": Bernini's bust of Louis XIV represents the pinnacle of High Baroque portraiture. Thanks to Chantelou's diary, this life-size masterpiece is also the best documented. Bernini began work almost immediately after his arrival in Paris in June 1665. He warned that he would need twenty sittings of two hours each—in fact he took seventeen, each lasting about an hour. Not finding a completely satisfactory block of marble, he had his assistant Guilio Cartari prepare *three* to work on simultaneously. Even so, the best turned out to be "too friable" and required extensive use of a drill (especially in the hair) in place of Bernini's preferred instrument, the chisel. Bernini made a series of impromptu sketches of Louis in action, not posing—in order to "soak and impregnate his mind with the image of the king."[61] He rapidly worked up small clay models to establish the "general conception" before studying the royal sitter close up. These he then put out of sight when tackling the marble, since he "did not want to copy himself but instead to create an original." He enveloped the ceremonial armor in taffeta to prepare a swath of drapery which, like the crowning cascade of curls, he wanted to appear "as light as possible." It was precisely this painterly profusion of curls and swirls, defying the marble medium, that both enlivens and elevates the king's features.

Beginning in mid-July, Bernini chiseled for almost a month before the king's first sitting (August 11)—but not before noble critics intervened. In response to the Marquis de Bellefonds's complaint about the bare forehead, Bernini carved a central curl, which in turn exaggerated the lumps over each brow. But to criticisms of the heightened forehead and enlarged eyes Bernini countered: "Small eyes are all right in life but big eyes give life to dead matter." By alluding to portraits of Alexander the Great, Bernini had sought to "bring out the qualities of a hero as well as make a good likeness."

Yet he was equally taken to task for faithfully rendering the king's most salient features. "Is my nose really a little crooked?" Louis whispered to the Duc d'Orléans, who nervously assured His Majesty that it would be "fixed." In fact, Bernini left it just so ("That's how I see it"). As in the bust of Borghese (plate 19), the sharply incised pupils bring the white face to life. During the sittings Bernini readjusted their markings in black chalk until he was finally satisfied; on October 5 he declared the bust finished.

Disdaining the French emphasis on costume, Bernini considered the bone-lace stock, so laboriously replicated, "something of very little taste." The flaming drapery, as in the Este bust (fig. 37), effectively concealed the truncation by a Baroque blur of energy, a flourish between Louis and his intended allegorical pedestal. Designed, but never executed, as a gilded globe resting on emblems of victory and virtue, it was to be inscribed with the words *picciola basa*: the world is "too small a base" for such a king. With an eye to the practical, Bernini explained that the globe "would prevent people from touching the bust, which is what happens in France when there is anything new to be seen."[62]

This image of absolute monarchy shows the artist's sincere admiration for the young French king, forty years his junior. Bernini had worked the marble for a biblical forty days—up to seven hours at a time—and with "so much love" that he justly concluded that "it was the least bad portrait he had done." The success of this speaking likeness, royally transfigured, was best summed up by the Venetian ambassador: "The king seems about to give a command to the Prince of Condé, or the Comte d'Arcourt, or M. de Turenne at the head of his army." Originally intended for the Louvre, the bust was fortunately taken by Louis to Versailles, where it escaped decapitation by Parisian mobs a century later.

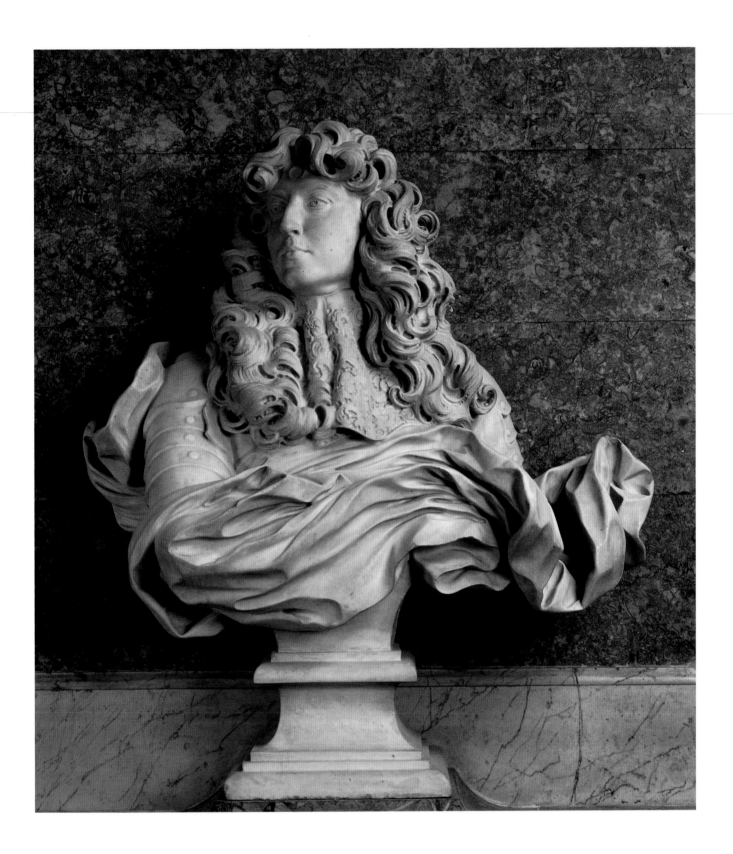

ELEPHANT AND OBELISK

1665–67

Marble

Piazza Santa Maria sopra Minerva, Rome

"It was as if he were a traveling elephant"—so Bernini described the throngs of curious people along his route to the court of the Sun King. Upon returning home in late 1665, he received from Alexander VII a final commission, for which he revived that exotic image to commemorate the enduring strength of the pope's intellect. Bernini had first seen a traveling elephant in 1630, which doubtless prompted his design (never executed) for a Barberini garden sculpture of a saddled elephant bearing a small Egyptian obelisk. In 1665 a similar obelisk was unearthed in the garden of the Dominican monastery of Santa Maria sopra Minerva, and Bernini was asked to design a sculptural base, as he had for Innocent X in the Piazza Navona. If Alexander's obelisk was smaller, it was no less charged with the wit and symbolism so dear to that scholarly pope, whose star-crowned mountains cap the pagan monolith. Early allegorical supports offered by Bernini included chained slaves, Hercules, Father Time, even the Dominican "watchdogs of the Lord," before the obelisk finally settled on the back of an elephant, perhaps at the urging of the Jesuit Athanasius Kircher. His treatise on the hieroglyphics (*Interpretatio hieroglyphica*) was rushed into publication in 1666, the year construction began; for Kircher's frontispiece Bernini adapted his old drawing of the Barberini elephant and obelisk, resaddled now with Chigi's escutcheon.[63]

Dedicated to the Virgin, Santa Maria sopra Minerva stood on the site of a Roman temple of Minerva and—earlier still—a sanctuary of the Egyptian goddess Isis. All three were considered embodiments of Divine Wisdom, the common denominator of the ground that yielded the obelisk "consecrated by the Egyptians to the highest genius, the World Spirit or World Soul, whose seat was fixed in the Sun." The motif of an obelisk-bearing elephant itself derived from a Dominican source, a woodcut in Francesco Colonna's *Hypnerotomachia Poliphili* (1499), and recalled the ancient oriental tradition of *turrigera fera,* or "towered beasts": Bernini had already designed one spewing fire from its trunk for the celebrations over the birth of the Spanish Infanta in 1651. According to millennia-old moralizing, the elephant was uniquely chaste because it mated only once and then solely for procreation; Aristotle considered it "nearest to man in intelligence." In the Renaissance, Cesare Ripa's *Iconologia* cited it as an appropriate symbol for a pope. Bernini based his fusion of emblems and allusions on an arresting, even a comic, naturalism. This beguiling beast is caparisoned with the ancient symbol of light under the Chigi star and the cross.

The elephant was carved between 1666 and 1667 by Ercole Ferrata, who had assisted in the recently completed *Cathedra Petri.* It was unveiled on July 11, 1667—seven weeks after the pope's death. The Dominican architect Padre Paglia, who supervised the unveiling, has been proposed as the true author of the monument.[64] But, as in the *Barcaccia,* the stones themselves refute such revisionist speculation; only Bernini could have conceived so thoroughly engaging a support for the weighty symbol. The regally draped beast inclines its head to greet the approaching viewer, its trunk flying back to point out the fantastic saddle. The layers of arcane meaning digested in the image were explained in inscriptions on the base: one recounts Alexander's dedication of the obelisk to Divine Wisdom and the baptism of its Egyptian-Roman roots; the other eulogizes the intellectual aspirations of the frail pontiff whom Bernini immortalized in the wittiest and most enigmatic of papal monuments: "Let every beholder of the images engraven by the wise Egyptian and carried by the elephant—the strongest of beasts—reflect upon this lesson: Be of strong mind, uphold solid wisdom."

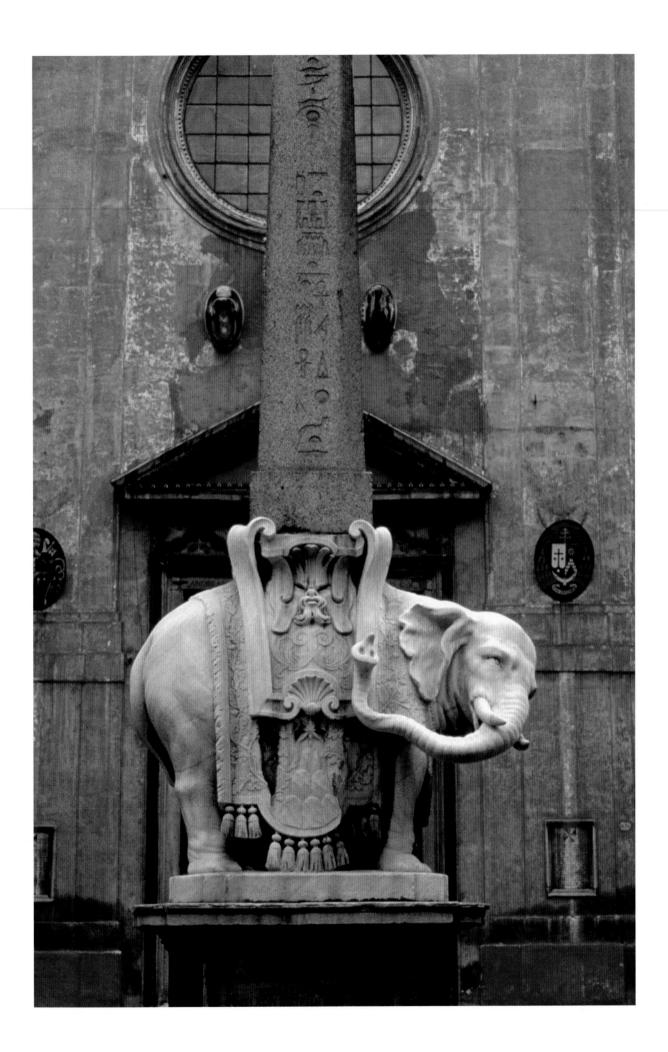

ANGEL WITH CROWN OF THORNS

1667–69
Marble, height c. 9′ (c. 2.7 m)
Sant' Andrea delle Fratte, Rome

Angels are, by definition, pure spirit—bodiless and sexless. But even spirits require iconographic attributes, and Early Christian artists adapted Roman winged Victories to fill the heavenly void. This archaeological pedigree was confirmed by Bernini on the Ponte Sant' Angelo (fig. 60). Dedicated in A.D. 134, the ancient Pons Aelius had originally been adorned by statues of Victories holding crowns in a triumphal approach to Hadrian's tomb, which was later christened the Castel Sant' Angelo. In the sixteenth century, stucco prophets and evangelists lined the bridge for Charles V's entry into Rome. Combining these precedents, Bernini blended classical and Christian, funerary and triumphal imagery with a vivid Counter-Reformation message. Displaying the Instruments of Christ's Passion, the means of redemption, his angels became guideposts along this Via Crucis for pilgrims approaching Saint Peter's.[65]

For each angel Bernini supplied a sketch. In his only surviving drawing (Museum, Leipzig) for the *Angel with Crown of Thorns,* one of the two originals he carved himself, he distilled its spiritual essence. Perched on a small cloud, the angel looks away from the instrument of torture, his wings contrapuntally balancing the windswept drapery. Through the subsequent figure studies and *bozzetti* Bernini developed a complementary pair, as he had earlier for the crossing (fig. 16; plate 14) and *Cathedra* (plate 29). Though doctrinally "sexless," these two angels bracket the continuum of androgyny—from this robust youth with the spiked crown, whose *bozzetto* (fig. 63) reveals an unambiguously male model, to the more feminine, lithe angel unfurling the paper scroll (fig. 61). This anatomical contrast, together with the drapery, conforms to the respective keynotes of suffering. Bernini magnified the angels' doubly "moving" aspects by incorporating a sequence of views to passersby along the bridge.

In January 1669 Bernini was seen at work with his son Paolo on the *Angel with Crown,* while his chief assistant, Giulio Cartari, tackled its companion piece. But shortly before their completion the pope decided to preserve these angels indoors and have studio replicas made for the bridge. Secretly carving the replacement *Angel with Superscription* (fig. 62), Bernini revealed his typical disdain of copying himself by creating a new variation that combined motifs from *both* originals. The graceful *contrapposto* of the body reflects Bernini's homage to the so-called *Antinous* (really a Hermes) in the Vatican gallery, to which he said he had often turned in his youth "as to the oracle." But that ancient source is transformed by the unclassical drapery, attenuation, and heightened emotion into a neo-Gothic image.

The deeply undercut, flamelike folds assume a life of their own as they respond to the thorny crown: a circular swirl rises in agitated cycles from the cloud base to the curls of hair. The eyes alone remain classically blank, so that ours may focus on the poignant object of meditation. Bernini has conflated in this sensualized abstraction of pain—both psychic (angel) and physical (crown)—the *leitmotifs* of Teresa's ecstatic suffering: cloud, angel, sharp instrument, transfigured face, frozen cry, and reverberating drapery. Jacob Burckhardt described that garment (not as a compliment) as "carved with a spoon in almond jelly."[66] But the modern artistic dogma of "truth to material" is not a valid criterion for judging such creations; otherwise, as the sculptor Henry Moore has observed, "a snowman made by a child would have to be praised at the expense of a Rodin or a Bernini." The angels remained in Bernini's studio until 1729, when his grandson Prospero donated them to the family church of Sant' Andrea delle Fratte. There they frame the dark sanctuary in glowing counterpoint, the closest any sculptor has ever come to capturing pure spirit in stone.

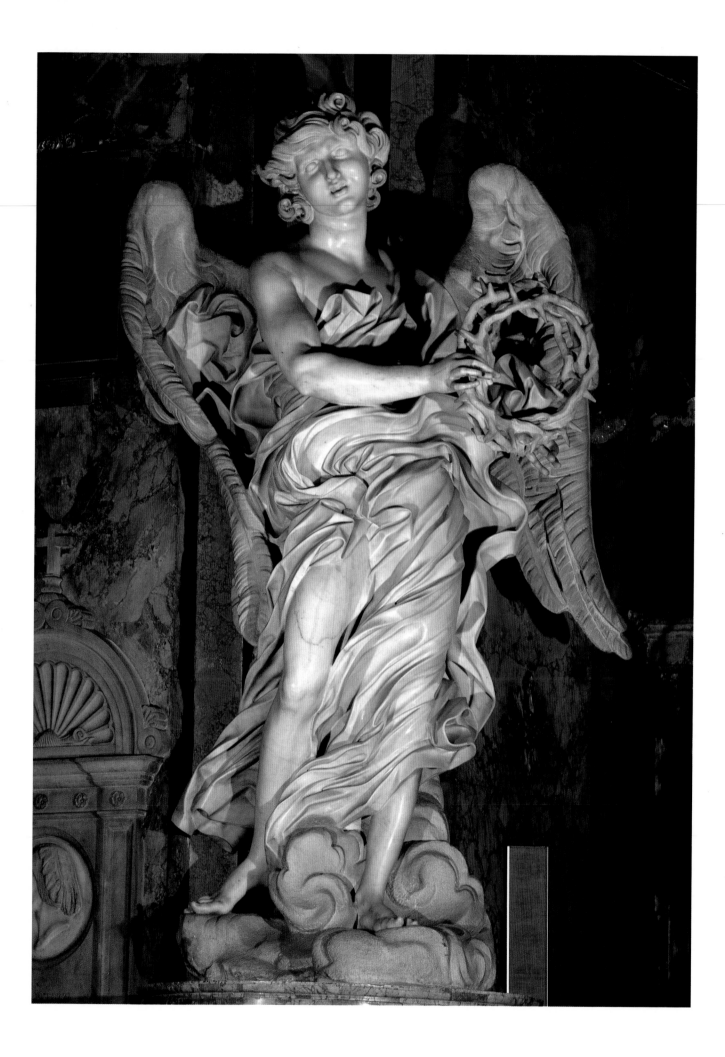

BUST OF GABRIELE FONSECA

c. 1668–75
Marble, over-life-size
San Lorenzo in Lucina, Rome

Nowhere is Bernini's late religious fervor expressed more clearly than in his portrait bust of the doctor Gabriele Fonseca. Born in Lamego, Portugal, Fonseca had been named physician to Pope Innocent X in 1644. During an outbreak of malaria, he was among the first to prescribe the new—and controversial—drug quinine. (Discovered by Jesuit missionaries, it was banned by the Protestant English as "the powder of the Anti-Christ.") An irascible patient, Innocent eventually dismissed Fonseca, and then died a year later. In 1657 Fonseca cured the new pope's nephew Flavio Chigi with quinine. In commissioning Bernini to design his family burial chapel in San Lorenzo in Lucina (c. 1663; fig. 65) Fonseca sought to commemorate both his devotion to medicine and his devout faith.[67]

Dedicated to the Annunciation in honor of Fonseca's patron saint, the archangel Gabriel, Bernini's chapel—a chamber version of Sant' Andrea (plate 31)—projects a mystical vision into the worshiper's space. From the Holy Spirit in the lantern, a stucco descant of cherubs swells into *putti* and finally into full-bodied bronze angels who carry the altarpiece, a copy of Guido Reni's *Annunciation* in the Palazzo Quirinale. (The side walls were originally decorated with two Old Testament scenes prefiguring the Eucharist and the curative powers of quinine.) Framed in rose-colored marble, Bernini's donor portrait emerges from the side, as if from a triptych wing. This arrangement, an adaptation of the recent De Silva reliefs in Sant' Isadoro (1662–63), ultimately harks back to the Cornaro chapel (plate 24). Dressed in an ermine-trimmed gown, Fonseca clutches a rosary, his left hand pressed to his breast as he turns toward the altar. His profile parallels his namesake Gabriel's at the very moment of Christ's incarnation. The extraordinary lifelikeness of the bust suggests that,

like King Louis's, it was prepared in drawings and *bozzetti* before Fonseca's death in 1668. But the accentuated, almost caricatured expression—the sculptural equivalent of Bernini's captivating penstrokes—and the stark chiaroscuro of the drapery suggest a date of the early 1670s for its carving; indeed, it seems not to have been installed before 1675.

This portrait-in-prayer is the resolution of a motif Bernini introduced a half-century earlier with the "speaking busts" of Gregory XV and Montoya. There has been some speculation about the content of Fonseca's prayer, but here the *context* evokes the text. Gabriele is surely reciting the refrain of the clutched rosary, which begins with the words of Gabriel's annunciation: "Hail, Mary, full of grace, the Lord is with thee; blessed art thou amongst women." The familiar prayer continues, "and blessed is the fruit of thy womb, Jesus," who is liturgically incarnated at the altar. In his will Fonseca beseeched Mary and her "angels in heaven" to pray for him at his death. That prayer of intercession gave rise to Bernini's altarpiece, his elevated homage to Guido Reni's "paintings of paradise," as he called them. He thereby fulfilled his patron's last wish by creating a miraculous setting for the Masses regularly offered for the perpetual repose of the good doctor's soul. Birth transfigures death in this annunciation of eternal life.

Bernini explained that he often "put himself in the attitude that he intended to give to the figure he was representing."[68] In his youthful *St. Lawrence* (fig. 8) Gianlorenzo had replicated the passion of his patron saint by holding a burning torch to his own flesh. Fonseca was to be no less intimately identified with *his* patron saint—but now by a mystical, not physical, equation in the old maestro's calculus.

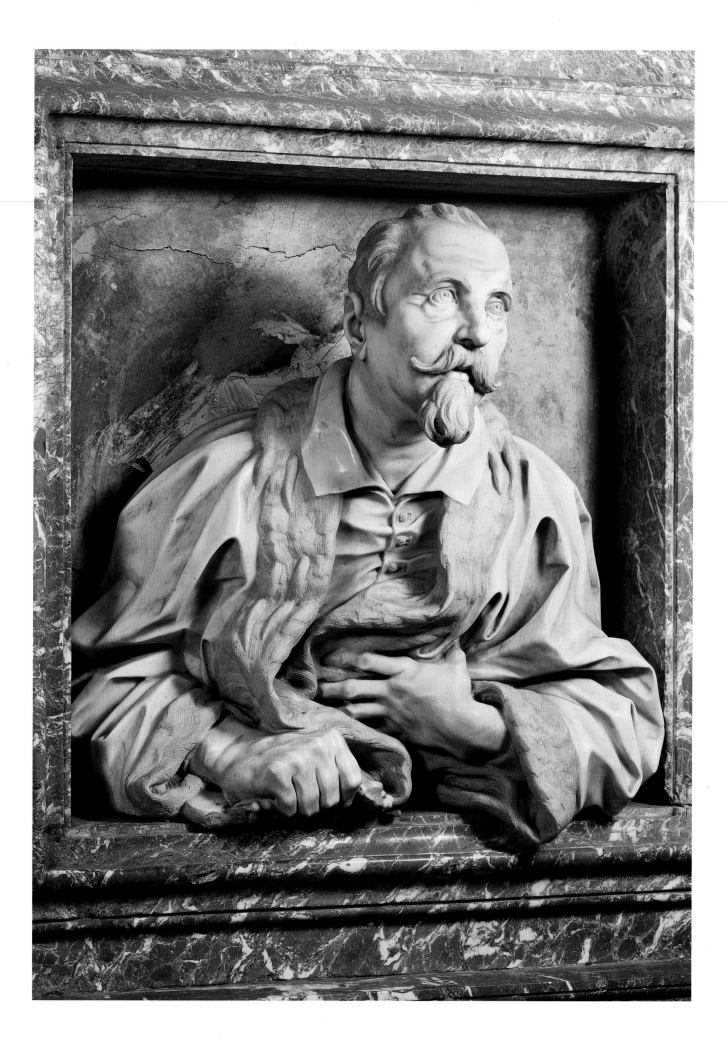

MODELLO OF LOUIS XIV ON HORSEBACK

1670
Terra-cotta, height 30″ (76 cm)
Galleria Borghese, Rome

Bernini raised the Baroque equestrian statue to its pinnacle to proclaim the virtue of the Sun King. He had first conceived such a statue as the centerpiece of his proposed steps up to the church of Trinità dei Monti (fig. 54). On that site he later staged a pyrotechnical apotheosis of the newborn dauphin (fig. 53), whose blazing emblem crowned the summit of illusionistic mountains. In his last royal emblem, Bernini fused the rearing equestrian statue and the mountaintop apotheosis into an allusion to Hercules, the hero from whom the French kings claimed descent. During Bernini's visit to Paris, the subject of Louis's equestrian monument was revived for a proposed amphitheater between the Louvre and the Tuileries. Then in December 1667 (six months after Bernini received the news that his Louvre would not be built) Colbert proposed yet another location, a new bridge over the Seine. The commission proceeded in fits and starts over a road made rockier by the dilatory payments of Bernini's annual pension from Louis. Finally in December 1669 Colbert wrote and requested that the king's statue be "similar" to the recently completed *Constantine* (plate 32), varied just enough to avoid being labeled a copy. The French Academy students were to assist in carving all but the head, which Bernini alone would execute; he would then retouch all the final surfaces "so that one can truly say that it is all a work of your hand." Bernini agreed to supervise the young French scupltors, for whom he made this *modello*. But he insisted that the statue would be "completely different from that of Constantine."[69]

The key to Bernini's differentiation between the two monuments was his allegorical *concetto*. Grounded in the rocky support for the rearing horse, it transformed an engineering necessity literally into a virtue. (Affixed to a wall by iron posts, Constantine's rearing steed might appear to defy gravity, but, as a freestanding sculpture, Louis's had to be balanced according to Nature's laws.) Conceived as Hercules at the summit of the mountain of Virtue, the king appears *all' antica*, in ancient costume and stirrupless as he extends the baton of military command. In this Baroque flourish of classical glory, Bernini describes through the fluid contours of the terra-cotta the varying textures of Louis's falling curls, the billowing drapery, the horse's mane, tail, and musculature, and finally its rocky base—all without benefit of color. In the final marble Bernini endowed Hercules-Louis with a smile of eternal bliss, the reward for having achieved the peak of virtue. There he also symbolized recent military victories by inserting curled flags between the rock and horse. "Since the poets tell us that Glory resides on the top of a very high and steep mountain," Bernini explained, "reason demands that those who nevertheless happily arrive there after privations joyfully breathe the air of sweetest glory. The wearier the labor of the ascent has been, the dearer Glory will be."[70]

But the glory was not to be the sculptor's. Though he labored tirelessly and brought it to near completion in two years (1671–73), the finishing work dragged on for four more. The statue was not sent to France until 1685—five years after Bernini's death. Louis's first reaction was to have it broken up, a sentence he commuted. Recarved for the Versailles gardens in 1687 by François Girardon to illustrate the legendary hero Marcus Curtius plunging to his fiery death (fig. 64), Bernini's royal apotheosis was deflated into a Roman self-sacrifice. That academic disfigurement doubtless spared the statue a worse fate during the revolution that eventually engulfed all of France—just a few years after Falconet had revived Bernini's Herculean formula for his rearing equestrian statue of Peter the Great in the Baroque sunset of Saint Petersburg.

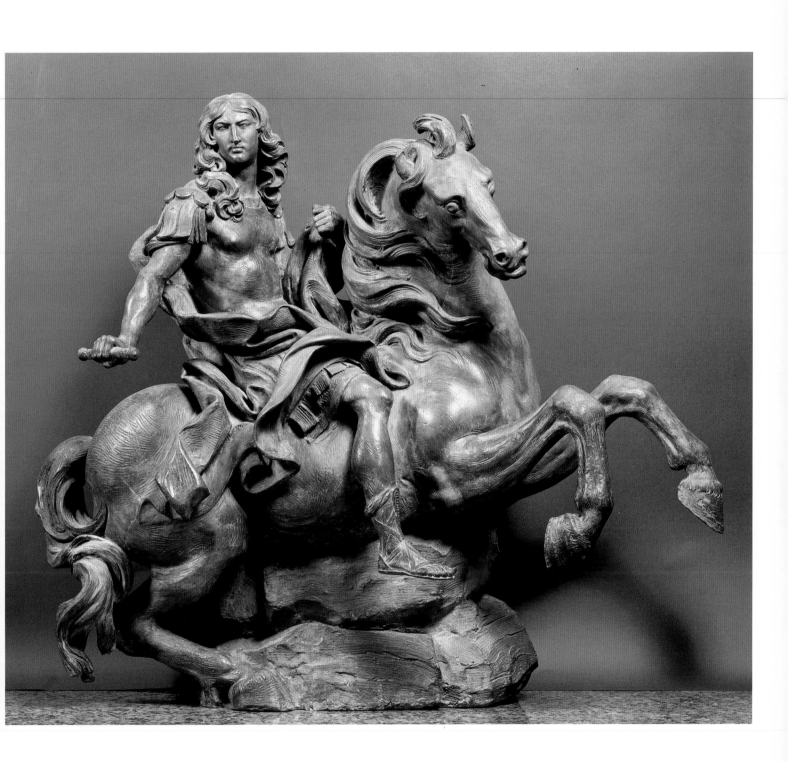

BLESSED LUDOVICA ALBERTONI

1671–74
Marble, over-life-size
San Francesco a Ripa, Rome

Bernini's last full-length marble figure in ecstasy resolves in muted reverberations his development of a religious theme ranging from the early *St. Bibiana* (plate 12) on through *Maria Raggi* (plate 23) and *St. Teresa* (plate 25). This Altieri commission was for a combined funerary monument and altarwork honoring the Blessed Ludovica Albertoni, an ancestor of Clement X's papal nephew. Like Maria Raggi, the widowed Ludovica had devoted her life to prayer and to serving the poor. At her death in 1553 she, too, was granted an ecstatic vision, which Bernini here staged above the altar of the family's burial chapel. Conceived in 1671, following her beatification, the work was finished in 1674.

Ludovica lies on her deathbed — "in the act of dying," in Domenico's words — and at the threshold of eternity. Carved in the form of a sarcophagus, the marble altar is wedded with the tomb sculpture in a luminous apparition at the end of the small, dark chapel. The walls converge as though wings of a huge triptych had been opened to reveal Bernini's most painterly tableau. With her head thrown back, *in extremis,* lips parted, and eyes upturned, Ludovica clutches her breast. Physical agony and metaphysical "movements of the soul" resonate through the folds of her dress. White cherubs float like snowflakes down streams of daylight from concealed side windows (the right one partially walled up); at the top of the vault the dove of the Holy Spirit hovers as the symbolic source. Behind Ludovica, Bacciccio's paradisaic painting of the Virgin and Child with St. Anne, to whom the chapel was dedicated, provides the window into Ludovica's vision.

The day before her death from fever Ludovica received the sacrament and then ordered everyone out of her room. When her servants were finally recalled, "they found her face aflame, but so cheerful that she seemed to have returned from Paradise." The intimacy — if not the spiritual intent — of the scene to which Bernini admits the viewer was appreciated by the novelist Aldous Huxley, to whom Ludovica's experience seemed so private "that, at first glance, the spectator feels a shock of embarrassment."[71] Scholarly opinion has been divided on the precise moment illustrated — is it her final death throes, or her ecstatic transport of the preceding day? The question is moot. As in the *St. Teresa,* allusions to *both* physical death and mystical "dying" coalesce in a single image.[72] The background reliefs of pomegranates and flaming hearts may refer to the *incendium amoris* ("fire of love") described in the popular Jesuit devotional manual *Pia desideria* (1624). Ludovica's consummation of divine love through death is shared sacramentally by all who partake of the Eucharist at her altar/tomb.

Bernini's juxtaposition of a framed painting and foreground sculpture recalls both Sant' Andrea (plate 31) and the Fonseca chapel (fig. 65) while it anticipates the narrative integration of his Sacrament chapel (plate 40). A comparison with the *St. Teresa* (plates 24, 25) illuminates the artist's profound revisions over the quarter century. A tactile apparition has modulated into an ineffable transfiguration — from body into soul. Architectural isolation (Teresa's monumental tabernacle) has yielded to dramatic immanence as Ludovica's jaspar pall (compare plate 39) cascades toward the spectator like the overflowing stage of Bernini's play *The Flooding of the Tiber.* Diagonals are resolved in sustained horizontals. No family effigies are here introduced as eternal witnesses. Even the choir of cherubs is reduced to a chamber ensemble. The Blessed Ludovica — the embodiment of "the good death," to which Bernini devoted his final meditations — is contemplated by the viewer alone. "Eternal rest grant unto them, O Lord, and let perpetual light shine upon them." This is Bernini's *Requiem.*

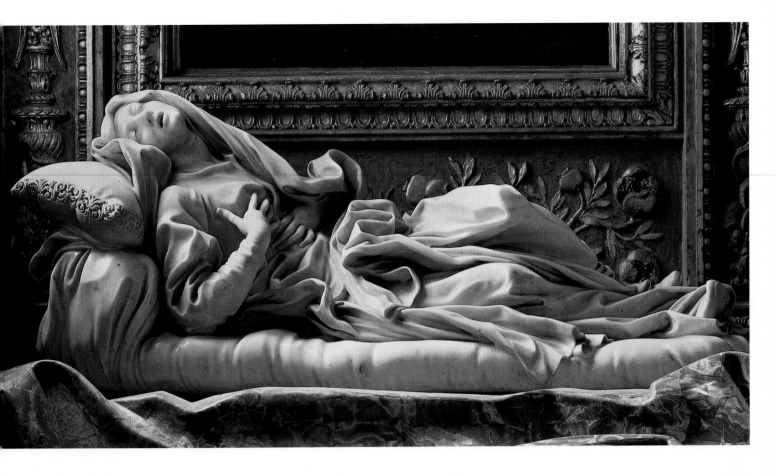

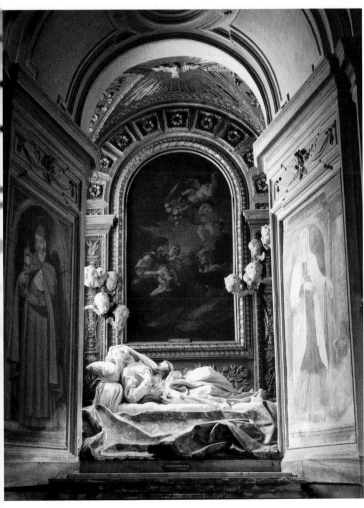

TOMB OF ALEXANDER VII

1672–78
Marble and gilded bronze
Saint Peter's, Rome

For his last tomb commission, that of Alexander VII, Bernini incorporated a startling *memento mori* within a Christian apotheosis—the triumph of faith over death.[73] Its site, a shallow niche in a side aisle of Saint Peter's, was punctuated by a door leading (at that time) to the basilica's sacristy. In his earliest surviving design (Philadelphia Museum of Art), Bernini framed this intrusive void by two allegorical figures below the enthroned pope, a practical adaptation of Urban's tomb (plate 18). In his expansive revisions he substituted a kneeling pope surrounded by Virtues—a reworking of Cardinal Pimentel's tomb (fig. 36) from relief into freestanding sculpture. Like the window above the *Cathedra Petri* (plate 29), the architectural obstacle became the catalyst for Bernini's dramatic *concetto*. Bringing the door forward, he reinterpreted it as at once the apparent door of Alexander's tomb and the classical portal of death, through which a gilded bronze skeleton flies upward, brandishing an hourglass. It is a sobering experience to pass through that door: it was meant to be. Yet despite its initial function as a *memento mori,* Bernini's most spirited skeleton is not ultimately terrifying but *uplifting.* Like his literary antecedent on Urban's tomb, Death has been recast as the agent of immortality.

Mors ad caelos—in his flight from the grave (as in the Chigi chapel) "Death opens the way to heaven." Doubling as Father Time, with wings and an hourglass, he begins to restore Alexander's clouded reputation. Emerging into the light, he pulls the shroud of Sicilian jaspar to reveal, on the right, the figure of Truth in all her naked splendor—that is, before Innocent XI had Bernini drape her in whitewashed bronze.[74] This unprecedented inclusion of Truth among the usual virtues (Charity, Prudence, Justice) highlights the political—as well as spiritual—redemption here signified. Bernini has heightened the pyramidal structure of Urban's tomb and the *Cathedra Petri* into a steeper "mountain" of figures capped, in an illusionistic oculus, by an immortal crown of stars—a monumental metamorphosis of Chigi's escutcheon. Hovering above the niche, that escutcheon is itself given a pair of wings to confirm Chigi's apotheosis.

As in the *Cathedra,* the two foreground figures are juxtaposed in a late example of Bernini's *contrapposti:* the Rubensian *Caritas* (carved by Giuseppe Mazzuoli) strides forward, infant in arms, while the Carraccesque *Veritas* (begun by Lazzaro Morelli and finished by Giulio Cartari) withdraws in seated modesty, her left foot resting on the world over which Truth reigns. By limiting Divine Love's offspring to a single infant Bernini associated her with the Virgin Mary. The humble gesture and long tresses of Truth suggest, by contrast, a Mary Magdalene by Annibale Carracci. Her humility is reflected above in the bareheaded pontiff. Unlike his enthroned Barberini predecessor, Alexander kneels in eternal adoration of the sacrament as he gazes toward the papal altar (plate 13) and the tabernacle (plate 41) beyond it. This praying pope, whose head alone was carved by Bernini, recalls his kneeling predecessors Sixtus V and Paul V in Santa Maria Maggiore, where the boy Gianlorenzo had first studied under his father.

By the time the tomb was dedicated in 1678, Bernini was approaching his eightieth birthday and his final two years of life. The collaborative carving has tended to distract modern critics from Bernini's symbolic *concetto* and its powerful realization. Like so many of the late works, it must be experienced face-to-face to be fully appreciated. Nowhere is Death confronted so directly—nor with such unblinking faith.

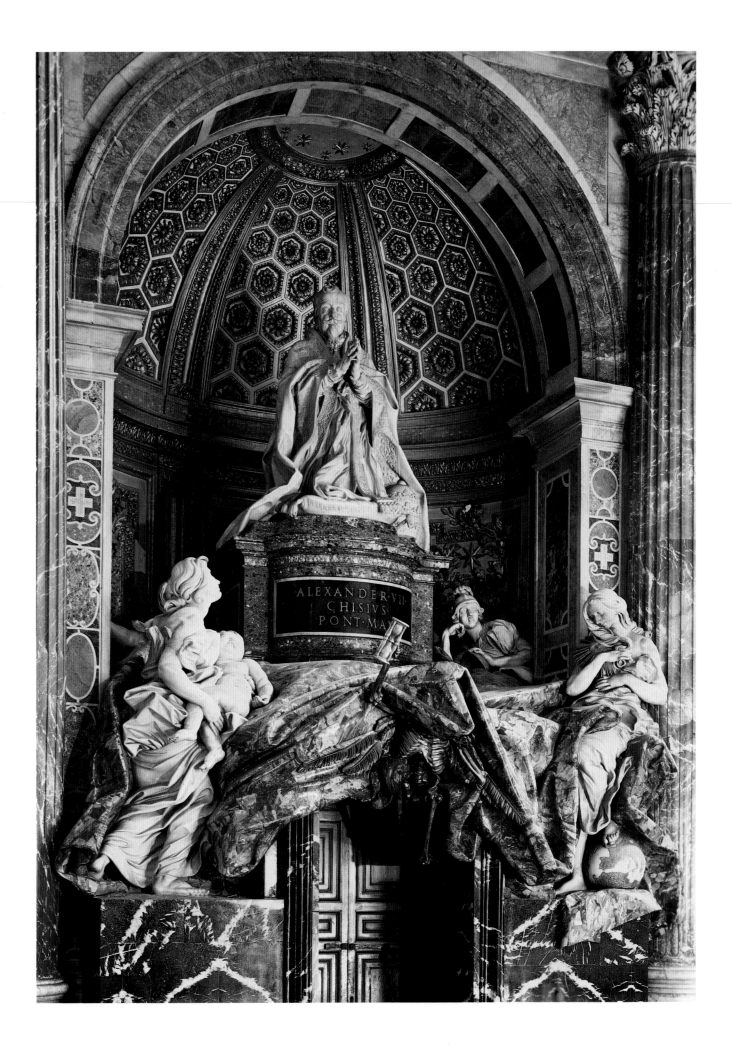

COLORPLATE 40

ALTAR OF THE BLESSED SACRAMENT

1673–74
Marble, gilded bronze, lapis lazuli
Saint Peter's, Rome

Bernini's final commission at Saint Peter's was also his last altarwork. This architectonic shrine of precious materials—gilded bronze, *porta santa* marble, and lapis lazuli—reflects its function as the permanent repository and symbolic tomb for the sacramental Body of Christ. Having visited the tomb and *Cathedra* of the apostle Peter, the votive altars, and papal tombs, the pilgrims completed their journey in silent adoration, kneeling at this Christian successor to the Holy of Holies, or Tabernacle of the Most High, God's dwelling-place in the ancient Hebrew Temple. Bernini's commission had originated with Urban VIII in 1629, while the *Baldacchino* was underway; his first wooden model (lost) for the tabernacle included several angels, *putti,* and figures of saints Peter and Paul. But work was suspended a few years later. Although the project was periodically revived by Urban's successors Innocent X and Alexander VII, its final realization is owed to the otherwise parsimonious Clement X, who decided in 1673 to proceed in earnest and to have the tabernacle completed in time for the Holy Year 1675.[75] For the last time Bernini presided over a team of assistants—sculptors, founders, goldsmiths—combining painting, sculpture, and architecture in his sublime summation of the Christian faith: the death, resurrection, and second coming of Christ.

Bernini's early conception of four kneeling angels holding candles as they effortlessly support the *tempietto*-tabernacle is preserved in a pen-and-wash drawing (fig. 68). Reminiscent of both his *Cathedra Petri* and the angel-borne tabernacle in the Sistine chapel of Santa Maria Maggiore, it may also incorporate elements of the wooden model Bernini had designed for Urban. His subsequent variations on this theme of angelic adoration may be followed through a series of drawings and *bozzetti,* an unprecedented number of which have been preserved. Relieved of their supporting roles, the angels were multiplied into two antiphonal rows of worshipers (first with four on a side, then three). As their candles became less prominent, Bernini progressively spiritualized the angels—as he had the Church fathers around the *Cathedra* (figs. 41, 42; plate 29). In the end he contracted the heavenly choir into a harmonious duet of personified prayer.

Through this intense simplification, a hallmark of Bernini's last works (see plates 36, 38, 42), he alluded to the Old Testament cherubim on the Ark of the Covenant, for which there were notable Renaissance precedents such as Sansovino's tabernacle at Santa Croce. Having finally freed his angels from all practical functions, Bernini recast the magnified figures in a *contrapposto* of ecstatic adoration. One reaches forward with praying hands, while the other withdraws with crossed arms pressed to his breast. This psychological pairing is a gilded revision of a motif he had introduced a half-century earlier at the high altar of Sant' Agostino (fig. 21) and later revived, in passing, for the *Cathedra Petri* (fig. 42). Set before Pietro da Cortona's altarpiece of the Trinity, which had been installed since 1631, the pair finally returned iconographically to Bernini's source, also a painting: Guido Reni's *Trinity* (fig. 20), which had been commissioned for the Holy Year 1625. Their demonstrative poses and contrasting expressions may evoke as well the two protagonists of the Annunciation, Gabriel and the Virgin. By this communicative allusion to the Incarnation—the Word made Flesh—Bernini's dialogue in gilded bronze both framed the tabernacle and announced its eucharistic *concetto.*

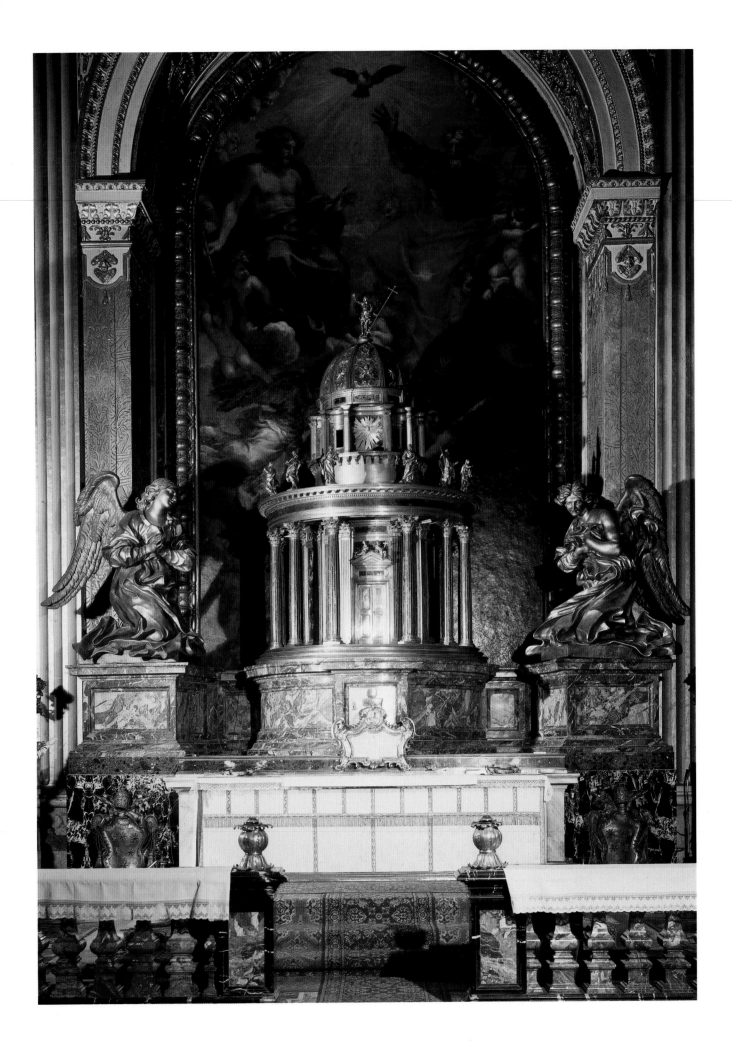

ANGELS AND TABERNACLE

1673–74
Marble, gilded bronze, lapis lazuli
Saint Peter's, Rome

In this vertically staged drama, Christ's sacrifice, liturgically reenacted at the altar and symbolized by the crucifix, is superseded a level higher by the round tabernacle—his burial and resurrection. A masterpiece of miniature architecture, its ribbed dome is a revised reduction of Michelangelo's at Saint Peter's, which Bernini has embellished with the papal keys and the Altieri stars of Clement X. Crowned by a gilded statue of Christ (in lieu of a cupola), its drum is encircled by a rhythmic ring of Corinthian pilasters; at the front, two dark windows offset a sunburst of the Holy Spirit. The lapis and bronze columns of the portico are surmounted by bronze statuettes of the twelve apostles, the "pillars of the Church," while Faith and Religion take their place over the main portal. The richly symbolic form of the tabernacle, epitomizing Bernini's architectural ideal for churches, refers at once to the Early Christian *Anastasis* (destroyed) erected over Christ's tomb at the church of the Holy Sepulchre in Jerusalem and to Bramante's *tempietto* outside San Pietro in Montorio, the site of St. Peter's martyrdom on the Gianicolo in Rome. As in the *Baldacchino,* Bernini fused references to Christ and his first vicar in a sculptural hybrid. Its topographical meaning is unchanged: Jerusalem has been spiritually transferred to Rome. The formal equation of tabernacles with Christ's tomb was stressed during the Counter-Reformation in response to their destruction by Protestants, who considered such shrines idolatrous. St. Charles Borromeo had prescribed that tabernacles "be round or octagonal and display an image of the Risen Christ in Glory or showing his wounds." By incorporating the former image, Bernini fulfilled his original plan for the *Baldacchino* (fig. 15). We recall that he had intended to crown it with a huge bronze statue of the Risen Christ but had to replace it with the much lighter globe and cross. By reviving that triumphant figure, he now resolved on a more intimate scale the *Baldacchino*'s suspended *concetto:* a three-staged narrative of death, resurrection, and enthronement. Here the narrative culminates not in the lantern of the dome, which Bernini had designed to provide overhead illumination, but rather in Pietro da Cortona's background altarpiece. This conceptual and illusionistic progression represents a reversal of the emergence from painting into sculpture which Bernini had introduced in Sant' Andrea and in his church at Ariccia.

One evening in Paris, while visiting a convent chapel to pray before the sacrament, Bernini complained that its massive silver tabernacle covered up two-thirds of a Guido Reni altarpiece, which he said "alone was worth half of Paris." Either the painting or tabernacle had to be moved, he concluded. Now, a decade later, he chose to exploit precisely such an "obstacle" by converting Pietro da Cortona's background canvas into an integral part of his composition and *concetto.*[76] In this final reconciliation of painting and sculpture, Pietro's colorful angels frame the heavenly dome of Bernini's tabernacle (which symbolically eclipses Pietro's globe) while Bernini's sculptured angels are coordinated in scale and placement with the Trinity in the painted heaven, their implicit source, so as to form a monumental triangle with the dove at its apex. Twice life-size, these exquisite apparitions—modeled by the maestro himself (fig. 69)—direct the worshipers to the sacred mystery they embrace. One turns in rapture toward the tabernacle while the other beckons the viewer to partake of the eternal.

In his first altarwork at Saint Peter's, Bernini had raised a huge, sculptural baldachin over an altar, itself above a tomb. Here he retranslated sculpture into miniature architecture—a bronze tabernacle described as a tomb and raised above an altar. Form and function are equated in this late work that radiates its creator's faith. Bernini repeatedly credited God as the source of his ideas; nowhere did he offer more inviting evidence of this belief.

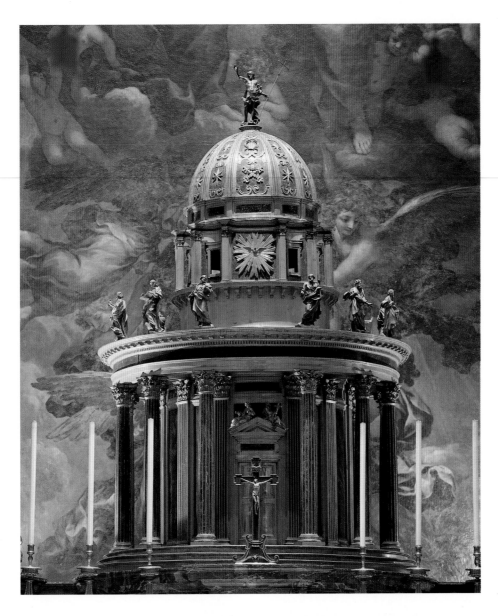

BUST OF THE SAVIOR

1679–80
Marble, height 36⅝″ (93 cm)
The Chrysler Museum, Norfolk, Virginia

In his final sculpture the eighty-year-old maestro "summarized and condensed all his art," Domenico writes, adding that his father's "bold conception" more than compensated for the "weakness of his wrist." Bernini undertook this parting work not for his own tomb, a marble slab in Santa Maria Maggiore, but as a gift for Rome's preeminent Catholic convert, Queen Christina of Sweden. When she refused to accept it, saying she could never afford to repay Bernini for its true worth, he bequeathed it to her. On his deathbed he asked for Christina's prayers since she shared "a special language with God." It was precisely through *Bernini's* special language of gesture and facial expression that his otherworldly "speaking portrait" of the Lord communicates its meaning.

The bust was originally mounted on a round Sicilian jasper base and supported by two angels kneeling on a gilded wooden socle. Bernini's sketch (Museum, Leipzig) for the pedestal reflects his drawing (also in Leipzig) of similar angels elevating a monstrance to display the sacramental Body of Christ (compare fig. 68). Bequeathed by Christina to Innocent XI, Bernini's *Savior* was later adapted as the official emblem of the Apostolic Hospital in Rome before vanishing in the early eighteenth century. Only a preliminary drawing (fig. 70) preserved Bernini's redeeming image until Irving Lavin published in 1972 the marble in Norfolk as the lost bust.[77] This was followed a year later by the discovery, in the cathedral of Sées, of the copy commissioned by Bernini's Parisian friend Pierre Cureau de la Chambre. While the latter bust reveals a classical beauty and polish typical of a competent copyist, the Norfolk version, on the other hand, appears almost Gothic in its spiritualized breach of conventional formulas—from the severe, abstracted drapery, to the whirlpools of hair shaded, as in the portrait of Louis XIV (plate 33), by rows of drilled holes. The iconic simplification of the face, the penetrating eyes, and the

arched brows are initially arresting, even disturbing, and this bust has remained in virtual limbo outside the realm of unqualified acceptance. Yet these unsettling features offer the strongest evidence of Bernini's authorship; they illustrate a "bending of the rules" that only the master himself would have incorporated in his final legacy.

Clearly no simple blessing, the unusual gesture that Lavin interpreted as an ambiguous combination of "abhorrence and protection" may, more precisely, refer to the *Noli Me Tangere*—the first appearance of the resurrected Christ to Mary Magdalene: "Do not touch me, for I have not yet ascended to the Father" (John 20:17). Evoked through Christ's upturned eyes and raised hand—an aloof, cautionary benediction—Bernini's biblical allusion would have been reinforced by the angels that, with hands covered, lifted the divine effigy above the touch of mortals. When designing a symbolic globe to raise his Louis XIV in a royal apotheosis, he explained that its *practical* function was to prevent viewers from touching the bust. Considered afresh in its original context, as a sacramental apotheosis, the *Savior* may finally come into focus. The features that seem exaggerated up close, even caricatured, are resolved into an expression of enormous spiritual intensity when viewed from below. Its *concetto* is emphatically eucharistic—a huge white Host elevated as "the Bread of Angels." This is Bernini's marble sacrament, raised in his last labor of adoration.

According to his biographers, Gianlorenzo's career commenced with the posthumous bust of Bishop Santoni, a public effigy (plate 1); seven decades later, it concluded with a private bust of the Eternal Savior, animated through marble folds that follow no natural pattern. The striking realism of the child prodigy was transfigured, in the end, by the ethereal vision of a genius for whom life and art were as inseparable as fact and faith.

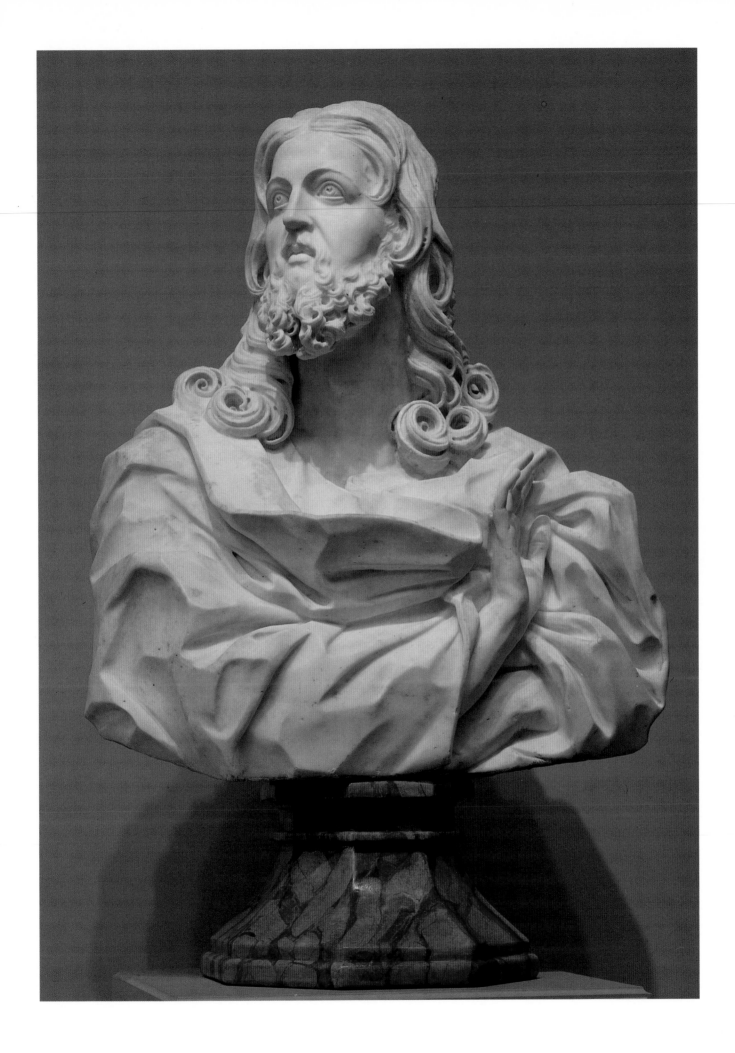

For *catalogue raisonné* and extensive bibliography of Bernini's sculptures, see R. Wittkower, *Bernini,* 3rd ed. (Ithaca, N.Y., 1981); for architecture, F. Borsi, *Bernini* (New York, 1980); for drawings, I. Lavin et al., *Drawings by Gianlorenzo Bernini* (Princeton, 1981); for artistic background, R. Wittkower, *Art and Architecture in Italy 1600–1750,* revised 3rd ed. (New York, 1980); for historical background, T. Magnuson, *Rome in the Age of Bernini,* 2 vols. (Stockholm, 1982, 1986).

Text

1. Filippo Baldinucci, *The Life of Bernini* (Rome, 1682), English ed. trans. by C. Enggass (University Park, Pa., and London, 1966), p. 8.
2. For Pietro, see J. Pope-Hennessy, *Italian High Renaissance and Baroque Sculpture* (London, 1970), pp. 92, 423–25; also exhibition catalogue, *Pietro Bernini: un preludio al barocco* (Sesto Fiorentino, 1989).
3. For analysis of Baroque style, see J. R. Martin, *Baroque* (London and New York, 1977).
4. P. Fréart de Chantelou, *Diary of the Cavaliere Bernini's Visit to France,* tr. by M. Corbett (Princeton, 1985), p. 52.
5. See C. Scribner, *Rubens* (New York, 1989), pp. 18, 54; also in *Ringling Museum of Art Journal,* 1983, pp. 164–77.
6. See notes 1, 4. For English excerpts of Domenico Bernini, *Vita del Cavalier Gio. Lorenzo Bernini* (Rome, 1713; rep. Munich, 1988), see G. C. Bauer, ed., *Bernini in Perspective* (Englewood Cliffs, N.J., 1976), pp. 24–41. For priority, see C. D'Onofrio, in *Palatino,* X, 1966, pp. 201–8.
7. Domenico Bernini (1713), p. 9.
8. See I. Lavin, in *Art Bulletin,* L, 1968, pp. 224–28.
9. See F. Zeri, *Dietro l'immagine* (Milan, 1987), pp. 268–72.
10. Domenico, p. 15. For the *St. Lawrence,* see R. Preimesberger, in I. Lavin, ed., *Gianlorenzo Bernini: New Aspects of His Art and Thought* (University Park, Pa., and London, 1985), p. 2, who dates it c. 1617. Lavin, in *Art Bul.,* L, pp. 232–33, proposes 1614. On basis of style, I prefer 1615–16.
11. See I. Lavin, in *Art Bul.,* L, p. 234.
12. See J. Montagu, *Roman Baroque Sculpture* (New Haven and London, 1989), p. 161.
13. See Wittkower, *Art and Arch.,* pp. 152–55; cf. "multiple views" of J. Kenseth, in *Art Bul.,* LXXX, 1981, pp. 184ff.
14. See F. Haskell, *Patrons and Painters* (New York, 1963), pp. 4, 28ff.
15. See C. Scribner, *An Important Sculpture by Bernini* (Christie's, New York, 1990).
16. Chantelou, p. 25.
17. Domenico, pp. 18–19.
18. Domenico, pp. 23–24.
19. Baldinucci, p. 15.
20. For architectural survey, see Wittkower, *Art and Arch.,* pp. 174–96.
21. Baldinucci, pp. 10–11.
22. Bauer, *Perspective,* p. 60 and passim; also Haskell, pp. 34ff.
23. See I. Lavin, *Bernini and the Crossing of St. Peter's* (New York, 1968).

24. See J. S. Held, in *Rubens and His Circle* (Princeton, 1982), pp. 90–91. For collaborators, see J. Montagu, *Roman Baroque Sculpture,* pp. 99ff; and in Lavin, *New Aspects,* pp. 25–61.
25. Baldinucci, p. 28.
26. Haskell, pp. 31, 41.
27. For title pages, see Scribner, in *Ringling Jn.,* pp. 164ff. For bust, see Wittkower, in *Burlington Magazine,* CXI, 1969, pp. 60–64.
28. Domenico, p. 28. For caricatures, see I. Lavin, in *Drawings,* pp. 25ff.
29. Domenico, pp. 54–57. For Bernini's plays, see also Baldinucci, pp. 82–85; Chantelou, passim and pp. 83–84, 339–41; Haskell, pp. 56–59; Lavin, *Bernini and the Unity of the Visual Arts* (New York, 1980), pp. 146–57; and in *New Aspects,* 1985, pp. 63ff.
30. H. Hibbard, *Bernini* (Harmondsworth and New York, 1965), p. 101.
31. Wittkower, *Bernini,* p. 32.
32. Chantelou, p. 73, n. 92.
33. *Ibid.,* p. 20.
34. Baldinucci, p. 26; also Chantelou, p. 70. For Richelieu, see Haskell, p. 176.
35. Haskell, pp. 36–37.
36. Domenico, p. 80.
37. *Ibid.,* p. 84.
38. *Ibid.,* p. 87.
39. See M. Worsdale, in *Vatican Splendour* (Ottawa, 1986), p. 99.
40. Baldinucci, p. 39.
41. See N. Cheetham, *Keepers of the Keys* (New York, 1982), p. 224.
42. Baldinucci, p. 42.
43. Haskell, p. 150ff.
44. Baldinucci, p. 76. For Christina, see Magnuson, II, pp. 147ff.
45. See Wittkower, in *Studies in Western Art* (Princeton, 1963), III, pp. 41ff.
46. Chantelou, pp. 9, 48. For *concetto,* see H. Brauer and R. Wittkower, *Die Zeichnungen des Gianlorenzo Bernini* (Berlin, 1931), p. 70, n.1.
47. See R. Battaglia, *Crocifissi del Bernini in S. Pietro* (Rome, 1942); U. Schlegel, in *Antichita viva,* XX 1981, pp. 37–42.
48. See T. A. Marder, in *Art Bul.,* LXXI, 1989, pp. 628ff.
49. Baldinucci, p. 82; and Chantelou, p. 326.
50. Chantelou, p. 208.
51. Scribner, *Rubens,* pp. 31, 94.
52. Baldinucci, pp. 43, 80.
53. See R. Krautheimer, *The Rome of Alexander VII* (Princeton, 1985), pp. 99–101; and C. Gould, *Bernini in France* (Princeton, 1982).
54. Baldinucci, pp. 47ff.
55. Chantelou, p. 10.
56. Domenico, pp. 126–27.
57. Chantelou, p. 14. Unless otherwise noted, quotations of Bernini in France are from Chantelou: see pp. 12, 33, 40, 44, 70, 72, 75, 79, 98, 102, 129, 139–40, 148, 165–69, 192, 323.
58. Baldinucci, p. 53.
59. Domenico, pp. 145–46.
60. Baldinucci, p. 62.
61. Chantelou, p. 94.
62. Domenico, p. 150ff.
63. Baldinucci, pp. 64ff.
64. See. R. Enggass, *The Paintings of Baciccio* (University Park, Pa., 1964), pp. 43–53.
65. Lavin, in *Art Bul.,* LIV, 1972, p. 159ff.
66. See V. Martinelli in *Commentari,* X, 1959, pp. 222ff.
67. Baldinucci, p. 68.
68. Lavin, in *Art Bul.,* LIV, pp. 160–62.
69. Chantelou, p. 75.
70. Bauer, *Perspective,* p. 64 and passim.

Colorplates

1. Chantelou, p. 260.
2. Lavin, in *Art Bul.,* L, pp. 223–48.
3. I concur with Pope-Hennessey (1970, p. 425); cf. Lavin, in *Art Bul.,* L, p. 229.
4. Lavin, *Art Bul.,* L, p. 230.
5. See J. Nissman, *Domenico Cresti (Il Passignano)* (Ph.D. diss., Columbia Univ., 1979).
6. Lavin, *Art Bul.,* L, p. 230; cf. C. D'Onofrio, *Roma Vista da Roma* (Rome, 1967), pp. 172–87.
7. See O. Raggio, in *Apollo,* 1978, pp. 406ff.; and M. Weil, in M. Fagiolo, ed., *Gian Lorenzo Bernini e le arti visive* (Rome, 1987), pp. 73ff.
8. See J. R. Martin, *The Farnese Gallery* (Princeton, 1965), pp. 83–126.
9. See I. Faldi in *Bollettino d'arte,* 1953, p. 146; cf. D'Onofrio, *Roma,* pp 241–72, who overpromotes Pietro.
10. See Preimesberger, in I. Lavin, *New Aspects,* pp. 7–10.
11. See Wittkower, in *Burl. Mag.,* XCIV, 1952, pp. 68–76.
12. See W. Collier, in *Journal of the Warburg and Courtauld Inst.,* XXXI, 1968, pp. 438–40; and J. Pope-Hennessey, *Catalogue of Italian Sculpture in the V & A* (London, 1964), II, p. 600.
13. See L. Grassi, in *Burl. Mag.,* CVI, 1964, pp. 170ff.
14. Lavin, *Drawings,* pp. 57–61.
15. See S. Howard, in *Art Quarterly,* II, 1979, pp. 140ff.
16. Scribner, *Rubens,* p. 70; and in *Ringling Jn.,* pp. 166–67.
17. Baldinucci, p. 14.
18. Chantelou, p. 16.
19. Lavin, in *Art Bul.,* L, p. 240.
20. Chantelou, p. 16.
21. *Ibid.,* p. 165.
22. Baldinucci, p. 11.
23. Wittkower, in *Studies,* III, pp. 41ff.
24. Montagu, in I. Lavin, *New Aspects,* p. 26.
25. See J. Kenseth, in *Art Bul.,* LXIII, 1981, pp. 194ff.
26. Preimesberger, in Lavin, *New Aspects,* pp. 10–13.
27. H. Kauffmann, *Giovanni Lorenzo Bernini* (Berlin, 1970), p. 57.
28. Borsi, *Bernini,* p. 291; Hibbard, *Bernini,* pp. 71–75.
29. Lavin, *Crossing,* passim; also, W. C. Kirwin, in *Römisches Jahrbuch für Kunstgeschichte,* XIX, 1981, pp. 141–71.
30. Borsi, pp 291–92; cf. Montagu, *Sculpture,* pp. 70–71.
31. Lavin, *Crossing,* pp. 24–38; Kauffmann, in Bauer, *Perspective,* pp. 98–110.
32. See C. Scribner, in *Art Bul.,* LIX, 1977, pp. 375–82.
33. See H. Hibbard and I. Jaffé, in *Burl. Mag.,* 1964, pp. 159–70.
34. Baldinucci, pp. 15–16.
35. See M. Levey, *National Gallery Cat. 17 and 18th Cen. Italian Schools* (London, 1971), pp. 15–16.
36. Wittkower, *Art and Arch.,* pp. 172–74; also V. Martinelli, in *Commentari,* I, 1950, pp. 95–104.
37. See Lavin, *Drawings,* pp. 62–68; M. Worsdale, in *Vatican Splendour,* pp. 29ff.: C. Wilkinson, in *L'Arte,* IV, 1971, pp. 54–68; H. Davis, in *Source,* VIII/IX, 1989, pp. 38–48.
38. Held, *Rubens and His Circle,* pp. 89–90.
39. Hibbard, in *Bolletino d'arte,* XLVI, 1961,

pp. 101–5. Also M. Weil, in *Source,* VIII/IX, 1989, pp. 34–39.
40. Pope-Hennessey, 1970, p. 123.
41. Chantelou, p. 73.
42. Hibbard, *Bernini,* pp. 110–14; F. Borsi, p. 311.
43. Lavin, *Drawings,* pp. 95–100; I. Lavin, *Unity,* pp. 70–74.
44. Chantelou, p. 142.
45. See J. Bernstock, in *Art Bul,* 1980, pp. 243–55; and Lavin, *Unity,* pp. 67–70.
46. Lavin, *Unity,* pp. 6–13; A. Blunt, in *Art History,* I, 1978, p. 76.
47. Bauer, *Perspective,* p. 53.
48. From Teresa's *Vida* (ch. 29), quoted in Lavin, *Unity,* p. 107.
49. *Ibid.,* pp 113–24.
50. Kauffmann, *Bernini,* p. 174; cf. N. Huse, in *Revue de l'art,* VII, 1970, pp. 7–17; R. Preimesberger, in *Münchner Jahrbuch,* XXV, 1974, pp. 77–162.
51. Lavin, *Drawings,* pp. 164–73; also M. Hesse, in *Pantheon,* XLI, 1983, pp 109–26.
52. Wittkower, *Studies,* III, pp. 41–50.
53. Brauer and Wittkower, *Zeichnungen,* pp. 64ff., esp. p. 70; also Wittkower, *Art and Arch.,* pp. 189–96.
54. Haskell, p. 152; also R. Krautheimer, *The Rome of Alexander VII, 1655–1667* (Princeton, 1985), pp. 63–73.
55. See H. Von Einem, in *Nachtrichten von der Akad. der Wissen. in Göttingen,* I, 1955, pp. 93–114; Lavin, *Drawings,* pp. 174–93.
56. Brauer and Wittkower, *Zeichnungen,* p. 113; Haskell, pp. 85–87.
57. Wittkower, *Art and Arch.,* pp. 182–84; Lavin, *Drawings,* pp. 194–207.
58. Domenico, pp. 108–109.
59. Lavin, *Drawings,* pp. 136–47.
60. Bauer, *Perspective,* pp. 60ff.
61. See R. Wittkower, *Bernini's Bust of Louis XIV* (London and New York, 1951).
62. Chantelou, p. 186.
63. See W. Heckscher, in *Art Bul.,* XXIX, 1947, pp. 155–82.
64. See C. D'Onofrio, *Gli obelischi di Roma,* 2nd ed. (Rome, 1967), pp. 230–37.
65. See M. Weil, *The History and Decoration of the Ponte S. Angelo* (University Park, Pa., and London, 1974).
66. Bauer, *Perspective,* p. 66.
67. See J. Dobias, in *Burl. Mag.,* 1978, pp. 65–71.
68. Chantelou, p. 60.
69. See Wittkower, in *De Artibus Opuscula XL,* I (New York, 1961), pp. 497–531.
70. *Ibid.,* p. 503. See also R. W. Berger, in *Art Bulletin,* LXIII, 1981, pp. 232–48.
71. Aldous Huxley, *Themes and Variations* (New York, 1950), p. 170.
72. See S. Perlove, *Bernini and the Idealization of Death* (University Park, Pa., 1990); also C. M. S. Johns, in *Storia dell 'arte,* L, 1984, pp. 43–47.
73. See J. Bernstock, in *Saggi e memorie di storia dell' arte,* XVI, 1988, pp. 169–90.
74. See P. Fehl, in *Art Bul.,* XLVIII, 1966, pp. 404–405.
75. See M. Weil, in *Journal of the Walters Art Gal.,* XXXIX-XXX, pp. 7–15; Lavin, *Drawings,* pp. 317–35.
76. Chantelou, p. 64. See K. Noehles, in *Röm. Jahr. für Kunst.,* XV, 1975, pp. 169–82.
77. Lavin, in *Art Bul.,* LIV, 1972, pp. 158–86; also in LV, 1973, pp. 429ff.: and LX, 1978, pp. 548–49; cf. C. Soussloff, in *Art Journal,* XLVI, 1987, pp. 115–21 (reply by J. S. Held, p. 132); also C. Scribner, in *Proceedings of the American Philosophical Society,* 1991.